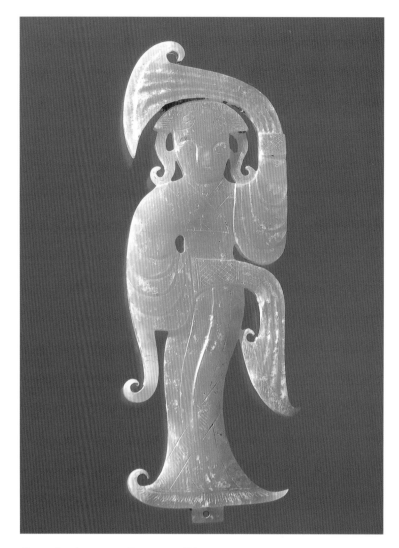

Female dancer, Eastern Zhou CAT. 119

Radiant Stones

Archaic Chinese Jades

Pierres radieuses

Jades archaïques chinois

Chinese jades from
the Neolithic period
through the Han dynasty

by Filippo Salviati

Myrna Myers

Préface

Ce n'est pas un secret : les céramiques, textiles, laques et jades que l'on peut voir dans les vitrines de ma galerie depuis tant d'années marquent le parcours que mon mari et moi-même avons suivi en tant que collectionneurs. Et collectionneurs, nous le sommes restés, dans l'âme.

Notre devise pourrait être : « Le hasard fait bien les choses », puisqu'une rencontre fortuite a souvent été le point de départ vers un domaine imprévu, que nous avons ensuite exploré à la recherche d'œuvres, témoins de ce nouveau thème. Nous avons eu la chance de pouvoir vivre avec ces trouvailles et d'apprendre beaucoup à travers elles, avant qu'on ne les retrouve dans ma galerie de la rue de Beaune. Cette exposition de jades archaïques chinois reflète parfaitement l'une de ces aventures : notre intérêt pour ces pierres mystérieuses naquit, il y a 26 ans, par pur hasard.

Notre premier jade archaïque, une cigale d'époque Han, no. 122, mon mari l'a trouvé dans une boite à chaussures parmi d'autres petits sujets, dans une brocante de Philadelphie, pendant l'été 1974. Ignorants de son origine et de sa signification, nous avons pourtant été séduits par cette forme de palet mi-pierre, mi-objet, par le subtil dégradé des couleurs et le doux toucher du minéral. Ce sont d'ailleurs ces qualités essentielles qui nous attirent dans les jades ainsi que la luminosité intérieure qu'ils recèlent.

Plusieurs pièces de cette exposition évoquent d'autres souvenirs. La lame no. 39 vient des bureaux de Warren Cox à New-York, de qui nous avons appris qu'un jade était « Zhou parce que c'est Warren Cox qui le dit ». Quant au disque huan no. 33, c'est un souvenir de notre visite à la Salle des Jades, dans ce lieu légendaire qu'était Rare Art sur Madison Avenue. Comme notre premier livre de référence était l'ouvrage de Berthold Laufer, Jade (1912), nous y avons forcément lu la description du disque cranté no. 34, mais n'aurions jamais imaginé qu'il serait un jour en notre possession.

Plus tard, une fois établis à Paris, nous avons pu acquérir des pièces provenant de collections et de ventes publiques telles les no. 23 et 25, ainsi que le disque bi no. 85 de la Collection Trampitsch et la magnifique plaque animalière no. 108 de la Collection Vignier dont la luminosité a inspiré le titre de cette exposition.

Empruntant la voie imprévisible des collectionneurs et des marchands, nous avons eu la chance de croiser beaucoup de générosité. Angus Forsyth, par exemple, a longtemps été pour nous une sorte de mentor, toujours prêt à partager ses observations. Sa femme Bibi et lui-même sont des amis chaleureux qui nous ont beaucoup encouragés.

Mais c'est grâce à la bienveillance de Giuseppe Eskenazi que nous avons franchi le pas entre notre collection et une exposition. Lui ayant exprimé notre désir de soumettre nos objets à une analyse spécialisée, il recommanda Filippo Salviati comme savant digne de confiance dans ce domaine difficile et trouva peu après l'occasion de nous le présenter. Nous tenons à lui exprimer notre gratitude car cette rencontre nous permit d'entreprendre l'étude commencée par le Dr Salviati pendant l'été 1999, mais aussi d'envisager la présente exposition.

Nous avons eu le rare privilège de pouvoir examiner nos pièces à la lumière des découvertes archéologiques les plus récentes grâce à Filippo Salviati. Inlassable dans ses efforts de recherche qui placent les jades de notre collection dans une perspective culturelle et historique, il a écrit un catalogue de grande qualité avec une vision cohérente de l'ensemble. Nous sommes très redevables à cet homme de culture.

Nos remerciements vont à Thierry Prat dont la photographie sensible capte les insaisissables qualités du jade, et à la société Tauros pour l'élégante conception de ce catalogue et sa réalisation. A Elisabeth Knight, dont nous admirons depuis longtemps le professionalisme, et à Louisa Ching d'Orientations, nous disons notre reconnaissance pour leur patiente collaboration à une réalisation vraiment internationale. Précieuses également furent l'aide de Françoise Isackson pour la mise en forme des textes et de Jacqueline Boudet, fidèle amie, pour la traduction en français.

MYRNA ET SAMUEL MYERS

It is no secret that the ceramics, silks, lacquers and jades which have appeared in the windows of my gallery over the years are so many signs of the itinerary my husband and I have traced as collectors; for essentially, we have remained collectors at heart.

We would agree with the French expression "Le hasard fait bien les choses" or "Chance arranges things nicely". A random encounter has often been our point of departure in an unforeseen direction where we are soon searching for works as variations on the new theme. We have indeed been fortunate to be able to live with and learn from these discoveries, although most of our finds eventually find themselves in my gallery on the Rue de Beaune. This exhibition of archaic Chinese jades reflects another of these adventures; our interest in these mysterious stones was awakened twenty-six years ago – by chance.

Our first archaic jade, the Han dynasty cicada no. 122, was one of a shoe-box full of small carvings my husband came across browsing in a cluttered shop in Philadelphia in the summer of 1974. Ignorant of its origin and significance, we nevertheless responded to its intriguing half-pebble, half-worked form, its subtle variations of color and the smooth feel of the stone. These are the essential qualities which appeal to us in jades, as well as the impression of inner light.

Several pieces shown here bring back other memories. The blade no. 39 came from the New York offices of Warren Cox, where we learned that a jade was "Zhou because Warren Cox says it is". The *huan* disc no. 33 recalls a visit to the Jade Room at Rare Art's legendary premises on Madison Avenue. As our first reference work was Berthold Laufer's *Jade* (1912), we surely read about the notched disc no. 34, but did not imagine that one day it would be ours.

Further along, and established in Paris, we were able to acquire from French collections and sales such pieces as the axes nos. 23 and 25 and the *bi* disc no. 85 from the Trampitsch Collection and, from the Vignier Collection, the wonderful animal plaque no. 108, whose radiance inspired the title of this exhibition.

On the unpredictable path of collecting and dealing, we have had the good fortune to meet with generosity. Angus Forsyth, for example, has for many years been something of a mentor, always willing to share his insights. He and his wife Bibi have been warm and encouraging friends.

However, the bridge between our collection and a gallery exhibition would not have been crossed without the generosity of Giuseppe Eskenazi. We had expressed to him our desire to submit our pieces to scholarly analysis; he recommended Filippo Salviati as worthy of confidence in this difficult field and shortly thereafter found the occasion to introduce us. We are sincerely grateful to him, for that meeting not only enabled us to proceed with the study, undertaken by Dr. Salviati in the summer of 1999, but led eventually to the present exhibition.

We have had a rare opportunity to examine our pieces in light of the most recent archeological discoveries thanks to Filippo Salviati. Unstinting in his efforts and research to place the jades in our collection in historical and cultural perspective, he has written a fine catalogue with a coherent vision of the ensemble. He is a gentleman and a scholar to whom we owe much.

We also wish to thank Thierry Prat whose sensitive photography captures the elusive qualities of jade, and Tauros for the elegance of the conception for this catalogue and for its realization. We are indebted to Elizabeth Knight, whose professionalism we have long admired, and to Louisa Ching of *Orientations* for their patience and cooperation in a truly international endeavor. Indispensable as well, was the help we received from Françoise Isackson in preparing the texts, and from Jacqueline Boudet our loyal friend for the French translations.

MYRNA AND SAMUEL MYERS

Jade, the radiance from within

Jade, pierre radieuse

It is hard to imagine a more fascinating experience than extracting minerals from the depths of the earth or cutting into an opaque boulder to reveal a concealed inner light, a luminous radiance.

Such a contrast between darkness and light, such a mysterious interpenetration of these two primeval natural elements, earth and light, in the form of glowing crystalline formations, has undoubtedly intrigued men since they first discovered the "hidden brightness" contained in the earth's minerals. Extracting the minerals, removing the opaque skin which protects them and finally shaping them to release the luminous qualities within, are all stages of a process through which men seek to possess the energy of the earth in its purest form.

Both the ancient Greeks and the Chinese conceived of metals and minerals as being generated by the solidification of vapors exhaled by the earth. For the Chinese, gold and jade were produced by the concretion of the *jing* or seminal essence of the *qi*, the primordial "pneumatic" and fluid energy pervading the universe and giving form to all things.[1]

Through successive periods of world history every culture has manifested its preference for certain minerals and gemstones, to which it attributed specific powers, magical properties and virtues, and invested them with particular meanings and symbolic values. Minerals and gemstones were regarded not as neutral substances but as concentrates of primeval energy radiating from their inner structure. This long association between stones and human beings —not merely a cultural but a physical bond, since most of the stones were worn or kept in close proximity to their owners— continues today, beyond mere aesthetic appreciation. The rediscovery of the protective, symbolic and curative values of

Il est difficile d'imaginer une expérience plus fascinante que celle d'extraire des minéraux des profondeurs de la terre ou de tailler à même un bloc de pierre pour lui faire révéler une luminosité interne cachée, une source radieuse.

Un tel contraste entre l'ombre et la lumière, une telle interpénétration mystérieuse entre ces deux éléments naturels originels, la terre et la lumière, sous la forme de concrétions cristallines rayonnantes ont, à l'évidence, intrigué les hommes depuis leur première découverte

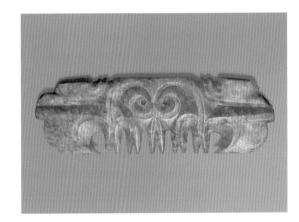

Toothed plaque, Hongshan CAT. 3

de la « lumière enfouie » au cœur des minéraux de la terre. Extraire les minéraux, les dégager de la gangue opaque qui les protège et les tailler pour libérer leurs secrètes qualités lumineuses, ce sont toutes les étapes d'un processus par lequel les hommes cherchent à s'approprier l'énergie de la terre sous sa forme la plus pure.

Les Chinois, comme les anciens Grecs, concevaient métaux et minéraux comme des matérialisations de vapeurs exhalées par la terre. Pour les Chinois, l'or et le jade étaient les concrétisations du jing, *principe vital du* qi *ou Souffle primordial, une énergie fluide qui anime l'univers et donne forme à toutes choses*[1].

Au cours des périodes successives de l'histoire du monde, chaque culture a manifesté sa

minerals is in fact one of the cornerstones of the New Age spiritual movements characteristic of our millennium.

It is worth remembering that the scientific name for one of the main mineralogical varieties of jade, nephrite, has its origin in the Spanish *piedra de los riñones* or "stone of the kidneys".[2] This is the expression used by the conquerors of the New World to indicate jade worn and used by the indigenous peoples who believed in its healing properties. The

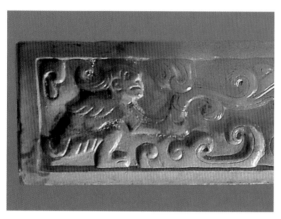

Ornament, Western Jin CAT.146

word jade itself derives from *piedra de hijada*, another Spanish expression, meaning "stone of the loins". These same healing properties, along with the extraordinary hardness and translucent beauty of the material, attracted the curiosity of such early European collectors of jades and gemstones as the Medici family of Florence during the Renaissance.[3]

As we know today from archaeological discoveries, Central America was one of the places in ancient times where jade was extensively worked by the cultures which flourished there: the Olmecs (c. 1200-300 BC), the Mayas (c. 1100 BC-1521 AD) and the Costa Ricans (c. 900 BC-700 AD). Other cultures which

préférence pour certains minéraux et gemmes, auxquels elle attribua des pouvoirs spécifiques, des propriétés et vertus magiques, en les investissant de significations particulières et de contenus symboliques. Minéraux et gemmes n'étaient pas considérés comme des substances neutres mais comme des concentrés de l'énergie vitale émanant de leur structure interne. Cette longue communion entre la pierre et l'être humain – un lien physique autant que culturel, puisque la plupart de ces pierres étaient portées ou gardées à proximité par leurs propriétaires – se poursuit de nos jours, bien au-delà de l'attrait purement esthétique. La redécouverte des valeurs protectrices, symboliques et curatives des minéraux est, de fait, une des pierres angulaires des mouvements de « renouveau spirituel » caractéristiques de notre millénaire.

Il faut se souvenir que le nom scientifique de l'une des principales variétés de jade, la néphrite, a son origine dans l'expression espagnole piedra de los riñones *ou « pierre des reins[2] ». Les conquérants du Nouveau Monde utilisaient cette expression pour désigner le jade porté et utilisé par les peuples indigènes qui croyaient à ses propriétés thérapeutiques. Le mot jade lui-même vient d'une autre expression espagnole,* piedra de hijada, *signifiant « pierre des hanches ». Ce sont ces qualités prophylactiques associées à la dureté extraordinaire du matériau et à sa splendeur translucide qui ont suscité très tôt l'intérêt des collectionneurs européens de jades et de pierres précieuses, comme les Médicis à Florence, dès la Renaissance[3].*

D'après les connaissances archéologiques actuelles, l'Amérique Centrale est un des lieux où, dans les temps anciens, les cultures locales ont largement développé le travail du jade: les Olmèques (c. 1200-300 av. JC), les Mayas (c. 1100 av. JC-1521 ap. JC) et les Costariciens (c. 900 av. JC-700 ap. JC). On connaît d'autres peuples sur le pourtour de l'océan Pacifique, qui

valued jade, granting it a special place in their ritual art and social life, are found in a geographic area distributed around the Pacific Ocean. In New Zealand, in the South Pacific, the Maori is a major jade-working culture.[4] On the rim of the Pacific Ocean, in China jade has been worked since prehistoric times.

In all these societies jade was essentially, if not exclusively, used to make similar types of objects: ceremonial insignia and weapons, objects symbolizing the social status of their owners, and ritual and funerary artifacts.

In China the jade carving tradition has been documented over an extremely long period of time extending from the Neolithic period (4th to 2nd millennium BC) to the present day.[5] Such importance is accorded to jade in China that, to the West, this material has become, together with silk, lacquer, bronze and porcelain, one of the quintessential materials with which this civilization achieved distinction. However, in the Chinese scale of values these materials do not have the same importance, perhaps because of the different sources from which they are obtained and the techniques required to work them. Silk and lacquer are organic materials produced by living organisms, silkworms and lacquer trees. The manufacture of silk and lacquer artifacts requires transformation of the raw materials which thus lose their original character. The same applies to metals and porcelain, requiring a laborious process of extraction, purification, melting, forging or firing into the desired forms. The artifacts are the result of a series of chemical and physical manipulations of the basic materials, whose pristine state has been radically changed. Jade, on the contrary, is complete in itself. It does not require any fundamental alteration of its structure and retains its original aspect virtually intact. As in other lapidary traditions, the intervention

accordaient un grand prix au travail du jade, lui conférant une place spécifique dans les arts rituels et la vie sociale. Ainsi, les Maori de Nouvelle-Zélande, dans le Pacifique Sud, dont l'art du jade est l'un des plus développés[4]. Sur des rivages plus éloignés de l'Océan Pacifique, en Chine, on taille le jade depuis les temps préhistoriques.

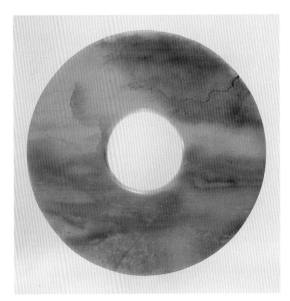

Bi disc, Neolithic CAT. 30

Dans toutes ces sociétés, le jade était réservé essentiellement, voire exclusivement, à la fabrication de types similaires de pièces : insignes et armes cérémoniels, objets symbolisant le statut social de leurs détenteurs, mobilier funéraire et rituel.

En Chine, la tradition ininterrompue de l'usage du jade est attestée sur une très longue période, s'étendant du Néolithique à nos jours[5]. Le jade occupe une place si importante que cette matière est devenue, aux yeux des occidentaux, et au même titre que soie, laque, bronze et porcelaine, une expression de la quintessence des arts de cette civilisation. Cependant, dans

of the Chinese craftsman on the stone is a process of subtraction, aimed at bringing out the quintessence of the jade, at emphasizing its natural qualities and revealing its inner radiance without altering it.

While from the beginning of its cultural history China was marked by the use of jade, this material was not worked continually and

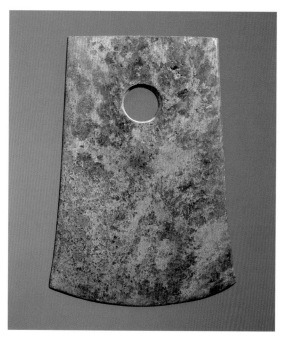

Yue axe, Liangzhu CAT. 27

was not always granted the same importance throughout the centuries.

However, jade is inextricably at the core of Chinese civilization and played an essential role in its self definition as one of its constituent, founding elements. Techniques of carving, the functions of the objects and even the values related to jade were established during the period of formation of Chinese culture, spanning the late Neolithic period to the age of the early empires. That is exactly the period to which the jades presented in this catalogue belong: from the 4th millennium BC to the

l'échelle des valeurs chinoise, ces matières n'ont pas la même importance, à cause de la différence de nature du matériau de base et de la technique requise pour le travailler. Soie et laque sont des matières organiques produites par des organismes vivants, les vers à soie et les arbres à laque. L'élaboration des objets en soie et en laque suppose une transformation du matériau brut qui, de ce fait, perd ses caractéristiques d'origine. Il en va de même pour les métaux et la porcelaine qui requièrent un long processus d'extraction, d'épuration, de fusion, de fonte ou de cuisson pour obtenir les formes désirées. Ces artefacts sont le résultat d'une série de manipulations chimiques et physiques des matières naturelles, dont l'état premier a été radicalement modifié. Le jade, au contraire, est en lui-même la matière finale. Sa structure ne subit aucune altération fondamentale et son aspect d'origine demeure intact. Comme dans les autres traditions lapidaires, l'intervention de l'artisan chinois est une opération d'épuration destinée à faire apparaître l'essence même de la pierre, à accentuer ses qualités naturelles et à révéler ainsi sa radieuse luminosité interne sans en altérer la substance.

Alors que, depuis le début de son histoire, la Chine est marquée par la présence du jade, le travail de cette matière n'a pas été continu et toutes les époques ne lui ont pas accordé la même importance.

Cependant, le jade est indiscutablement au cœur de la civilisation chinoise et joua un rôle prépondérant dans sa définition d'elle-même, étant l'un de ses éléments constitutifs. Les techniques de taille, la fonction des objets et la valeur attribuée au jade se sont établies pendant la période de formation de la culture chinoise, que l'on situe du Néolithique tardif aux premiers empires. C'est précisément à cette longue période allant du IVe millénaire av. JC au IVe siècle ap. JC, qu'appartiennent les jades

4th century AD, from the Neolithic period to the Han (206 BC - 220 AD) and Western Jin (265-317 AD) dynasties.

Although the use of jade in China has its roots in the remote Neolithic period, only some of the many early cultures which existed in the vast territory corresponding to present-day China worked jade intensively. For example in the area of the Yellow River, long believed to be the cradle of Chinese civilization, Neolithic cultures such as Yangshao do not provide substantial evidence of a systematic use of jade. In fact it is among the early societies which flourished in the peripheral border areas of eastern and southern China –Hongshan (c. 4000-2500 BC) in the northeast, Liangzhu (c. 3300-2200 BC) in the area of Lake Tai, Dawenkou (c. 4500-2300 BC) and Longshan (c. 2500-1700 BC) in Shandong province – that jade was used to craft the earliest ritual objects and the earliest emblems of status and prestige destined for members of the elite, objects which signal the emergence of hierarchically organized societies anticipating traits of the later Bronze Age dynastic period. Specific classes of objects in jade, especially artifacts of the Hongshan and Liangzhu cultures, bore images that corresponded to their religious concerns.[6] The stylised mask motifs carved on Liangzhu jades are of particular importance, since they anticipate similar images which were to be used to decorate ritual artifacts in bronze in the Shang dynasty (16th-13th century BC).[7] This iconographic relationship has led to a reconsideration of the factors which shaped ancient Chinese civilization during the critical passage from the late Neolithic period to the early Bronze Age.

From these early periods, jade was used to make objects which had ornamental, ritual and symbolic functions, as well as serving as emblems of status and of religious authority.

présentés dans ce catalogue, du Néolithique aux dynasties Han (206 av. JC - 220 ap. JC) et Jin de l'Ouest (265 - 317 ap. JC).

Bien que son usage en Chine remonte aux premiers temps du Néolithique, seuls quelques peuples parmi tous ceux répandus sur le vaste territoire qui constitue la Chine d'aujourd'hui, ont pratiqué, de manière intensive, le travail du

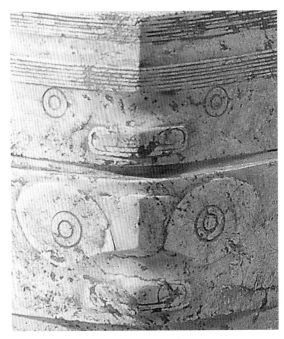

Cong, Liangzhu CAT. 10

jade. Dans la région du Fleuve Jaune, par exemple, que l'on a longtemps tenue pour le « berceau » de la civilisation chinoise, des cultures néolithiques comme celle de Yangshao n'offrent pas de preuve solide de son usage systématique. En fait, c'est par les cultures qui ont prospéré dans les zones périphériques de l'est et du sud de la Chine – Hongshan (c. 4000-2500 av. JC) au nord-est, Liangzhu (c.3300-2200 av. JC) dans la région du lac Tai, Dawenkou (c. 4500-2300 av. JC) et Longshan (c. 2500-1700 av. JC) dans la province du Shandong – que le jade fut employé pour fabriquer les premiers objets rituels

Jades indicated – through their size, form, iconography, quality of material and quality of carving – the rank and position of their owners within the society, in this life and in the afterlife. The values attached to jade persisted over the centuries. In this sense, the

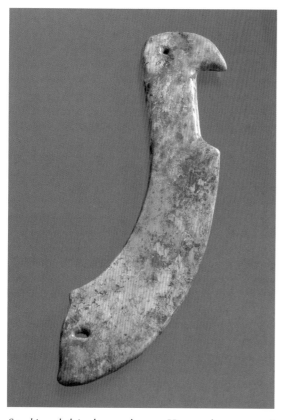

Stylized bird pendant, Hongshan CAT. 8

pendants worn in the Neolithic period by Hongshan and Liangzhu members of the elite played essentially the same role as those worn by the aristocracy of the Eastern Zhou period. It is likely that, even in the Neolithic period, people responded to the aesthetic properties of the finished objects. However, jade was not used at this early stage to create artifacts for their purely aesthetic appeal, as was the case in much later periods, especially during the Song (960-1279 AD) and Qing (1644-1911 AD)

et les premiers insignes de statut et de prestige destinés aux membres de l'élite. Ces objets témoignent de l'émergence de sociétés organisées et hiérarchisées, dont certains aspects anticipent la période dynastique ultérieure de l'Âge du Bronze. Certains types spécifiques de jades, ceux des centres de Hongshan et de Liangzhu, présentent des décors liés à des préoccupations religieuses[6]. Les motifs stylisés de masques gravés sur les pièces de Liangzhu ont une importance capitale puisqu'ils préfigurent des images analogues qui vont orner les bronzes rituels des Shang (XVIe - XIIe s. av. JC)[7]. Cette similitude iconographique a conduit à réexaminer les éléments constitutifs de l'ancienne civilisation chinoise au cours du passage critique entre le Néolithique tardif et le premier Âge du Bronze.

Depuis ces temps anciens, on utilise le jade pour des objets à caractère ornemental, rituel et symbolique, de même que pour les emblèmes de statut social et d'autorité religieuse. Les jades indiquaient par leur dimension, leur forme, leur iconographie, la qualité de la pierre et celle de la taille, le rang et la position dans la société de leurs détenteurs, dans cette vie et dans l'au-delà. Ces valeurs associées au jade se sont pérennisées à travers les siècles. Dans ce sens, les pendentifs portés par l'élite de Hongshan et de Liangzhu jouaient à peu près le même rôle que ceux que revêtait l'aristocratie des Zhou de l'Est. Dès le Néolithique, sans doute, on savait apprécier les qualités esthétiques des objets achevés. Mais le jade n'était pas utilisé, à cette époque lointaine, pour créer des objets à des fins purement esthétiques, comme ce fut le cas aux périodes plus tardives, et plus spécialement sous les dynasties Song (960-1279 ap. JC) et Qing (1644-1911 ap. JC), où les jades archaïques devinrent objets de contemplation pour les lettrés[8].

Une autre caractéristique de ces pièces est que, dès le tout début, ils furent personnels, même s'ils véhiculaient des valeurs et des signi-

dynasties, when archaic jades became objects of contemplation for sophisticated connoisseurs.[8]

Another important characteristic of objects in jade is that they were, from the very beginning, underline, personal, even if they conveyed values and meanings shared by the whole community, the clan or the elite. As a consequence, jades were often of small dimensions, portable objects intimately related to the individuals to whom they belonged. This close physical contact with their personal jades allowed people to benefit from the *qi* of the stone. At the same time, the jade somehow acquired the personality of the individual who wore or handled it, becoming an intrinsic part of that person. Jades buried with the deceased or specifically made for funerary purposes may be regarded as the epitome of an intimate exchange: in the tomb, the natural decomposition of the body would, by the gradual alteration of the stone, transmit to the jades something of the essence of the person buried.

However, in the late Neolithic period and more specifically in the Liangzhu culture, some categories of jade artifacts took on a completely different aspect, assuming quite imposing, even massive, dimensions, clearly meant for display. This is particularly true of ritual objects such as the Liangzhu *bi* disc and the *cong* and, in some cases, weapons carved in jade. This monumentality somehow changes the nature of the objects, giving them a pronounced public or collective quality rather than a personal one. These large jades become an element of cultural recognition and identification for the community or for a particular group, anticipating a similar role played by ritual bronzes in the Shang dynasty.[9] Under the Shang, bronze became the ritual material *par excellence*, and jade carving was limited mostly to items of very small dimensions;

fications partagées par la communauté entière, le clan ou l'élite. Souvent de petites dimensions, intimes, les jades étaient strictement liés à la personne de leur propriétaire. Ce contact physique étroit permettait au porteur de bénéficier du qi *de la pierre. En retour, le jade captait*

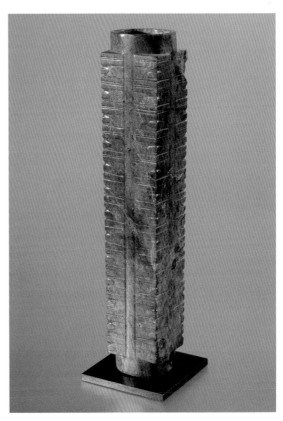

Cong, Liangzhu CAT. 12

la personnalité de l'individu qui le possédait ou l'avait en main, devenant ainsi une part intrinsèque de cet être. Les jades ensevelis avec les défunts ou fabriqués spécialement pour des pratiques funéraires traduisent comme l'épitomé d'un échange intime : dans la tombe, la décomposition naturelle du corps transférait au jade, par l'altération progressive de la pierre, une part de l'entité physique du mort.

Cependant, au Néolithique tardif, et plus précisément dans la culture Liangzhu, certains

presumably these miniature jades, especially by the end of the Shang period, were worn as ornaments because of their protective qualities, the same talismanic function small jade carvings have to this day.

It is only at the beginning of the Western Zhou period that, while the production of small carvings continues, jades are again fashioned into objects of considerable size.

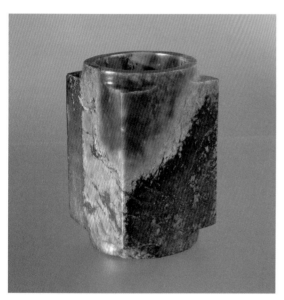

Cong, W e s t e r n Z h o u CAT. 75

Interestingly, the larger jades are mostly made in imitation of the archaic *bi* and *cong* typical of the Liangzhu culture in what seems an almost deliberate effort to recreate ancient forms. It is likely that the Zhou recreation of archaic artifacts was related to a reestablishment of the symbolic values which these objects were supposed to have had. This intellectual process was accompanied by the first effort to interpret and establish a nomenclature of jade types. Specifically, the circular shape of the *bi* was said to be associated with Heaven and the quadrangular form of the *cong* with Earth, assumptions which laid the

jades prirent un aspect tout à fait différent, avec des dimensions imposantes, voire massives, à l'évidence destinés à l'apparat. C'est le cas en particulier d'objets rituels Liangzhu, comme les disques bi, *les* cong *et, quelquefois, d'armes taillées dans le jade. Mais l'aspect monumental change la nature même des pièces, en soulignant leur caractère public et collectif plutôt que personnel. Ces jades majestueux deviennent des signes de reconnaissance sociale et d'identification pour la communauté ou le clan, signes précurseurs des fonctions identiques attribuées aux bronzes rituels de la dynastie Shang. Sous les Shang[9], le bronze devint la matière rituelle par excellence, et la taille du jade se limita alors, le plus souvent, à des pièces de toutes petites dimensions, sans doute ces jades miniatures qui, vers la fin de la dynastie, étaient portés comme ornements pour leurs vertus protectrices, avec ce rôle de talisman que les petits jades ont encore aujourd'hui.*

Il faut attendre le début de la période des Zhou de l'Ouest, alors que la production de petits sujets continue, pour voir réapparaître des jades de dimensions plus importantes. On peut noter que les plus grands sont souvent des répliques du bi *et du* cong *archaïques, caractéristiques de la culture de Liangzhu et marquant, semble-t-il, une volonté de recréer des formes anciennes. Il se pourrait que la reprise par les Zhou d'artefacts archaïques soit liée au rétablissement du sens symbolique que l'on pouvait leur attribuer. Cette évolution intellectuelle fut corrélative des premiers essais d'interprétation et de classification des types de jades. Ainsi, la forme circulaire du* bi *fut associée au Ciel et la forme carrée du* cong *à la Terre, postulats qui constituent la base des hypothèses avancées depuis lors sur la signification de ces objets[10]. Sans doute la réappropriation des symboles rituels primitifs par les Zhou, peuple d'origine non chinoise, correspond-elle à un désir d'établir une codification*

basis for speculation ever since on the significance of these objects.[10] Perhaps the reexamination of earlier ritual symbols was prompted by the desire of the Zhou, a people of a non-Chinese origin, to establish a codification based in part on pre-Shang sources which would reinforce their legitimacy.

The interaction between the Chinese world and that of the nomadic people of the North had an impact on the cultural and artistic climate, and hence the jade carving tradition, of the Eastern Zhou and Han periods. The permeability of the political and cultural barriers during the Eastern Zhou period favored this interaction, resulting in the adoption by the Chinese of forms and images alien to their traditional repertory, but which ultimately merged in a style and iconography which, by the Han period, was completely sinicized.

It is interesting, for example, to follow the evolution of the dragon motif as it develops from the way it is represented in the jades of the late Spring and Autumn period to its rendering in jades of the Han dynasty. Initially the mythical beast is highly stylized, then it gradually acquires more definite features, borrowing elements from the feline creatures which are a dominant motif in Eastern Zhou jade iconography. Equally interesting is the combination on the same jade of dragons and phoenixes, the two most powerful creatures of Chinese mythology. At first only the head of the phoenix is represented, usually carved at the end of the dragon's tail, while in later examples the two are clearly and individually rendered.

It is not by chance that dragons, and more generally mythical composite beasts, are a major theme of Eastern Zhou and Han period jades. These are not simply carved on the stone. The jade is carved in the form of drag-

fondée sur des sources pré-Shang, pour renforcer leur légitimité.

L'interaction entre le monde chinois et les peuples nomades du Nord eut un impact sur le climat culturel et artistique et, par conséquent, sur la tradition de la taille du jade sous les Zhou de l'Est et les Han. La perméabilité des frontières politiques et culturelles pendant la période des Zhou de l'Est favorisa un échange qui abou-

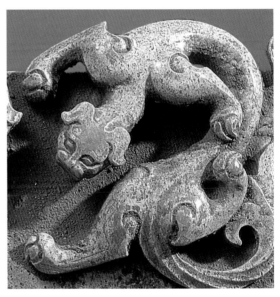

Scabbard slide, Western Han CAT. 139

tit à l'adoption par les Chinois de formes et de décors étrangers à leur répertoire traditionnel, mais qui finirent par se fondre dans un style et une iconographie totalement sinisés à la fin de l'époque Han.

Il est intéressant, par exemple, de suivre l'évolution du motif du dragon depuis la période des Printemps et Automnes jusqu'à la dynastie Han. La période la plus ancienne montre l'animal mythique extrêmement stylisé; puis il acquiert progressivement des traits plus définis grâce aux éléments empruntés aux créatures félines de l'iconographie des Zhou de l'Est, dont elle constitue le trait dominant. Tout aussi inté-

ons, the mythical creatures which represent for the Chinese one of the primeval forms of energy in the universe. Since the images do not portray or mirror real beings, but allude to forces and energies which are embedded in the jade, the material and the decor become one. These forces are not static but dynamic, in continuous transformation. The jades take on the shape of dragons with sinuous bodies and dragons dissolve into almost pure geometric patterns, another way of materializing the

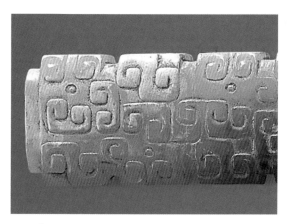

Pendant, Eastern Zhou CAT. 81

world of spirits and energies to which jade, by its very nature, belongs. This continuous passage from representation to abstraction and back is an ancient phenomenon in Chinese art and is reflected in its jade carving tradition. This process can already be seen in the jades of the Liangzhu culture and even in the abstract shapes of Hongshan pendants.

Jade thus is never simply a medium used to carry decorative motifs, but represents the matrix from which the images carved in the stone emerge. The creatures which emanate from within the stone are visual representations of the same forces which created the jade. This phenomenon assumes particular relevance in the late Eastern Zhou and early

ressante est la combinaison, sur le même jade, des motifs de dragons et de phénix, les deux créatures souveraines de la mythologie chinoise. Au début, seule la tête du phénix est représentée, gravée en général à l'extrémité de la queue du dragon, alors que, dans les exemples ultérieurs, les deux motifs sont clairement séparés et individualisés.

De manière plus générale, ce n'est pas par hasard si les dragons et les animaux mythiques composites se posent en thème majeur sur les jades des Zhou de l'Est et des Han. Il ne s'agit pas d'un simple motif incisé sur la pierre. La taille du jade décalque la silhouette du dragon, cette créature mythique qui incarne, pour les Chinois, la forme primordiale de l'énergie universelle. Puisque les représentations ne décrivent ni ne reflètent des êtres réels, mais évoquent les forces et énergies encloses dans le jade, le matériau et le décor ne font plus qu'un. En outre, ces forces ne sont pas statiques, mais dynamiques et en continuelle transformation. Tantôt les jades prennent la forme de dragons aux corps sinueux, tantôt les dragons se dissolvent en figures purement géométriques, manière de concrétiser le monde des esprits et des énergies auquel le jade, intrinsèquement, appartient.

Ainsi, le jade n'est jamais un simple support de motifs décoratifs, mais la matrice d'où émergent les images taillées. Les formes qui jaillissent du corps de la pierre sont des représentations visuelles des puissances qui créèrent le jade. Ce phénomène s'illustre tout particulièrement sous les Zhou de l'Est et au début de l'époque Han. C'est à ce moment en effet que se manifeste la transformation des motifs qui, d'un traitement de bas-relief en deux dimensions, caractéristique des périodes anciennes, accède à la plénitude d'une représentation en trois dimensions. Les dragons semblent alors surgir de la pierre, fusionner avec elle, puis s'en dégager. Bien que paraissant s'évader des limites natu-

Han periods. It is then that the motifs decorating jades shift from essentially bidimensional low relief treatments typical of earlier periods to fully three-dimensional renderings. Now the dragons are represented as emerging from, merging with and passing through the stone. Although they seem to break the natural boundaries of the objects, to violate the natural hardness of the material with their twisting, sinuous bodies and writhing movements, they remain ultimately and inextricably part of the stone. If at times the dragons seem to have an independent existence and could be removed from their support, this is in fact an illusion. They are truly the manifestation of the released energy of the stone, of its inner radiance.

FILIPPO SALVIATI

relles de l'objet, rompre la dureté du matériau par leurs torsions, leurs corps sinueux et leurs mouvements convulsifs, ils restent irrémédiablement, unis à la pierre. Si par moments, les dragons peuvent donner l'impression d'avoir une existence autonome, au point de pouvoir se libérer de leur support, ce n'est bien sûr qu'une illusion. En réalité, ils donnent à voir l'énergie concentrée dans la pierre, sa « radiance enfouie ».

FILIPPO SALVIATI

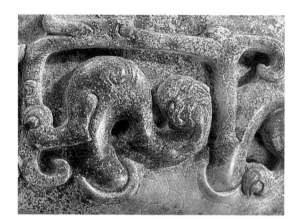

Belt hook, Western Han CAT.142

1 Needham 1959, pp. 636-641.
2 Middleton and Freestone 1995, p. 413.
3 Salviati 1998, p. 59.
4 For an overview of the use of jade in Central America and among the Maori, see Keverne 1991, pp. 316-341 and pp. 220-255 and Beck and Neich 1992.
5 See the Introduction in Rawson 1995, pp. 13-109.
6 For an analysis of the motifs carved on Liangzhu jades, see Salviati 2000.
7 Li Xueqin 1992.
8 See Yang Boda in Keverne 1991, pp. 128-187 and Desroches 1998.
9 For a thorough analysis of the role of jade and bronze artifacts in early China, see Wu Hung 1995, pp. 17-75.
10 Rawson 1995, pp. 56-58.

1 *Needham 1959, pp. 636-641.*
2 *Middleton and Freestone 1995, p. 413.*
3 *Salviati 1998, p. 59.*
4 *Pour un aperçu général de l'usage du jade en Amérique Centrale et chez les Maori, voir Keverne 1991, pp. 316-341 et pp. 220-255, et Beck et Neich 1992.*
5 *Voir l'Introduction de Rawson 1995, pp. 13-109.*
6 *Sur l'analyse des motifs gravés sur les jades de Liangzhu, voir Salviati 2000.*
7 *Li Xueqin 1992.*
8 *Voir Yang Boda dans Keverne 1991, pp. 128-187 et Desroches 1998.*
9 *Pour une analyse du rôle des jades et des bronzes dans la Chine archaïque, voir Wu Hung 1995, pp. 17-75.*
10 *Rawson 1995, pp. 56-58.*

Neolithic China

Hongshan	c. 4000–2500 BC
Dawenkou	c. 4500–2300 BC
Songze	c. 4000–3400 BC
Liangzhu	c. 3300–2200 BC
Longshan	c. 2500–1700 BC

Early dynastic period

Erlitou	c. 2000–1500 BC
Shang	c. 1500–1050 BC
Western Zhou	1050–771 BC
Eastern Zhou	
Spring and Autumn	770–475 BC
Warring States	475–221 BC

Imperial China

Qin	221–207 BC
Western Han	206 BC–9 AD
Xin	9–25 AD
Eastern Han	25–220 AD
Three Kingdoms	220–280 AD
Western Jin	265–317 AD

Catalogue

Neolithic Period

1 *Cloud-scroll plaque*

pale yellow-green jade

Neolithic, Hongshan culture, c. 3500-3000 BC
width 8.2 cm; height 4 cm

Because of its abstract shape, this type of ornament, typical of the Hongshan culture, has been called a "cloud-scroll" plaque.[1] The present piece shows the basic form of this class of ornament, associated with tombs of members of the Hongshan elite. The plaque is composed of a central curling element from which extend four lateral appendages. These recall another group of Hongshan jades: small pendants shaped like stylized miniature weapons. The central, curvilinear portion can be compared to the *zhulong* or "pig-dragon" pendants, another class of Hongshan jades. The constituent elements of this plaque are fully consistent with the Hongshan repertory of jade forms. Similar plaques have been discovered at Niuheliang (tomb IM14:3) and Hutougou (tomb M1:3), Liaoning province.

2 *Cloud-scroll plaque*

pale yellow-green jade

Neolithic, Hongshan culture, c. 3500-3000 BC
width 12 cm; height 4.8 cm

This plaque can be regarded as a double cloud-scroll ornament, with the central curling element and lateral appendages duplicated and reversed. The sinuous, undulating movement is accentuated by shallow grooves on the polished surface of the jade, while the protrusions are less pronounced and more integrated in the body of the object.

3 *Toothed plaque*

light green jade with beige areas

Neolithic, Hongshan culture, c. 3500-3000 BC
width 13 cm; height 4.4 cm

Compared to the two previous examples, this plaque exhibits a more formal, symmetrical and balanced shape. However, given the scanty archaeological evidence, it is hard to establish whether this shape is a late development of these Hongshan ornaments. The curling appendages are now fully absorbed into the design, while the pointed edges visible in the other plaques have become a row of sharp protrusions at the bottom. The central curling motif has been doubled and mirrored: two central perforations and shallow grooves suggest the eyes and eyebrows of an abstract animal face.[2]

Though these jades are usually described as pendants, Guo Dashun has advanced another interpretation.[3] Noting the placement of these objects in the graves –on or near the chest but positioned vertically, not horizontally– Guo Dashun has suggested that they might have been ritual miniature versions of knives or weapons, symbols of status and power. Jenny F. So has suggested that the shape of the toothed plaque might have been derived from older stone tools or knives with serrated edges.[4]

1 For a typological and iconographical study of cloud-scroll plaques, see Du Jinpeng 1998 and Liu Guoxiang 1998.
2 Yang Xiaoneng 1999, p. 88, no. 14.
3 Guo Dashun 1996.
4 So 1993, p. 90.

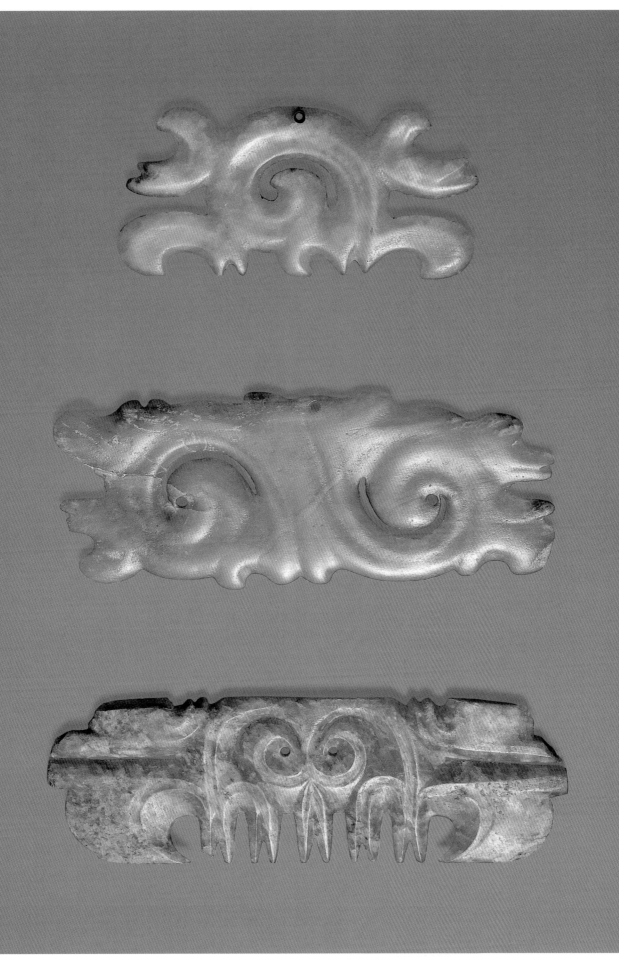

4 *Hoof-shaped ornament*

mottled beige and green jade with extensive alteration
Neolithic, Hongshan culture, c. 3500-3000 BC
height 8 cm; top width 8.8 cm; bottom width 6.6 cm

Resembling a horse's hoof, these elegantly shaped hollowed tubes have been found in graves of the Hongshan culture near the head of the deceased or under the skull, as in tombs M4 and M15 at Niuheliang Area 11 (Jianping, Liaoning province).[1] This placement suggests that these jades might have been head-pieces or hair ornaments. In the latter case, the hair would have passed through the tube and been secured by a hairpin inserted in the small perforations visible at the base of several known examples. The perforations are absent here, as in an example in the Tianjin Museum which has similar small chips on the top edge and a small indentation at the base.[2] The differences in size and degree of finish of the hoof-shaped ornaments may represent distinctions of social status, although not enough archaeological data allows for confirmation of this theory.

5 *Ring ornament*

mottled green jade with extensive alteration
Neolithic, probably Hongshan culture, c. 3500-3000 BC
diameter 5 cm; height 3.2 cm; circular opening 4.2 cm
from a French collection

The function of this object is difficult to determine, although it might have been a kind of hair ornament. In the absence of comparative examples from controlled excavations, it is tentativly attributed to the Neolithic period and to the Hongshan cultural sphere. The old label reading "Douanes Exposition, Paris" is a reminder that many archaic jades, including those now identified as belonging to the Neolithic period, have been circulating outside China since the end of the 19th century.

6 *Squared disc*

yellow-green nephrite with brown inclusions
Neolithic, Hongshan culture, c. 3500-3000 BC
length 9.8 cm; width 7.5 cm

The texture of the microcrystalline aggregates of nephrite visible in this finely cut and polished ornament is typical of the kind of high quality nephrite of Hongshan jades. Its outer edge and inner area near the central perforation are thinner than the body of the object, giving it a lens-shaped cross-section. This piece can be compared to similar ornaments from a grave at Sanguandianzi, Liaoning province,[3] and from tomb M21 of the Niuheliang site, Liaoning,[4] though this example lacks the suspension holes of the excavated jades. It cannot be ruled out that this disc was part of a set forming an elaborate necklace or pectoral, such as one discovered at the site of Zouxian Yedian, Shandong, dated to the middle Dawenkou culture period (c. 3500-2900),[5] contemporaneous with the Hongshan culture.

1 *Wenwu* 1986, 8, pp. 1-17.
2 *Zhongguo Yuqi Quanji,* vol. 1, no. 2.
3 *Wenwu* 1997, 8, pp. 9-14. The tomb has yielded nine ornaments of this kind of varying size: see figs. 3: 2, 3: 8, 4: 2-4, 7-9, 10 and 11.
4 *Zhongguo Yuqi Quanji,* vol. 1, no. 4.
5 Ibid., no. 34.

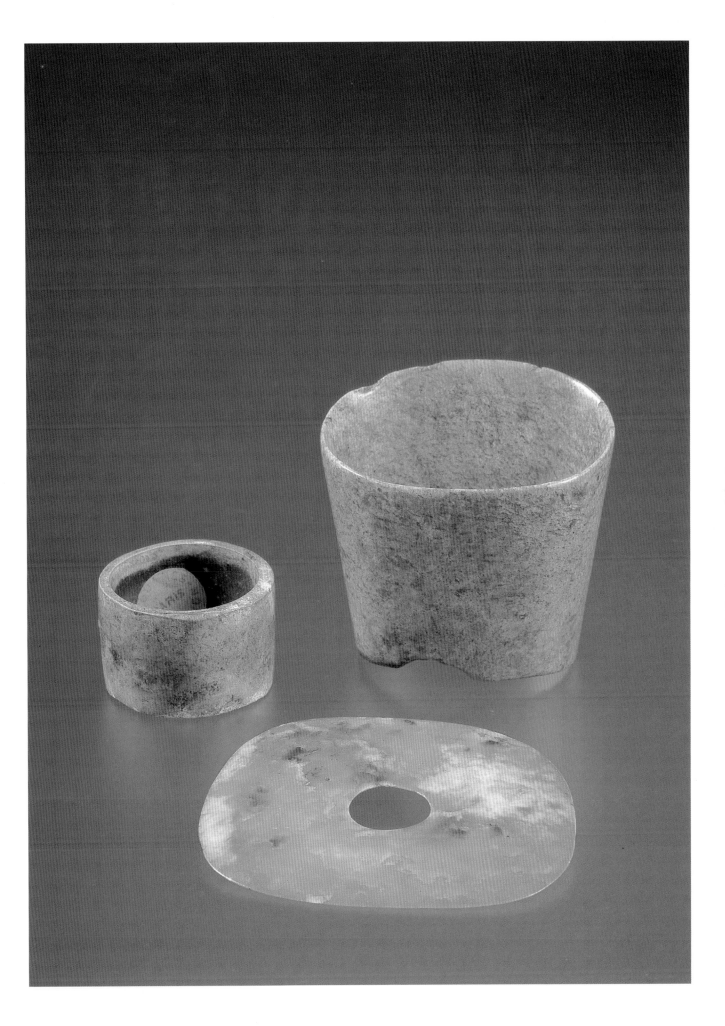

7 *Bird pendant* (right)
yellow-green jade
>Neolithic, Hongshan culture, c. 3500-3000 BC
>height 4.1 cm; width 3.8 cm

This pendant carved as a bird of prey with spread wings illustrates another major category of Hongshan jades, alongside the cloud-scroll plaques (nos. 1-3) and the hoof-shaped ornaments (no. 4). Contrary to the highly abstract and stylized form of those objects, this pendant is part of a group of more realistic small jade carvings representing animals such as tortoises and insects. The bird has a small head with round, slightly bulging eyes just above a faintly raised beak; below the small round bosses indicating the feet, there is a protrusion representing the tail, while the wings are marked by vertical grooves. A loophole in the back, consistent with carving techniques used by Hongshan craftsmen,[1] suggests that the piece was suspended and worn as a pendant. Similar examples exist in private collections and museums, and a few have been discovered in controlled excavations.[2]

8 *Stylized bird pendant* (left)
mottled green jade with yellow and altered areas
>Neolithic, possibly Hongshan culture, c. 3500-3000 BC
>length 13.9 cm; width 2.5 cm

Although photographed in an upright position, this jade is actually a pendant which was probably worn horizontally, using the small holes pierced at each end. The indented area suggests the silhouette of a stylized bird, an impression further enhanced by the hole which serves as the eye.

Several arc-shaped pendants (*huang*) in jade have been found in sites of the Songze culture, which flourished in the Lake Tai area of eastern China around 4000-3400 BC. An irregularly shaped piece excavated in 1974 in tomb M60 of the Songze site (Qingpu, Shanghai) has one extremity carved as a stylized bird's head.[3] However, the large size of the present pendant, the nephrite used, its degree of finish and polish, and its style, are not characteristic of the Songze culture. Though lacking an excavated counterpart, this pendant may tentatively be attributed to the Honghsan cultural sphere. The outline of the indented portion corresponds to the way other Hongshan jades have been cut and worked (as in the pendants shaped as miniature weapons); the bird imagery is also consistent with Hongshan iconography.

1 Forsyth 1990.
2 See a jade owl excavated at Hutougou, Fuxin, Liaoning province (Yang Xiaoneng 1999, p. 91, no. 16) and one in the Hotung Collection (Rawson 1995, p. 117, no. 1: 5).
3 *Zhongguo Yuqi Quanji,* vol. 1, no. 112.

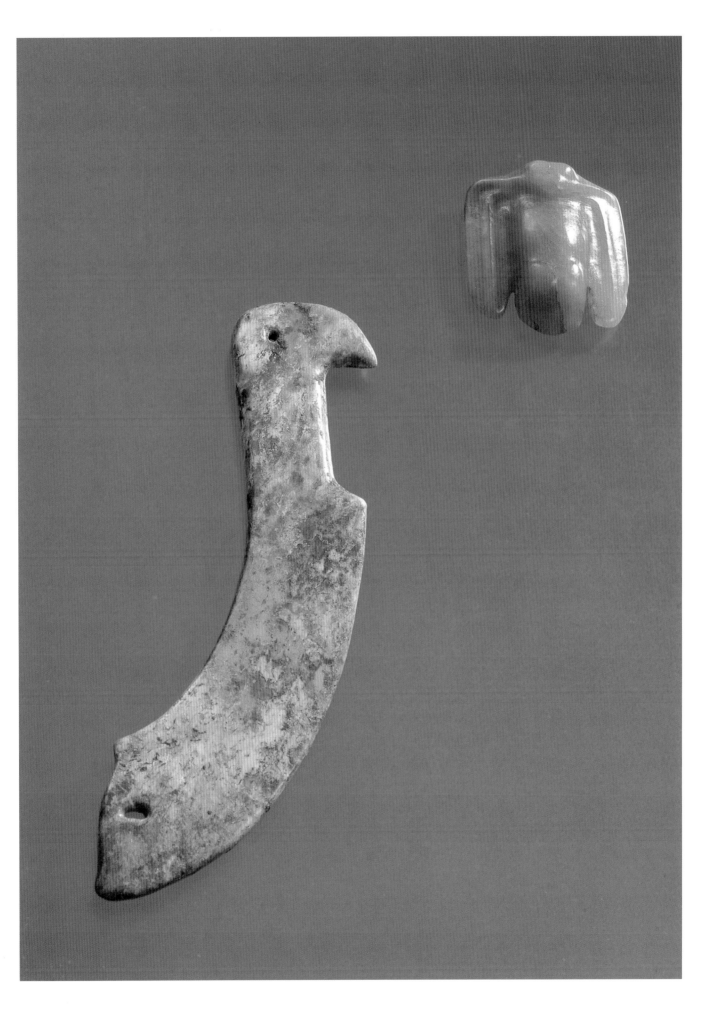

9 *Bi disc*

altered jade

Neolithic, Liangzhu culture, c. 2500 BC
diameter 14.6 cm; central opening 4 cm; thickness 0.8-1 cm

The rounded shape of many pebbles and boulders of raw jade, especially those collected from river beds, was probably the immediate source of inspiration for Neolithic jade carvers who crafted circular objects such as those discovered in Hongshan (see no. 6) or Dawenkou culture (c. 4500-2300 BC) sites. However, accurately proportioned discs in jade with a central perforation, displaying a deliberate effort to reproduce in stone the geometry of the circle, are not documented before the Liangzhu culture (c. 3300-2200 BC). To date, the majority of excavated *bi,* the traditional name by which these discs are known, come from Liangzhu sites.

The *bi* presented here has turned completely white and the process of alteration has deeply penetrated the stone, as can be seen from the small chip near the edge; the groove visible on the surface is a mark left by a rotating tool used to cut the jade. This piece and the following *cong* probably come from Liangzhu culture sites located in Yuhang county, Zhejiang province, where many creamy white jades were discovered in undisturbed burials.[1]

10 *Cong*

altered jade

Neolithic, Liangzhu culture, c. 2500 BC
height 6.3 cm; width 9.5 cm; central opening 6.6 cm

The term *cong* is used to indicate an object characterized by a squared outer perimeter and a cylindrical inner perforation running through its whole length. On the basis of current archaeological data, Liangzhu is presently regarded as the culture which "invented" the *cong.*[2] The original function and the context of use of the *cong* are still matters of speculation. That the object had a religious and ritual significance is suggested by the decorative motifs finely incised within the registers at the corners of the *cong,* as can be seen in the present example. These stylized motifs, a human face above that of an animal (see also no. 11), constitute the decor dominating Liangzhu iconography. They have also been regarded as the forerunners of the theriomorphic motifs which appear on Bronze Age artifacts, especially on ritual bronzes of the Shang dynasty (16th-13th century BC).[3]

It is thought that complete discoloration of the stone, as is the case of this *cong,* was artificially obtained by Liangzhu craftsmen through heating. It is hard to establish whether this was done for ritual, practical or aesthetic purposes. However, the practice of heating jade is documented among other jade-using cultures, such as the New Zealand Maori: they heat nephrite to facilitate color change and obtain a stone similar to one of the most prized but rare varieties, called *inanga,* related to their mythological lore.[4]

1 A number of creamy white jades from sites in Yuhang county are reproduced in Wang Mingda and Lu Wenbao 1998.
2 Watt 1990, pp. 14-16.
3 Li Xueqin 1992.
4 Keverne 1991, pp. 246-247.

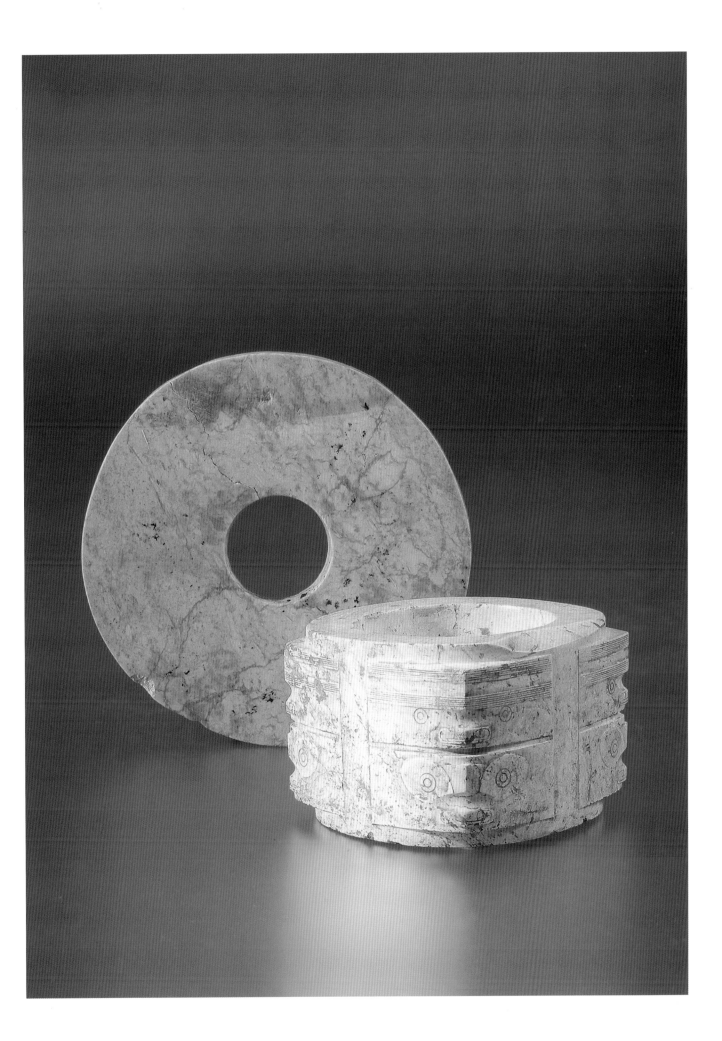

11 *Cong*

Dark green and brown nephrite with iron-red veins, partly altered
Neolithic, Liangzhu culture, c. 2600-2400 BC
height 6.6 cm; top width 12 cm; bottom width 11.6 cm; central opening 8.5 cm

Before the archaeological discoveries provided sufficient material to establish a chronology for the stylistic development of Liangzhu iconography,[1] very few scholars recognized the difference between the two mask motifs which appear on the *cong* of this culture. A notable exception was Alfred Salmony (1890-1958) who, in 1952, in the description of a *cong* in the Edward and Louise B. Sonnenschein Collection, clearly identified the masks as belonging to two different types.[2] The riddle of the two masks was partly solved after the excavation of the Liangzhu cemeteries of Yaoshan and Fanshan (Yuhang, Zhejiang province), whose richly furnished tombs have yielded hundreds of decorated jades.[3] Many of them are carved with a complex motif representing a frontal view of an anthropomorphic being wearing what resembles a large feathered headdress placed above, as if riding, a mythical animal with large

eyes, clearly delineated mouth and front legs. On the basis of this version of the motif, the stylized masks carved at the corners of *cong* similar to that presented here have been interpreted as simplified versions of the two motifs: the anthropomorphic and the zoomorphic being. The treatment of the eyes as circles with pointed canthi for the first type, and circles inscribed in slanting oval shapes for the second, clearly preserves the distinction between them.

This large *cong* is carved out of a substantial block of nephrite very similar to the stone used to produce a similar *cong* excavated in 1965 at Sanlidun, Jiangsu.[4] However, the two *cong* differ in size, as the Sanlidun piece is slightly smaller and has only one register carved with the simplified anthropomorphic mask.

1 Sun Zhixin 1997.
2 Salmony 1952, pl. LIX.
3 James 1991.
4 Zhejiang 1990, pl. 37.

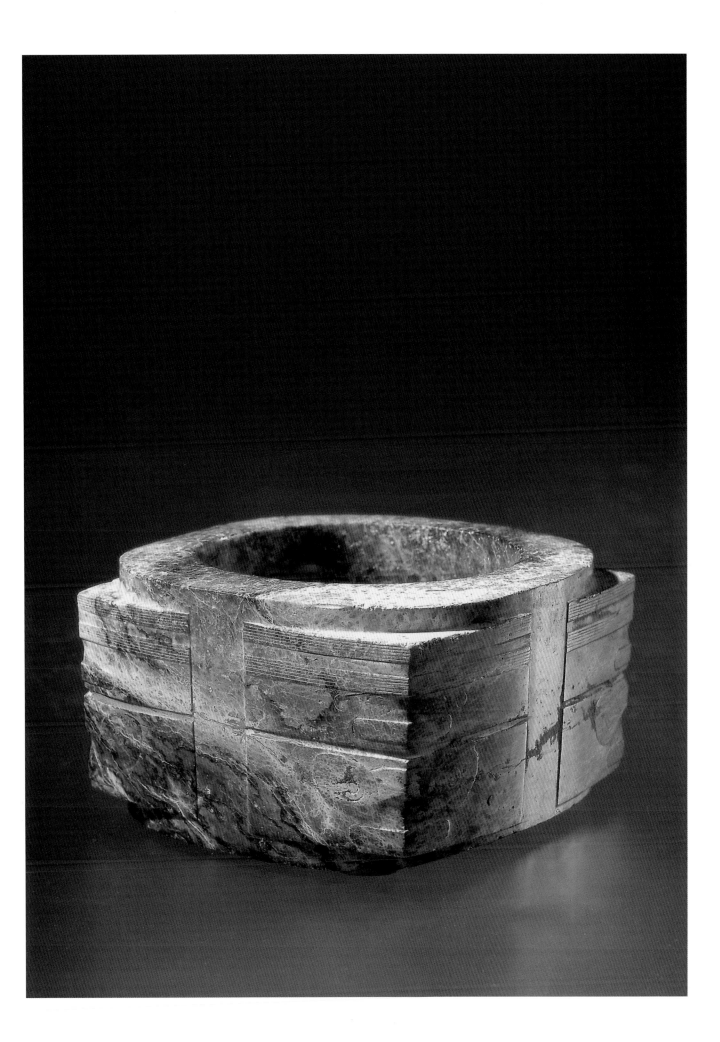

12 *Cong*

dark green jade with white veins

Neolithic, Liangzhu culture, c. 2400-2300 BC
height 37.8 cm; top width 7 cm; bottom width 6.5 cm

The two chronological extremes marking the development of Liangzhu culture *cong* are currently represented by a short bracelet engraved with four stylized mask motifs, each set within a rectangular frame, discovered in tomb M4:02 at the Zhanglingshan site (Wuxian, Jiangsu),[1] and by very tall *cong*. The bracelet from Zhanglingshan, a site dated to around 3200 BC, is regarded by many scholars as representing the basic form and decoration from which all successive types of *cong*, both small and large ones, developed in the millennium during which the Liangzhu culture flourished. It was during the late Liangzhu phase that *cong* grew taller and taller until they reached quite exceptional sizes, as in this case. However there is a substantial difference between the bracelet-derived type of *cong* and the much larger ones, a difference hinting at two parallel lines of development and at two distinct uses of the objects fashioned in one way or the other. While small *cong* could have been handled easily, the bigger ones would have required, as in the case of the large *bi* discs, use of both hands to be lifted, carried or positioned. This suggests that tall *cong* were conceived as objects for display, possessing a special ritual quality, which is underlined by the large size of the objects and the amount of material and time necessary to make them.

The thirteen regularly aligned registers of the *cong* shown here are each incised at the corners with an extremely stylized version of the human mask: a short bridge for the mouth, two striated bands indicating a simplified headdress and two small, thin circles – very faint in many of the registers – marking the eyes. The circular collars at the top and bottom of this piece are thinner, however, than those of other similar *cong*. The alteration in some areas of the surface has weakened the nephrite, so that the *cong* has lost a small part of its base.

Tall *cong* have usually been discovered in Jiangsu province sites, such as that of Wujin Sidun,[2] which yielded the tomb of a male about 20 years old. At the time of burial, his body was literally covered with jades and thirty-three *cong* of varying dimensions were placed all around it, almost forming a jade shroud. Some of the *cong* discovered at Sidun exceed 30 cm in height, as does this one, and are carved with a series of thirteen registers.

1 *Wenwu ziliao congkan*, 6, 1982, pp. 25-36.
2 *Kaogu* 1981, 3, pp. 193-200 and 1984, 2, pp. 109-129;
 Wenwu 1984, 2, pp. 17-22.

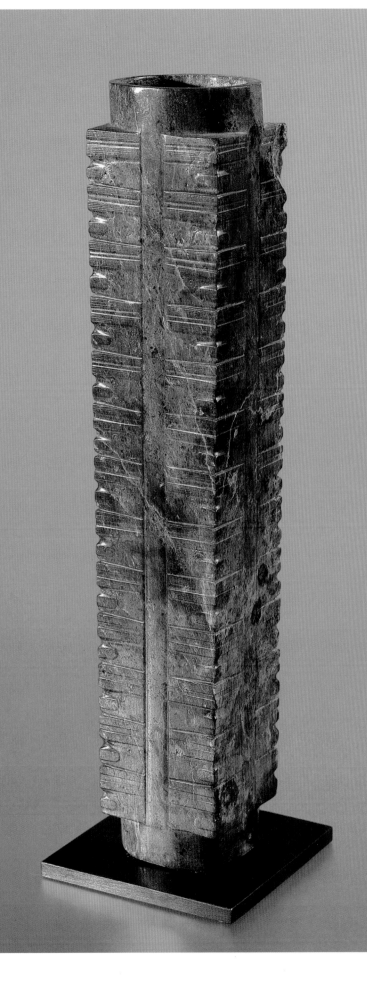

13 *Bi disc*

dark green jade with extensive alteration

Neolithic, Liangzhu culture, c. 2500 BC

diameter 24 cm; central opening 4.8 cm; thickness 0.4-1.4 cm

The alteration of the stone, typical of buried jades, has reached quite a spectacular and unexpected aesthetic effect in this *bi*. The surface is marked and crisscrossed by a network of white veins following the disposition of the crystals affected by the chemical changes. A more advanced stage of the process of alteration is visible in the white area near the border, where the original consistency and appearance of the nephrite has changed substantially. This veining effect can be seen on several excavated Liangzhu *bi*, such as one from tomb M20:170 of the Fanshan site (Yuhang, Zhejiang province) and another from grave M40:111 of the Fuquanshan site (Qingpu, Shanghai):[1] the dimensions of the latter (23 cm in diameter, 1.4 cm in thickness and the central opening of 5.6 cm) are very close to those of this *bi*.

1 Zhejiang 1990, pls. 75 and 85 respectively.

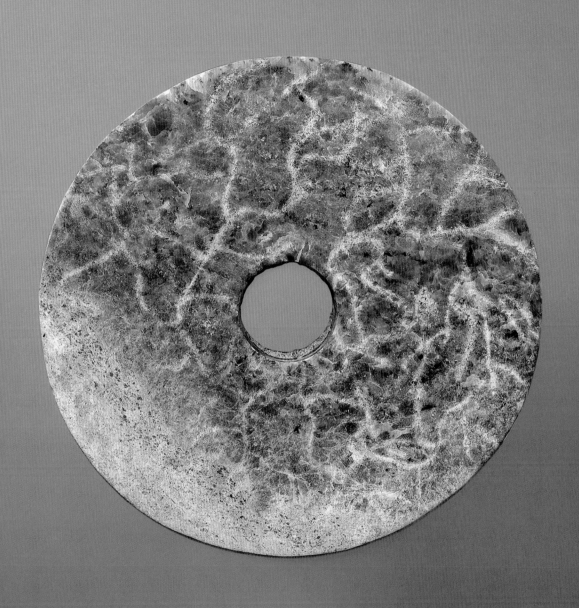

14 *Bi disc*

blue-gray jade with green areas and diffused alteration

Neolithic, Liangzhu culture, c. 2500 BC

diameter 27.3 cm; central opening 4.7 cm; thickness 0.8 cm

This large *bi* disc is a celebration of the pure geometry of the circle. Its size, fine polish and almost perfect shape are remarkable. A *bi* similar in texture and dimensions – with a diameter of 21.2 cm, a central opening of 5 cm and the same thickness – has been excavated at the Caoxieshan site (Wuxian, Jiangsu province) from tomb M198-11:10.[1] The funerary objects placed in this tomb were grouped in three clusters. The typology and disposition of the jade and stone implements discovered there has prompted Chinese archaeologists to suggest that the main tomb occupant was a male accompanied by two females,[2] one of whom was laid horizontally at the man's feet and had the *bi* placed in the area of her chest.

The possible function *bi* discs might have had within the Liangzhu culture, which made such extensive use of them, can only be hinted at through analysis of excavated burials and the placement of *bi* inside the graves; all theories which, over time, have been advanced about the possible ritual significance of the *bi* remain highly speculative in the absence of clearer archaeological data.[3] The analysis of the burial context however reveals that the placement of *bi* discs in graves seems to follow quite precise prescriptions. The more refined discs of the best nephrite are usually placed near the head or below and over the torso of the deceased, such as in the case of the Caoxieshan burial referred to above. The less refined ones, of inferior quality jade, are frequently piled in stacks near the feet.[4] The differing number and quality of *bi* placed in the tombs may also suggest that these discs were symbols denoting the status of the deceased: the larger the number, the higher the social position of the individual. Insofar as the origin of the *bi* form is concerned, interesting remarks have been made by Jean M. Green, according to whom the *bi* might have developed from the spindle-whorl, thus sharing with the *cong,* which derived from the bracelet, humble origins prior to their becoming ritual objects and symbols of status.

1 Zhejiang 1990, p. 61, pl. 79.

2 *Wenwu ziliao congkan,* 3, 1980, pp. 1-24 and pp. 10-12 on this specific burial.

3 Huang Tsui-mei 1992, pp. 157-186 for a detailed overview of the theories on *bi* and *cong.*

4 Rawson 1995, pp. 130-131. This view was also strongly supported by archaeologist Wang Mingda who had studied the placement and stone quality of hundreds of *bi* discs discovered during the excavation of Liangzhu cemeteries in the Yuhang district (private communication, Hangzhou 994).

5 Green 1993.

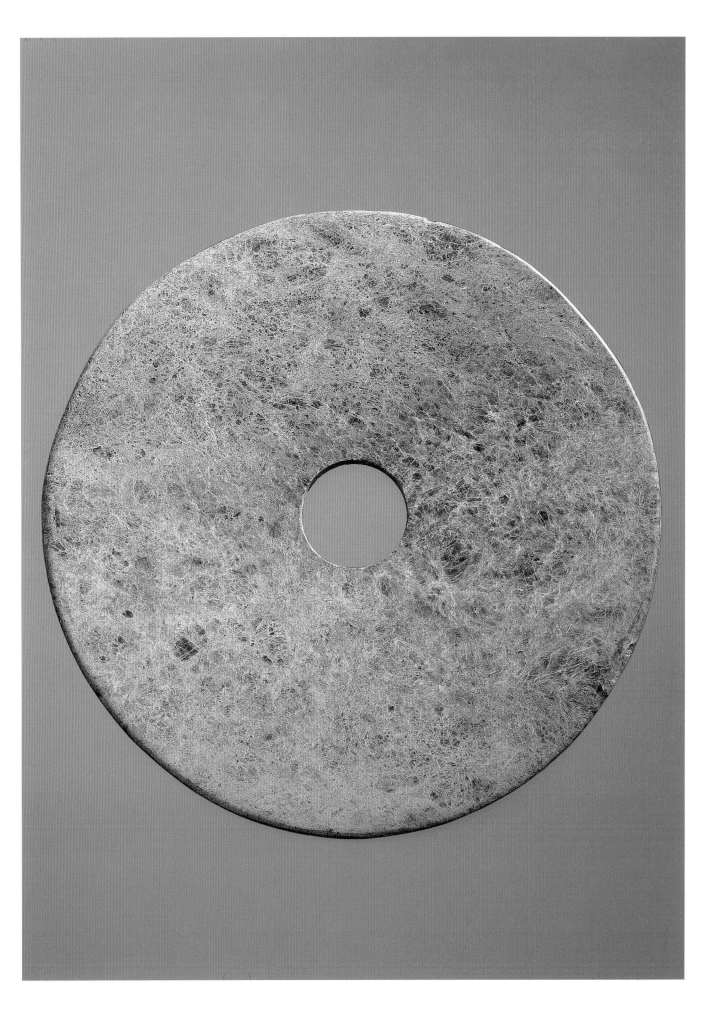

15 *Bracelet* (top)
altered jade
>Neolithic, possibly Liangzhu culture, c. 2500 BC
>diameter 8 cm; central opening 5.2 cm; thickness 2.5 cm

The relatively crude treatment of this bracelet suggests it is an unfinished piece. Its strong indentation, uneven thickness and internal ridge are features seen on similar creamy altered jades discovered at Liangzhu sites in Zhejiang province. This bracelet can be compared to others found in Neolithic sites distributed along the lower reaches of the Yangzi river valley and in Anhui province.[1]

16 *Miniature cong bead* (left)
altered jade
>Neolithic, Liangzhu culture, c. 2500 BC
>height 2.9 cm; width 1.4 cm

The shape of this bead and the stylized masks carved on its surface make it a perfect miniature replica of a *cong*. Similar beads have been discovered in tombs M7:43, M9:12 and M7:44 of the Yaoshan site adjacent to jade axes. Archaeologists think they may have been suspended, as whirling ornaments, from the top and bottom jade fittings of an axe.[2]

17 *Necklace beads* (bottom)
altered jade, two retaining part of the original color
>Neolithic, Liangzhu culture, c. 2500 BC
>length 2.3 to 4.4 cm; diameter 1 cm
>from a French collection.

These six plain tubular beads would originally have been part of a necklace, such as those discovered in tomb M11:95-96 of the Yaoshan site which have an average length of 2.2 cm, corresponding to the smallest bead of the present group. The original color of the jade, still visible in the two partly altered beads, matches that of beads forming a necklace excavated from tomb M7:72 of the Yaoshan site.[3]

18 *Awl-shaped ornament* (right)
mottled yellow-green jade partially altered
>Neolithic, Liangzhu culture, c. 2800 BC
>length 15.5 cm; width 0.5 cm

The expression "awl-shaped ornament" designates a type of elongated and pointed jade with a round or square section. The varying placement of these ornaments in graves of the Liangzhu culture suggests more than one possible use. In a number of cases they have been found in sets placed near the head of the deceased, such as in tomb M12:47 of the Fanshan site (Yuhang, Zhejiang), which has produced the largest set so far.[4] At Fuquanshan (Qingpu, Shanghai) tomb T27M2 yielded a group of six awls originally part of a necklace[5] and five others located near the lower limbs, which may mean they were originally suspended from the waist.

This awl can be compared to one excavated from tomb T15M3:76 of the Fuquanshan site, with square section measuring 15 cm in length and 0.45 cm in thickness.[6]

1 Compare three bracelets from Anhui reproduced in *Zhongguo Yuqi Quanji*, vol. 1, nos. 72-74.
2 *Wenwu* 1988, 1, pp. 39-40 and figs. 23, 36.
3 Zhejiang 1990, p. 130, pl. 167.
4 Zhejiang 1990, pp. 104-105, pl. 137 and Wang Mingda 1997, pp. 44-45.
5 *Wenwu* 1986, 10, pp. 1-25, fig. 8.
6 *Wenwu* 1986, 10, p. 23 and fig. 60, no. 21.

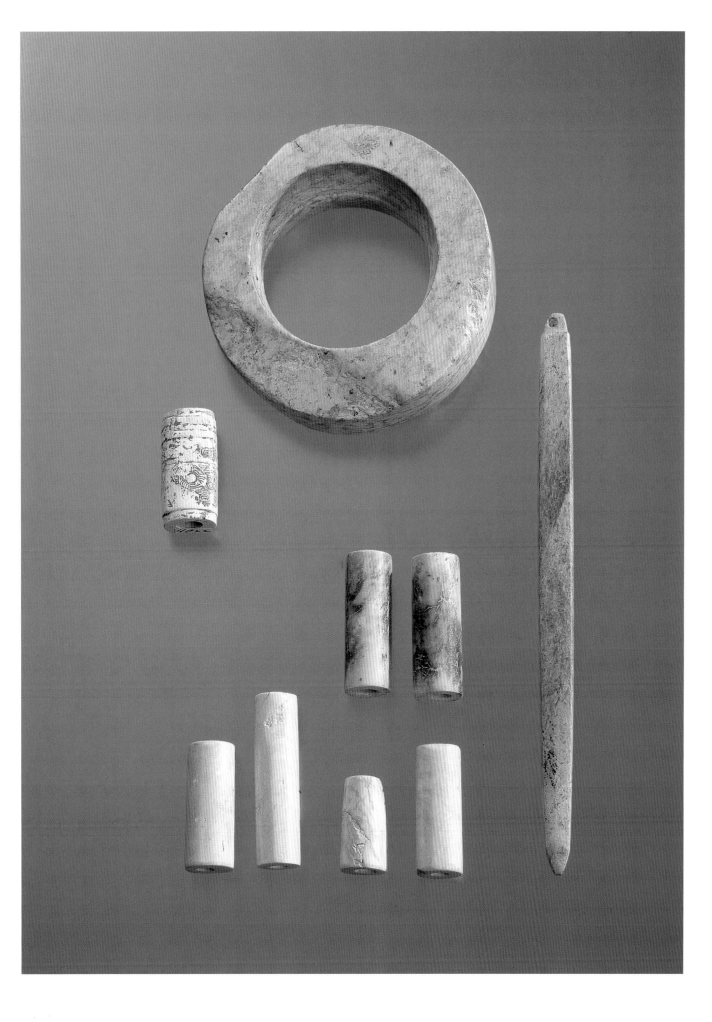

19 *Ring* (top right)
green jade with reddish-brown areas
Neolithic, possibly Liangzhu culture, c. 2800 BC
diameter 6.2 cm; central opening 6 cm; width 3.6 cm

This simple, elegantly shaped ring with a concave profile reminds one of a section of bamboo cane. Similar Liangzhu ornaments have been excavated at Zhanglishan (Wuxian, Jiangsu province, tomb M4:011 and 021) and Fuquanshan (Qingpu, Shanghai, tomb M9:29),[1] although those are slightly thicker than the present one. They may be identified as a type of bracelet, but differ from no. 15 which seems closer to those more often found in the Liangzhu sites of Zhejiang province, typical of the middle and late period of this culture.

20 *Pair of bracelets or bangles* (left and bottom)
green jade with reddish-brown areas, traces of alteration
Neolithic, possibly Liangzhu culture, c. 2800 BC
diameter 9.5 cm; central openings 5.9 cm and 6.4 cm; width 0.8 cm and 1.2 cm

These bracelets and the ring described above all seem to have been carved from the same block of raw material, suggesting they might come from the same tomb or site. Bracelets with a squarish cross-section have been found in Neolithic sites in the Lake Tai area and Jiangsu province dating to as early as the Songze culture (c. 4000-3400 BC). Similar ornaments have been discovered at Caoxieshan (Wuxian, Jiangsu),[2] a site belonging to the first period of the Liangzhu culture. During the middle Liangzhu period, bracelets became more refined and had a pronounced convex shape.

1 Zhejiang 1990, pls. 104, 105 and 107.
2 *Wenwu Ziliao Congkan*, 3, 1980, pp. 1-24.

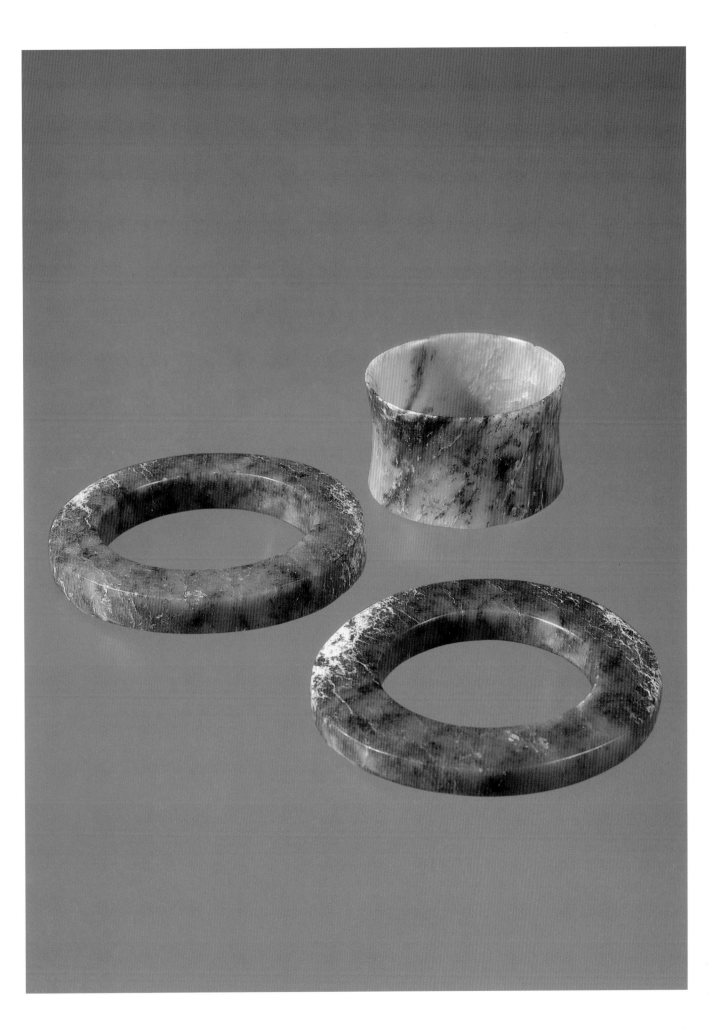

21 *Adze*

dark gray stone

Neolithic, Dawenkou or Liangzhu culture, c. 2500 BC
length 9.9 cm; width 4.2 cm; thickness 2 cm

22 *Adze*

gray stone

Neolithic, Dawenkou or Liangzhu culture, c. 2500 BC
length 13.3 cm; width 6.6 cm; thickness 1.7 cm

Luxuriant forests covering the area around Lake Tai during the Neolithic period provided building materials since the time of the Hemudu culture (Yuyao, Zhejiang province, c. 5000-3600 BC). The Hemudu site itself has yielded abundant remains of wooden houses, primary evidence of the carpentry skills of that Neolithic people. Sophisticated tools used in wood working have been found in a number of Liangzhu sites. Although very few Liangzhu habitation sites have been discovered and excavated, the use of wood is attested by remains of a few houses, linings protecting the inner walls of wells and remnants of coffins. Archaeologists have also discovered evidence of boats which would have plied a network of canals and waterways, a distinctive feature of the landscape in this region of China.

Stepped stone adzes similar to those presented here have been excavated at Fuquanshan (Qingpu, Shanghai).[1] The stepped section would have been fitted to a wooden handle and tied with cord. The varying size and thickness of the stepped stone adzes and the different angles of the cutting edges so far discovered suggest that they were adapted for working different types of wood or for other specific functions.

While the two stepped adzes may be regarded as tools, their high polish and the absence of wear, characteristics also found in excavated examples, suggest a ceremonial, non-utilitarian use and a possible value as prestige goods in the burial context.[2]

1 *Dongnan Wenhua* 1987, 1, pp. 1-17, fig. 14: 8-12.
2 Shanghai Museum 1992, pp. 68-69.

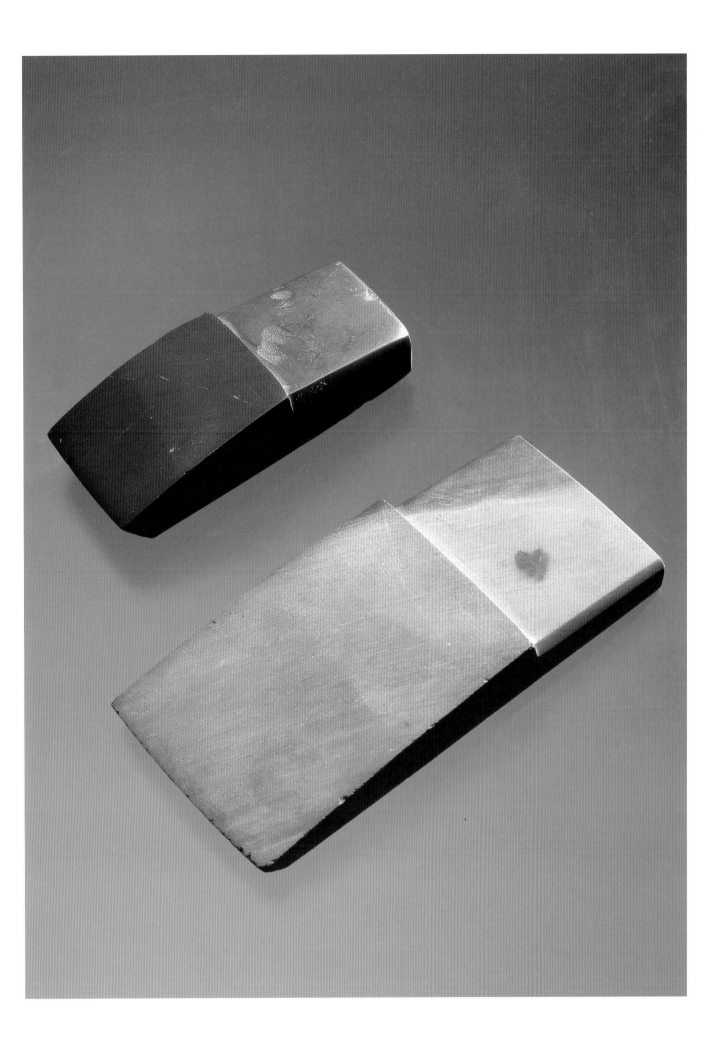

23 *A x e* (top left)
beige stone
> Neolithic, Liangzhu culture, c. 3000-2500 BC
> length 14.2 cm; top width 9.4 cm; bottom width 10.4 cm; hole 1.9 cm
> from the Armand Trampitsch Collection

Tapered toward the upper edge and gently broadening toward the blade, this finely polished squared axe is representative of the kind of stone ceremonial weapons of the Liangzhu culture which were also fashioned in nephrite jade (see no. 27). These axes were probably not intended for use,[1] as many known examples lack traces of wear (the small chip on the blade edge is due to flaking). Comparable examples have been excavated at Fuquanshan (Qingpu, Shanghai), such as those in tomb M139 where several stone axes were aligned on both sides of the deceased with some placed near the feet.[2] The same type of axe, in jade, has been found in Liangzhu culture sites of Zhejiang province, such as at Yaoshan, tomb M7:32.[3]

24 *A x e* (top right)
mottled brown stone
> Neolithic, Songze or Liangzhu culture, c. 3500-2500 BC
> length 13 cm; top width 5 cm; bottom width 6.5 cm; hole 2.7 cm

This axe has an elongated shape, a thick body, a straight shoulder and a rounded cutting edge. The quite large hole, drilled from both sides, indicates that the axe was attached by means of a strong cord to a wooden handle – the straight shoulder fit into a slot cut into the shaft, making it a tool strong enough to work wood.

25 *A x e* (bottom left)
dark gray stone with light brown areas
> Neolithic, Songze or Liangzhu culture, c. 3500-2500 BC
> length 15.6 cm; width 11 cm; hole 3.4-3.6 cm
> from the Armand Trampitsch Collection

In the Neolithic cultures which flourished in the Lake Tai area, this type of axe with a large hole, thick body and rounded cutting edge was initially documented in sites of the Songze culture (c. 4000-3400 BC); it continued to be made in the following Liangzhu period. The piece is finely polished, the top right angle of the shoulder is missing and the top left has a chip.

26 *A x e* (bottom right)
dark gray stone with red and beige clouding
> Neolithic, Songze or Liangzhu culture, c. 3500-2500 BC
> length 15.4 cm; top width 8 cm; bottom width 10.2 cm; hole 2.4 cm

Although it has a thicker body and a slightly smaller hole, this axe is similar to no. 25. The chips along the cutting edge and on the straight shoulder may indicate a practical, more than a ceremonial, use of the axe.

1 Rawson 1995, pp. 167-169.
2 A line drawing of the tomb is in Shanghai Museum 1992, pp. 22-23. See also a photograph of the burial at p. 37.
3 Reproduced in Zhejiang 1990, pl. 227.

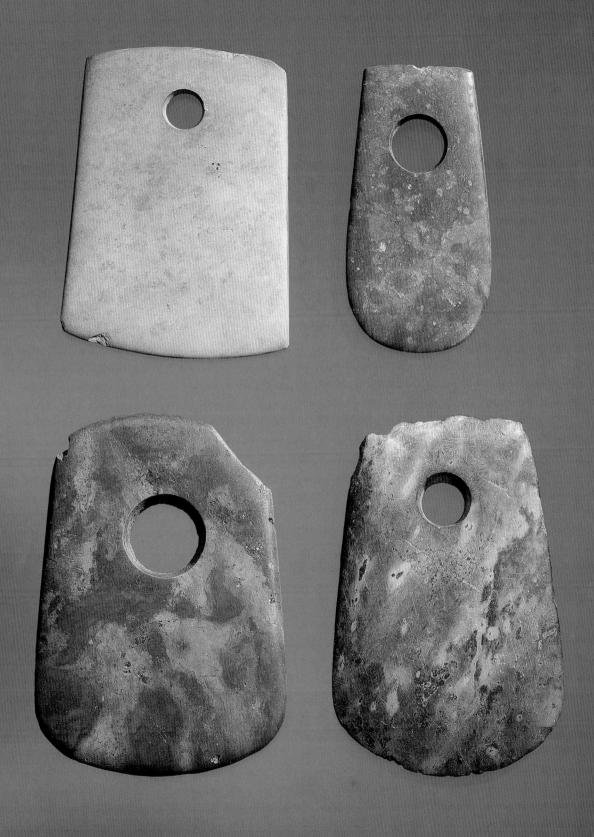

27 *Yue axe*

green jade with extensive alteration

Neolithic, Liangzhu culture, c. 2500 BC

length 17.4 cm; top width 9.9 cm; bottom width 11.8 cm; hole 2.6 cm

Typical of the ceremonial weapons of the Liangzhu culture, this finely cut and polished *yue* axe has a gently curving and bevelled cutting edge, a straight shoulder, rounded slightly tapering lateral edges and a perfectly circular hole, which are all features found in excavated examples, such as those from Yaoshan (Yuhang, Zhejiang province, tomb M7:32), Zhanglingshan (Wuxian, Jiangsu province, tomb M4:016) and Fuquanshan (Qingpu, Shanghai, tomb M9:25).[1] This shape can also be regarded as a forerunner of the later bronze *yue* axes of the Shang dynasty (16th-11th century BC).

The role of ceremonial weapons in Neolithic cultures such as Liangzhu can, to some extent, be surmised by observing their use in contemporary traditional societies. A good comparison is offered by the Maori of New Zealand, whose jade artifacts comprise implements, ornaments, weapons and ceremonial adzes. The latter, carefully crafted and polished, were above all meant for display, being the tangible symbols of the authority, power and rank of their owners. The jade ceremonial adzes, called *toki poutangata,* were attached to elaborate wooden handles and used only on special social occasions. Many of them even had names, suggesting that the object possessed its own personality and that it was closely associated with its owner. Some were passed from one generation to the next and thus became treasured heirlooms. A famous example is a ceremonial adze housed in the Auckland Institute and Museum, said to be the original blade made and owned by Ngahue, the mythical ancestor of the first Maori who reached New Zealand.[2]

1 Zhejiang 1990, pls. 227, 232 and 233 respectively.
2 Beck and Neich 1992, pp. 89-90.

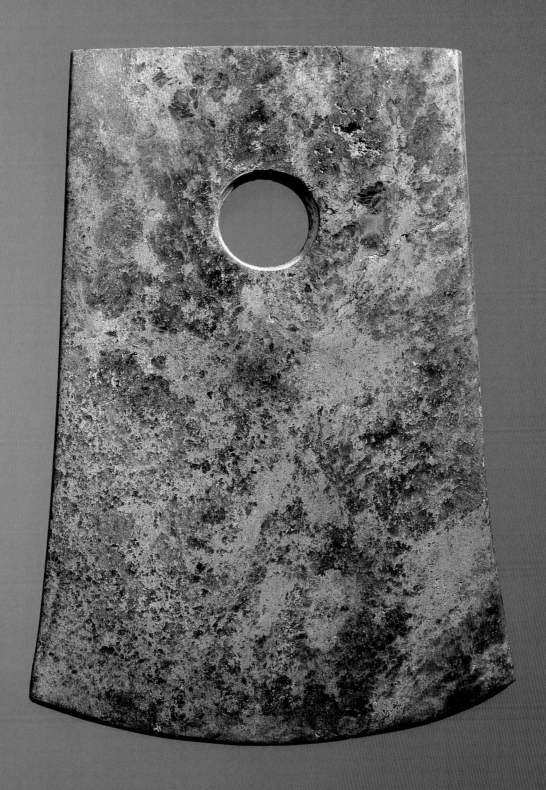

28 *Axe*

dark-green nephrite with brown areas

Neolithic, southern China, 3rd millennium BC
length 15 cm; top width 6.8 cm; bottom width 7.3 cm; hole 1.5 cm
from an English collection

A collector who once owned this densely textured jade axe left an attribution in white ink which identifies the piece as "China (Pre-dynastic)". The axe can, in fact, be assigned to the late Neolithic cultures which flourished in southern China just before the Bronze Age in a period, the millennium between 3000 and 2000 BC, which can rightly be called pre-dynastic. Several of these cultures, Liangzhu in particular, are characterized by a society hierarchically organized, ruled by an elite whose members defined their social, religious and political status through objects fashioned in jade, a valuable, exclusive material also used to convey an iconography alluding to religious beliefs. These are all traits which anticipate characteristics of the Bronze Age societies of the dynastic period.

Stone and jade axes and tools have attracted the interest of Western scholars since the late 19th century, when they began to be collected as evidence that China, like other civilizations, had passed through a prehistoric phase. The first systematic study of Chinese prehistoric tools was conducted by the Italian anthropologist, Enrico H. Giglioli, who, as early as 1898, described a jade axe from the region of Fuzhou and a similar one in stone from Shaanxi province.[1]

29 *Axe*

reddish-brown jade

Neolithic, possibly Liangzhu or Dawenkou culture, 3rd millennium BC
length 25.5 cm; top width 10 cm; bottom width 12 cm; hole 0.9 cm
from a French collection.

This large and imposing blade can tentatively be assigned to the Liangzhu culture on the basis of its clearly delineated shape, curved cutting edge and the small hole which is occasionally seen on ceremonial Liangzhu jade blades, such as the one discovered at Fanshan (Yuhang, Zhejiang province, tomb M12:100).[2] However, large blades of this kind are also found in Dawenkou culture (c. 3500-2900) sites in Shandong province: see for example a blade with similar dimensions (24 cm in length and 10 cm in width) excavated at Zhangqiu Jiaojia.[3] The color of the stone has here been almost completely altered by repeated handling, although when exposed to strong light the jade reveals the fine and compact microcrystalline structure typical of nephrite.

1 Giglioli 1898, p. 374.
2 Zhejiang 1990, p. 179, pl. 238.
3 *Kaogu* 1998, 6, p. 21, fig. 3: 7.

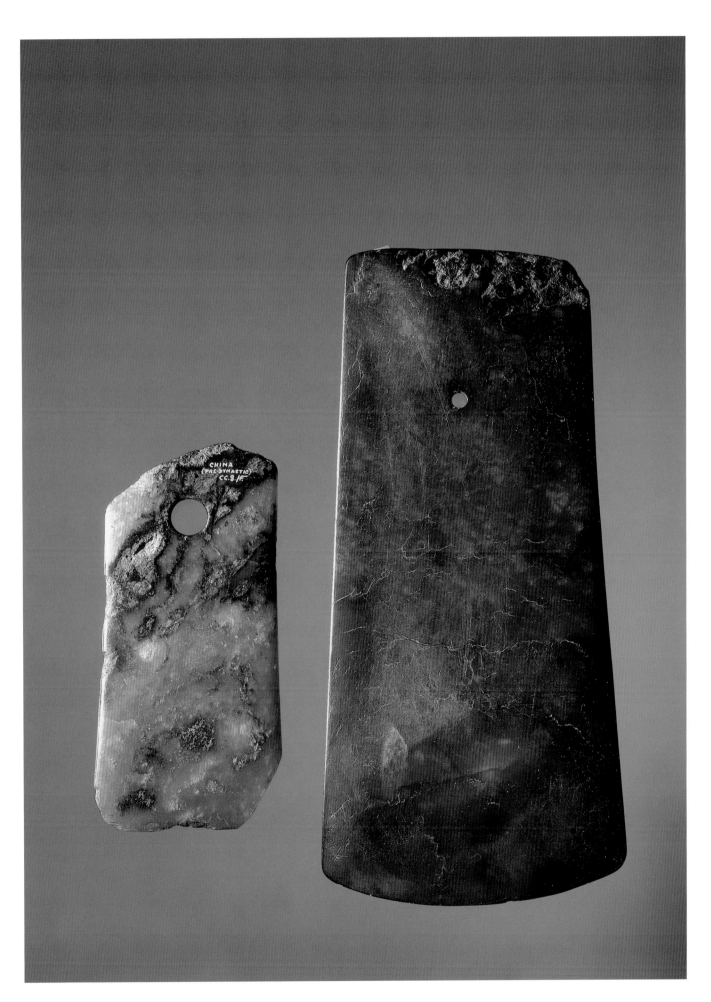

30 *Bi disc*

light yellow jade with brownish areas and beige clouding

late Neolithic, early Bronze Age, c. 2500-1900 BC

diameter 18 cm; central opening 5.7-6.3 cm

As pointed out by Huang Tsui-mei, only a few of the hundreds of excavated *bi* discs have been discovered in Neolithic sites outside the geographical area covered by the Liangzhu culture.[1] Since these sites are later than Liangzhu, this suggests a diffusion of the *bi* disc type from Liangzhu to other late Neolithic cultures, some of them located as far away as Gansu and Qinghai provinces in northwest China.[2] More archaeological data and relative chronologies are needed to confirm such a hypothesis. However, in terms of workmanship and stone these discs differ substantially from their Liangzhu counterparts: the hole is drilled from only one side, so that there is no central ridge typical of Liangzhu *bi,* which is produced by drilling the hole from both sides. The material also differs substantially from the nephrite used by Liangzhu craftsmen, which is frequently a hardstone superficially similar to jade. The workmanship of discs from northwest China is often quite crude, with irregular thickness and uneven surfaces showing tool marks.

On the basis of the few excavated examples, it is possible to suggest that much more refined discs, as this one, might have been crafted by other cultures, such as Taosi (Xiangfen, Shanxi province, c. 2500-1900 BC).[3] However, in the absence of more substantial archaeological data, discs of this type are very difficult to date. A high degree of finish is not necessarily an indication of a late date; these discs may range from the late Neolithic period to the early Western Zhou period (11th century BC).[4] A fragment of a disc of similar color was discovered in Shaanxi province,[5] while a disc similar in size and stone from the Virginia Museum of Fine Arts was sold in New York in 1998.[6]

1 Huan Tsui-mei 1992, p. 57 ff.

2 See for example the disc discovered in tomb 95TZM200:5 of the Zongri site (Tongde, Qinghai province) reproduced in *Kaogu* 1998, 5, color plate 5, no. 2.

3 A disc from Taosi is reproduced in Rawson 1995, p. 152, fig. 4, alongside a disc in the British Museum attributed to the northwestern tradition but not dated (Ibid., p. 152, fig. 5).

4 The assumption is based on the fact that *cong,* differing from their Liangzhu prototypes, have been discovered in early Western Zhou sites. See no. 74 in this catalogue.

5 Gao Dalun and Xing Jinyuan 1995, p. 71, pl. 11, not dated.

6 Sotheby's 1998, p. 81, no. 338, not dated.

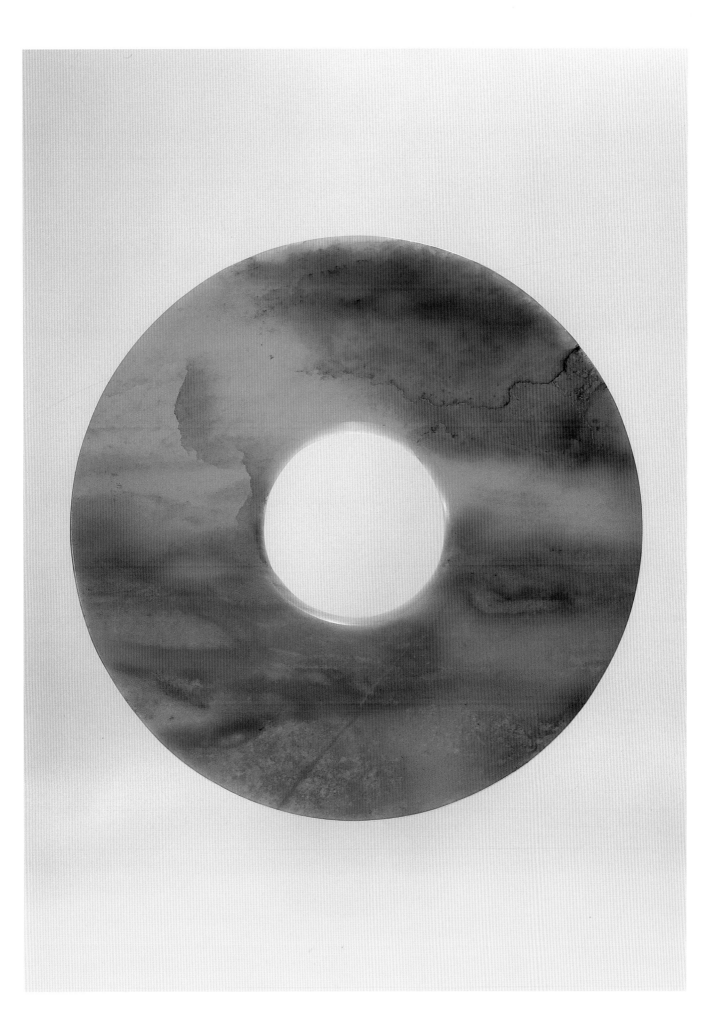

31 *Yuan disc*
greenish-brown jade with altered area
late Neolithic, early Bronze Age, c. 2500-1900 BC
diameter 13.5 cm; central opening 6.6 cm
from a French collection

32 *Bi disc*
brownish jade with darker area
late Neolithic, early Bronze Age, c. 2500-1900 BC
diameter 12 cm; central opening 3.6 cm

33 *Huan disc*
green jade with brown areas
late Neolithic, early Bronze Age, c. 2500-1900 BC
diameter 14.7 cm; central opening 5.8 cm
from Rare Art, Inc.

Different types of discs with varying ratios between the width of the central opening and that of the jade area have been traditionally referred to using names derived from the classification contained in the ancient Chinese etymological dictionary *Er Ya* (c. 11th-3rd century BC). According to this text, a disc with a central opening measuring in width half of the jade area is called a *bi,* while in the opposite case it is a *yuan.* If the central opening and the jade area are of equal width, it would then be called a *huan.*[1]

Today, this terminology is followed mostly in the archaeological reports and in Chinese articles and books on jade. It has been adopted here because the three discs, possibly from Shaanxi province, offer an opportunity to illustrate an ancient, idealized systematization of disc proportions. However, it is undeniable that the excavation of sites dating from the late Neolithic period to the early Western Zhou (11th century BC) is gradually bringing to light, in an area stretching from the northwest to central China and up to Shanxi province, discs made in a variety of stones exhibiting features which bring them close to the types described in the *Er Ya.*[2]

1 Huang Tsui-mei 1992, pp. 157-162.
2 Preliminary studies on discs from northwest China have been done by Yang Meili 1994 a-c. See also Rawson 1995, pp. 150-152.

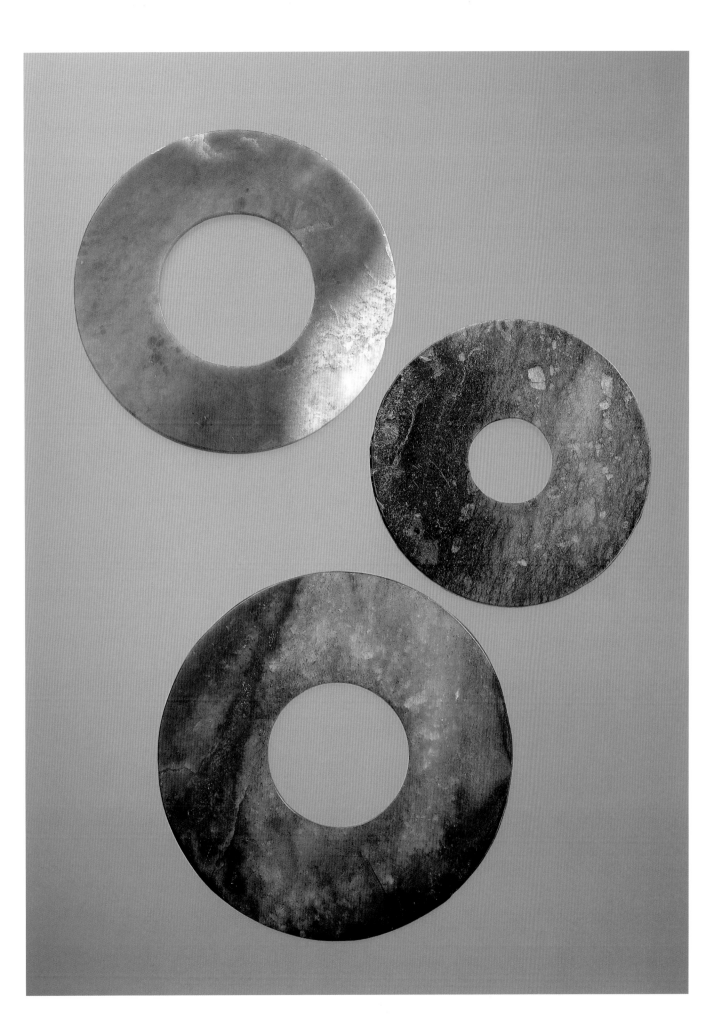

34 *Xuanji, notched disc*

deep reddish-brown jade

late Neolithic, early Bronze Age, possibly Longshan culture, c. 2500-2000 BC
diameter 18.6 cm; central opening 8.4 cm
from the Wu Dacheng Collection (by repute)
from the Berthold Laufer Collection

exhibited
The Dayton Art Institute, Dayton, Ohio
San Antonio Museum of Art, San Antonio, Texas
Pacific Asia Museum, Pasadena, California
Palm Springs Desert Museum, Palm Springs, California

This object links us directly with the two scholars who laid the foundations for the modern study of ancient Chinese jades, Wu Dacheng (1835-1902) and Berthold Laufer (1874-1934). This notched disc is reputed to have belonged to Wu Dacheng[1] who, in 1889, published it in his *Guyu Tukao* (Illustrated Study of Ancient Jades). In this work, following the tradition established by Song dynasty (960-1279) antiquarians, Wu Dacheng illustrated through line-drawings jades from his collection and described them by matching names derived from classical sources with actual artifacts. Thus, Wu Dacheng identified the jade presented here as a *xuanji,* a term derived from a passage of the *Shujing* (Book of Documents) to indicate an astronomical instrument in jade used by the mythical emperor Shun to examine the sky and the heavenly bodies.

This interpretation of the *xuanji,* as many others of Wu's theories, was reiterated by Berthold Laufer in his *Jade. A Study in Chinese Archaeology and Religion* (1912),[2] the first thorough publication on jade in a Western language which remained for decades the standard reference work until archaeological discoveries prompted thorough revisions in this field of studies.[3] On the basis of Wu Dacheng's drawings of the two sides of the *xuanji,* reproduced in Laufer's book as figs. 36 and 37, it is possible to assume that the piece presented here was the one in the collection of the Chinese scholar before passing into that of Berthold Laufer. It is interesting to note that, after so much time, the function of the *xuanji* still remains an unsolved mystery, although the development of its shape has been partly clarified by the most recent archaeological discoveries.

1 See Christie's October 30, 1995 catalogue, no. 916.
2 Laufer 1912. See pp. 104-147 of the reprinted edition.
3 Hansford 1968, pp. 65-68. Hansford too shared the opinion that the *xuanji* might have been an astronomical instrument.

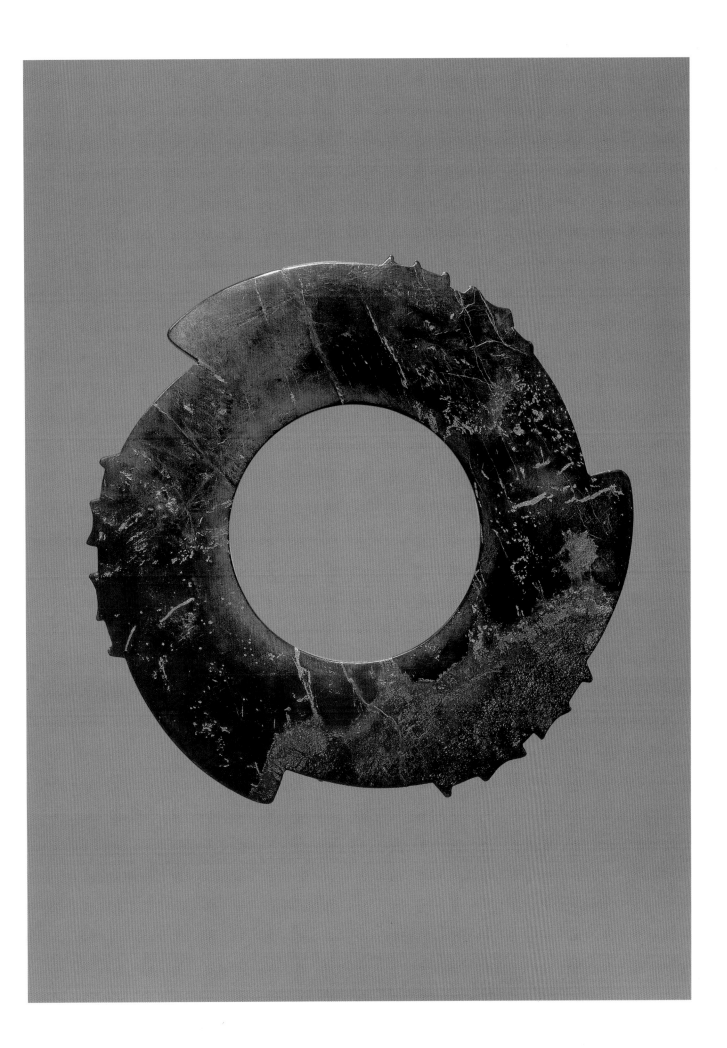

35 *Notched disc*
 green jade with dark areas
 late Neolithic, early Bronze Age, possibly Longshan culture, c. 2500-1700 BC
 diameter 11.6 cm; central opening 6.5 cm
 from an English collection

36 *Notched disc*
 pale green jade with beige areas
 late Neolithic, early Bronze Age, possibly Longshan culture, c. 2500-1700 BC
 diameter 10 cm; central opening 6.8 cm
 from an English collection

As argued by Yang Meili, the prototypes from which these peculiarly shaped discs might have been derived are small Hongshan (c. 4000-3000 BC) ornaments with a notched outline from Liaoning province.[1] The discs presented here are characterized by a structured shape which is typical of similar discs excavated in sites of the Dawenkou (c. 4500-2300 BC) and Longshan (c. 2500-1700 BC) cultures in Shandong province.

The presence of small engraved circles corresponding to the three notches on no. 35 transforms the abstract outline of the disc into stylized profiles of birds' heads; the crenellations can be seen as complementing the image and standing for the birds' crests.

This iconography is consistent with the bird imagery which characterizes the art of the Neolithic cultures of eastern China.[2] The regular crenellations can also be related to similar profiles carved on a number of Longshan culture jades used to define the contours of images of birds.[3]

It seems that these notched discs represent the confluence of different artistic traditions originating in eastern China, while belonging to a category of its own within the body of known Longshan jades. They probably did not have a practical function, as was believed in the past (see no. 34), but it is likely that they served as symbols of social prestige.

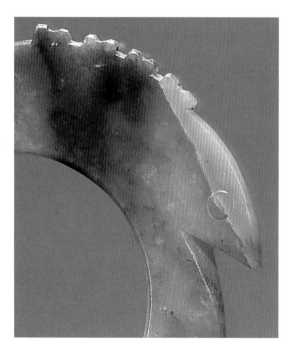

1 Yang Meili 1993. A detailed account of Yang Meili's study is given in Rawson 1995, pp. 160-162.
2 Wu Hung 1985; Salviati 1995.
3 Compare, for example, the outline of a jade pendant in The Art Institure of Chicago and a disc in openwork in the Musée Cernuschi, both reproduced in Wu Hung 1985, figs. 21 and 20 respectively.

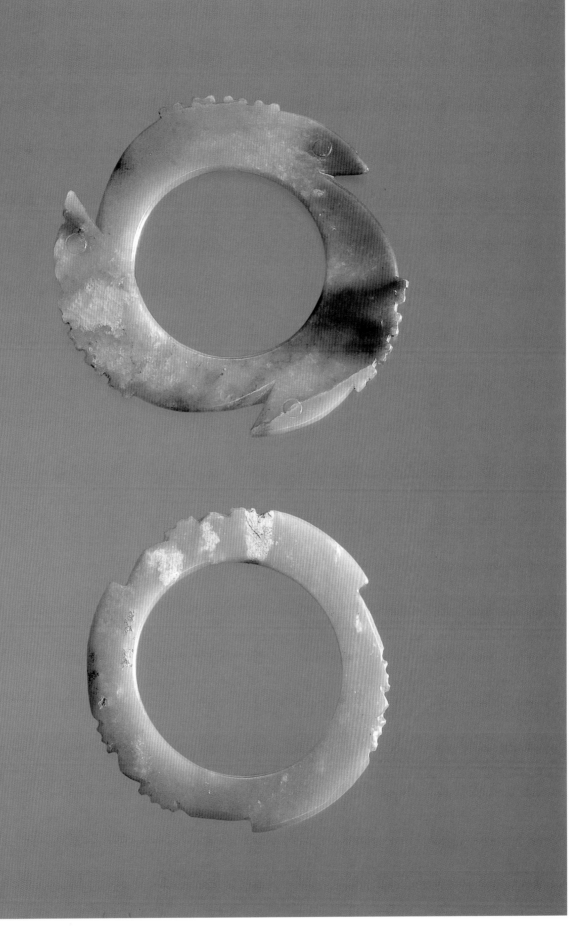

37 *Ceremonial blade*
greenish-beige jade with light and dark veining
late Neolithic, Longshan culture, c. 2500-1700 BC
length 21.5 cm; top width 4.2 cm
from an English collection

This long, rectangular ceremonial blade belongs to another category of jades typical of the Longshan culture (c. 2500-1700 BC). Since it lacks the clearly defined cutting edge typical of ceremonial weapons, this type of blade has also been described as a tablet or a scepter, *gui,* following the terminology given in the *Zhou Li* (Rites of the Zhou) for the six types of ritual jades.[1] However, the hole – drilled from only one side – indicates that the blade was secured to a shaft by means of cords and that the blade was not positioned vertically, as a tablet. While the surface is finely polished and plain, two series of parallel bands in low relief are carved on the sides of the blade near the hole. A blade carved out of similar material is in the Hotung Collection.[2]

38 *Axe or blade* (left)
yellow-green jade
late Neolithic, c. 2500 BC
length 20.8 cm; top width 6 cm; bottom width 6.8 cm

This axe or blade has a much thinner translucent body than the other two examples. The three evenly spaced holes also show less refinement and testify to a different way of securing the blade to the handle. It can be assigned to the late Neolithic cultures of eastern China.

39 *Blade* (right)
light and dark green jade with black area
late Neolithic, early Bronze Age, c. 2500-2000 BC
length 19.5 cm; top width 5 cm; bottom width 6.4 cm
from Warren E. Cox

Though similar in shape to no. 37, this blade has sides flaring towards the edge, more like a ceremonial weapon. The nephrite is a good example of bi-colored jade, having two areas of different shades of green. The black strip on the edge of the blade and the reddish area along the left border are the skin of the boulder of jade out of which the object was carved. The edge is also marked by a perpendicular black vein, a penetration in the stone of the external dark coloration via a natural fracture. This use of the chromatic peculiarities of the nephrite, persisting in later jade carving tradition, shows the capacity of Chinese craftsmen to exploit fully all the characteristics of the stone, even its defects, which are transformed in the finished object into aesthetic enhancements.

1 Hansford 1968, pp. 56-62.
2 Rawson 1995, p. 187, no. 10: 20.

Bronze Age

40 *Yazhang ceremonial blade fragment*
black jade
>early Bronze Age, c. 2000-1700 BC
>length 17.5 cm; top width 7 cm; bottom width 5.2 cm
>from the Lionel Jacob Collection

41 *Yazhang ceremonial blade*
yellow jade with white veins
>early Bronze Age, c. 2000-1700 BC
>length 37.5 cm; top width 6.5 cm; bottom width 4.9 cm

42 *Yazhang ceremonial blade*
green jade with altered areas
>early Bronze Age, c. 2000-1700 BC
>length 29.3 cm; top width 5.7 cm; bottom width 3.8 cm; hole 0.7 cm
>from a French collection

These three sword-like blades belong to a well-known group of jades called by the traditional Chinese name *yazhang*.[1] They are characterized by a long thin blade widening toward the end, usually bevelled with a splayed V-shaped profile, often with pointed edges, as in no. 42. The tang, usually pierced with a hole, is neatly distinguished from the blade by small projections or crenellations which may assume an elaborate form, especially in those examples excavated at the early Bronze Age site of Erlitou (Yanshi, Henan province, c. 19th-16th century BC). These blades cover a wide span of time and a broad geographic area. The earliest examples have been brought to light at late Neolithic sites of the Longshan culture (c. 2500-1700 BC) in Shandong province, while the latest ones date to the end of the Shang period and the beginning of the Western Zhou period (c. 1200-1000 BC) and have been discovered at Guanghan, Sichuan province. *Yazhang* blades have also come to light in central China, Shaanxi province, and in sites along the middle reaches of the Yangzi river.

An example has also been excavated in Hong Kong.[2] This distribution and chronological framework suggest that this type of blade probably originated in eastern China and then was gradually transmitted to other areas. The cultural or political factors which allowed the persistence of the form over time are as yet not properly understood.[3]

The chronological and regional differences outlined above are reflected in the blades presented here. Nos. 41 and 42 belong to the type found in central China, Shaanxi province. No. 41 is also in a stone not dissimilar from the one used to craft the *bi* disc in no. 30. The blade fragment, no. 40, is made of a kind of dark colored stone, virtually black, used to carve *yazhang* excavated in southern China.[4] Finally, while no. 41 is flat and of even thickness, no. 42 has a central ridge, a feature recalling metal blades, thus reinforcing its attribution to the early Bronze Age period.

1 For a discussion of this type of blade see Rawson 1995, pp. 188-191 and Rawson 1996, pp. 81-84.
2 On the basis of the pottery found at the site, the archaeological context is dated to the Warring States period, if not later. See Tang Chung 1991, pp. 87-89 and p. 81, fig. 92.
3 Childs-Johnson (1995) has tried to relate this type of blade and others from the same period to the Xia dynasty, but her conclusions seem unsatisfactory.
4 This type of jade is discussed by Yang Boda 1995, pp. 58-59.

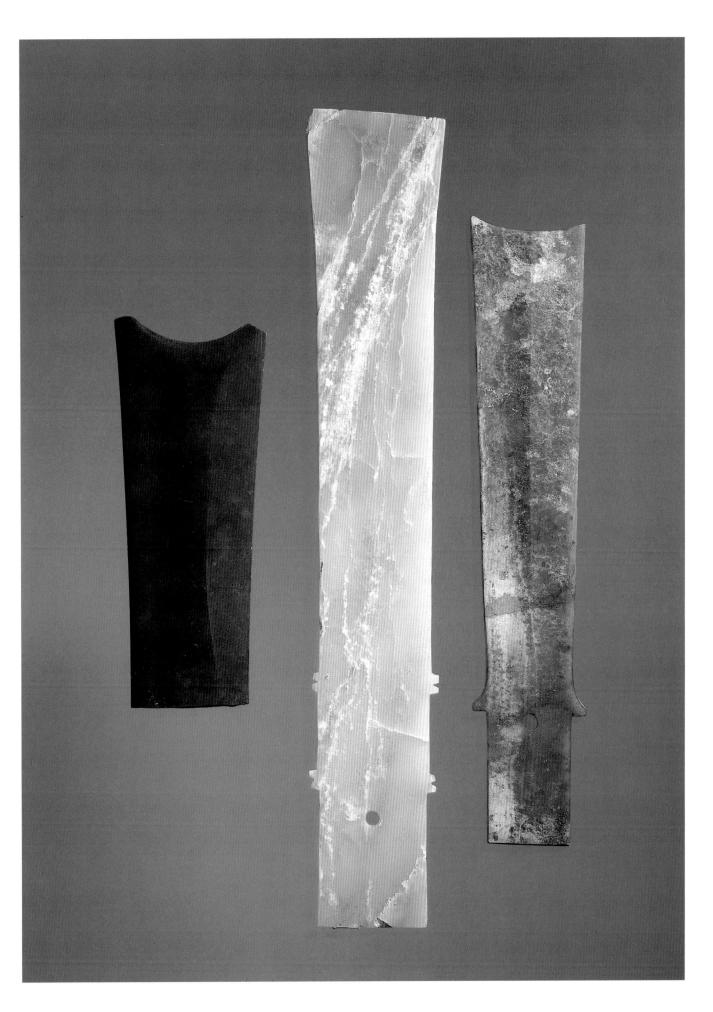

Bronze Age and Shang Period

43 *Knife-shaped object*

beige jade with alteration

late Shang period, Anyang phase, c. 13th-11th century BC
length 14.8 cm; width 3 cm
from a French collection

The shape of this knife-like object recalls that of a category of jade artifacts usually described as handles (see no. 54). However, the bevelled sides, the chipped tip and the flattened and rounded cross-section differentiate this object from such jades. Similar objects have been excavated from tombs located at Yinxu (Anyang, Henan province), the site of the last Shang capital. Compare for example a jade from tomb M232, possibly slightly earlier than the 13th century BC,[1] and another from a tomb at Dasikongcun, one of the *loci* excavated at Anyang.[2]

44 *Dagger*

white jade with brown areas

late Shang period, Anyang phase, c. 13th-11th century BC
length 12.8 cm; width 3 cm

The tang and part of the blade of this dagger or halberd-shaped jade –*ge* in Chinese– are decorated in low relief with a *taotie* mask, the principal motif of the Shang artistic repertory. The shape and decoration of the blade recall similar artifacts in bronze: indeed the object was meant to be a replica in jade of a type of weapon found in many areas of China during the Shang period, characterized by a distinctive V-shaped outline.[3] *Ge* halberds in jade represent the last major category of ceremonial weapons fashioned in jade. The tradition begun in the Neolithic period of putting jade weapons into tombs as part of the funerary offerings ended in the late Western Zhou period (c. 1050-770 BC).

45 *Blade*

ivory-colored jade

early Bronze Age, first half of the 2nd millennium BC
length 15 cm; top width 5 cm; bottom width 7.1 cm

This substantial blade was carved of opaque white jade with a few rust-like veins. Its regular proportions, smooth cutting edge and precisely incised decoration contrast with the ridges running along the whole length of the sides, which make the blade seem unfinished. However, this and other features are seen on similar jade artifacts excavated at the early Bronze Age site of Erlitou (Yanshi, Henan province, c. 19th-16th century BC). In particular, the regular geometric pattern of incised crisscrossed lines decorating the tang of this blade match a motif occurring on one side of a very large jade knife from Erlitou.[4]

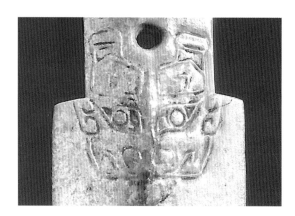

1 Chang 1980, p. 82 and fig. 18.
2 Hansford 1968, pl. II: 4.
3 See Jian Rong 1993 for a typological analysis of the *ge* and its possible origins.
4 Wen Fong 1980, pp. 76-77, no. 3.

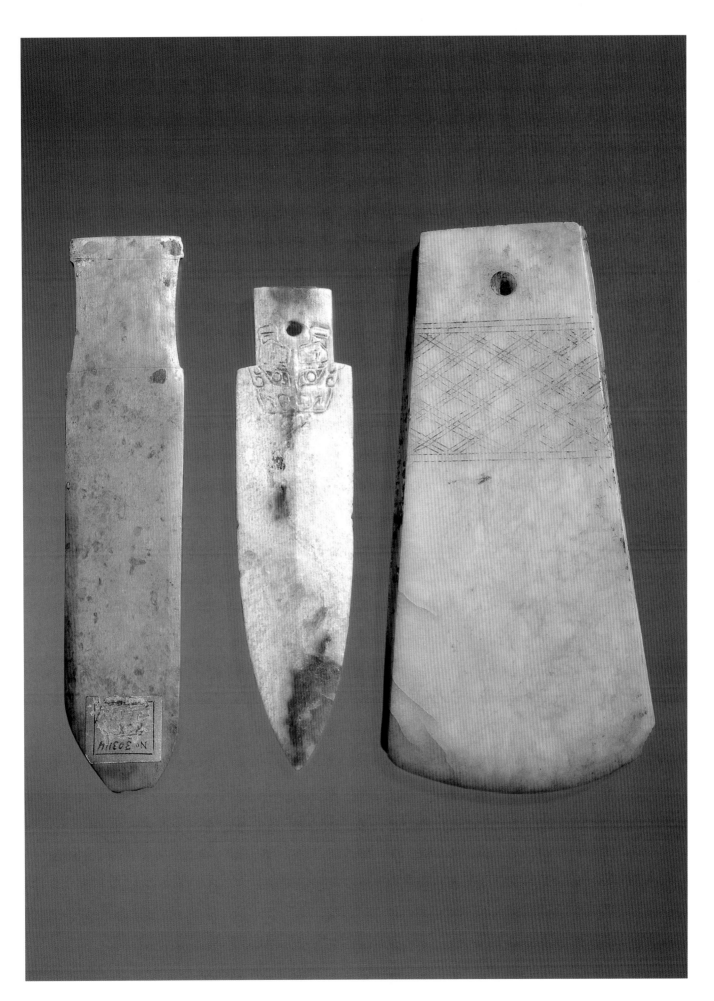

Shang Period

46 *Pendant*
altered jade
length 7 cm; width 2.6 cm

47 *Pendant*
white jade
length 10.6 cm; width 3.2 cm

48 *Pendant*
light brown jade
length 6.7 cm; width 1.3 cm

49 *Pendant*
altered jade
length 8 cm; width 2.3 cm

50 *Pendant*
yellow-green jade
length 5.5 cm; width 2.4 cm

51 *Pendant*
green jade
length 7.6 cm; width 2.3 cm

52 *Pendant*
altered jade with dark areas
length 8.8 cm; width 3.2 cm

53 *Ring*
bone
diameter 3 cm

54 *Handle-shaped fitting*
beige jade
length 7.7 cm; width 2.1 cm

55 *Carved fragment*
bone
length 4.7 cm; top width 3.6 cm; bottom width 2 cm

all late Shang period, Anyang phase, 13th-11th century BC
all from a French collection

Pendants in the form of small blades or knives, together with small carvings of animals, belong to a category often found among jades excavated from Shang tombs at Anyang, Henan province. The curved shape of nos. 47 to 51 suggests that these pendants were made by reworking fragments of larger jades, such as rings or discs. No. 51 differs from the other curved pendants not only by virtue of the bright green color of the stone, but also because its upper end is carved as a bird's head in profile, with one of the conically drilled holes serving as its eye. It can be compared to a similar pendant in the Hotung Collection.[1]

No. 54 belongs to the type of jades described as handle-shaped objects documented in sites dating from the early Bronze Age (Erlitou, Yanshi, Henan province, c. 19th-16th century BC) to the early Western Zhou period (c. 10th century BC). However, one of its sides is incised with regularly spaced cavities and straight or T-shaped shallow lines, giving the object the aspect of a ruler.

Nos. 53 and 55 are made of bone, another material favored by Shang artisans working at Anyang, where archaeologists have discovered two work-shops for the manufacture of objects in bone. No. 55, a fragment of a larger object, probably a handle, is decorated in intaglio with two *taotie* masks similar to the one carved on the tang of no. 44.

1 Rawson 1995, pp. 195-156, no. 10: 27.

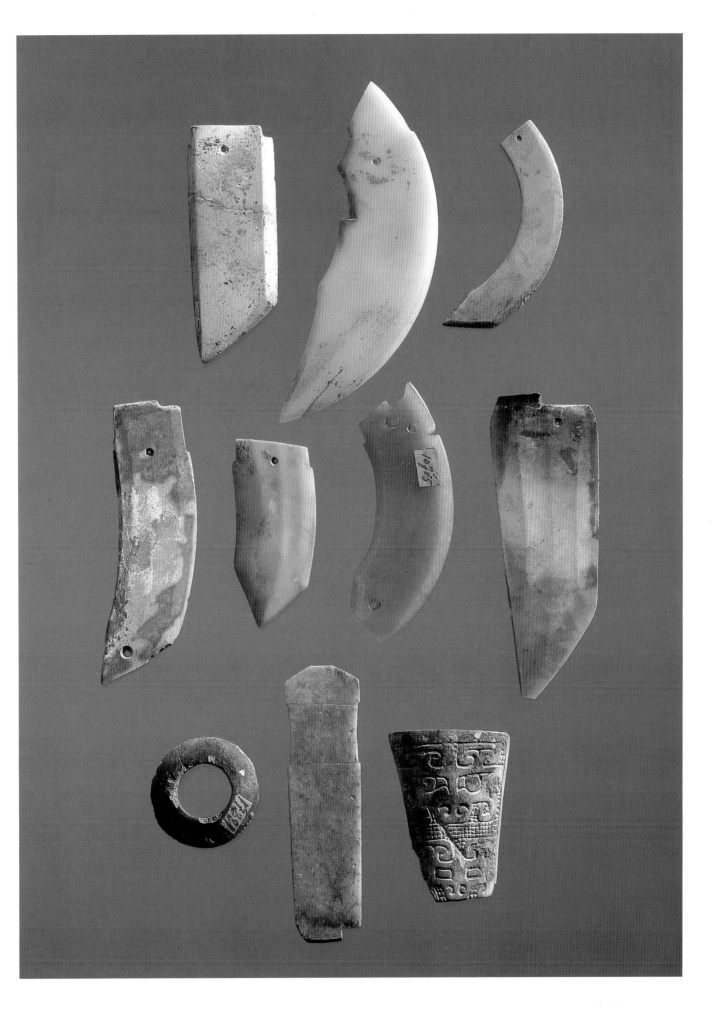

56 *Zoomorphic pendant*

white jade with brown areas

late Shang period, Anyang phase, c. 1250 BC
length 5.3 cm; width 2 cm

In the form of a crested bird in profile, this pendant is carved with a clearly defined head, beak, wings, tail and claws. The details covering the body are rendered by tiny raised lines obtained by abrading the areas between them; the same technique was used for the *taotie* mask decorating no. 44. Although the line patterns are mostly abstract in nature, recalling the spiral motifs commonly used in the decoration of Shang ritual bronzes, the curvature of the bird's tail and the line decor suggest the profile of an elephant's head and trunk.

The small hole pierced at the top of the bird's crest permits suspension as a pendant, while the slightly curved shape suggests it might have been carved from another arc-shaped jade, such as a *huang* pendant. The curved shape and, above all, the iconography of the pendant are consistent with a group of similar objects discovered at Anyang, Henan province.[1] Several, but not all of them, have a small tang at the bottom, probably for insertion into some kind of support. A piece without a tang similar to the one presented here was discovered in the tomb of Fu Hao, dated to c. 1250 BC.[2]

It is possible that the iconography of these pieces reflects, as it does on ritual bronzes, religious beliefs of the Shang. Wu Hung has noted, for example, that all known pendants of this kind are carved either with images of birds or human figures or a combination of the two, such as human figures with clawed feet and hands. He related this pattern and other features of Shang art to the iconography of the late Neolithic cultures of eastern China, in which birds play a relevant role, to suggest a possible eastern origin of the Yi clan which founded the Shang dynasty.[3]

1 See the thorough discussion of this type in Rawson 1995, pp. 218-219, no. 12: 14.
2 A line drawing of the object is in Yang Jianfang 1987, pl. xv: 7.
3 Wu Hung 1990; see also Wu Hung 1985.

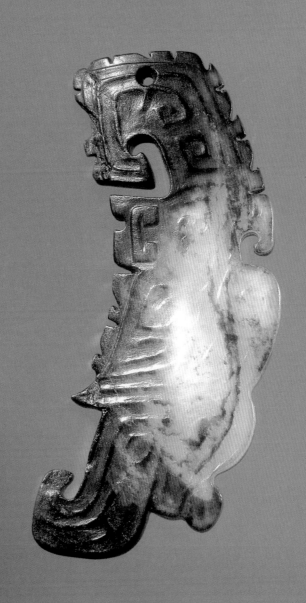

Shang and Western Zhou Period

57 *Silkworm pendant*
green jade
late Shang period, 13th-11th century BC
length 4 cm; width 0.5 cm

58 *Insect pendant*
green jade with traces of alteration
late Shang period, 13th-11th century BC
length 4.5 cm; width 0.7 cm

59 *Handle-shaped fitting*
green jade with traces of alteration
late Shang period, 13th-11th century BC
length 7.2 cm; top width 2.8 cm; bottom width 2.6 cm

60 *Crouching dragon pendant*
green jade
late Shang period, 13th-11th century BC
length 4.7 cm; height 1.9 cm

61 *Crested bird pendant*
light green jade
with traces of alteration
late Shang, early Western Zhou period, 11th-10th century BC
length 3.8 cm; height 2.4 cm

62 *Bird pendant*
yellowish jade
early Western Zhou period, 11th-10th century BC
length 3.8 cm; height 2 cm

63 *Fish pendant*
green jade with traces of alteration
early Western Zhou period, 11th-10th century BC
length 7 cm; height 2.5 cm

all from a French collection

Animals form a distinct category of miniature jades which makes its appearance in the archaeological records by the Anyang phase of the late Shang period.[1] Several of the animal shapes first seen at Anyang continue to be made in the following early Western Zhou period, making it difficult to date these small pieces with certainty. An exception is the crouching dragon, no. 60, with stylistic and iconographic features typical of late Shang art.[2] In many cases these small jades seem to have been carved from fragments of larger pieces (see nos. 47-52). This is probably the case of the two small insects, nos. 57 and 58, less common although documented in the category of Shang animals in jade. The crested bird no. 61 has also been carved from something else: its awkward beak and head clearly show how the artisan had to adapt to a fragmentary piece of jade. The early Western Zhou bird no. 62 has a more graceful and balanced outline,[3] with a fish-like tail. Fish pendants, such as no. 63, with clearly delineated fins, are quite common during the early Western Zhou period, though they are more often carved in an arc-shape, like those from tombs in Shaanxi province.[4] An exception to the animals in this group is the handle-shaped fitting no. 59, which belongs to the same category as no. 54, although it has more carved detail.

1 Rawson 1995, pp. 205-208.
2 However, it did not disappear in the Western Zhou period: see for example the crouching dragon in jade excavated at Zhangjiapo, Chang'an, Shaanxi province, reproduced in Hansford 1968, pl. 19, top right.
3 Compare it to the birds in jade excavated at Dasikongcun, Anyang, in Hansford 1968, pl. 12, nos. 3-7.
4 Zhang Changshou 1993, pls. 6: 2: 2-3, 7: 1: 1-2 and 7: 2: 2.

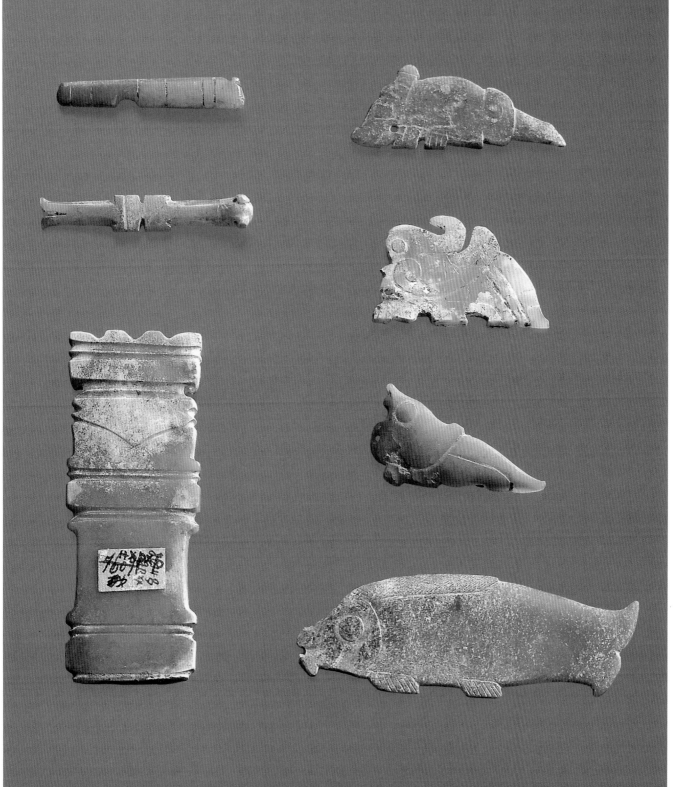

64 *Notched axe pendant*
green jade
late Shang, early Western Zhou period, 11th-10th century BC
length 5.1 cm; top width 3.9 cm; bottom width 4.6 cm
from a French collection

65 *Bird pendant*
creamy white jade with grayish areas
Western Zhou period, 11th-10th century BC
length 9 cm; height 2.8 cm
from the Armand Trampitsch Collection

66 *Crested bird pendant*
yellow jade with traces of alteration
late Shang, early Western Zhou period, c. 1100-1000 BC
length 3.8 cm; height 2.5 cm
from the Armand Trampitsch Collection

67 *Rabbit pendant*
green jade with altered areas
early Western Zhou period, 11th-10th century BC
length 6 cm; height 2.2 cm
from an English collection

68 *Bird pendant* (right)
dark green jade
early Western Zhou period, 11th-10th century BC
length 8.7 cm; width 2.5 cm
from an English collection

There is limited archeological information to help us understand how these pendants were actually used; in the excavation reports, the exact position of these small jades is not always indicated. However, one might suggest that they were grouped together to be worn as necklaces or pectorals or hung from the waist. A documented case is offered by tomb M2 of the early Western Zhou site at Liulihe (Fangshan, Beijing, 10th century BC). There the head of the deceased was surrounded by hundreds of tiny beads, shells and a few jade pendants shaped as blades and animals.[1] Tomb M251 of the same site yielded an elaborate pectoral composed of turquoise and agate beads and jade pendants in the shape of fish, rabbits and birds.[2] It is possible to speculate that pendants worn on the body were thought to have protective qualities and considered to be amulets, auspicious symbols or miniature symbols of status. As a cultural comparison, one may note the use in 5th and 6th century Korea of variously shaped pendants suspended from elaborate girdles which were part of the gold ornaments worn by Silla kings.[3] During the Liao period (907-1125), pendants in jade shaped as animals were hung from the waist to ward off evil forces.[4]

1 *Wenwu* 1996, 6, pp. 15-27, figs. 2, 6, 15 and color plate 1: 1-4.
2 Rawson 1996, pp. 120-21, no. 56.
3 Such as the one discovered in the *Ch'ŏnmach'ong* or "Heavenly Horse" tomb at Kyŏngju: Goepper 1999, pp. 180-184, no. 27.
4 A set of five animals in white jade hung from a jade plaque comes from the tomb of the Prince and Princess of Chen, buried in 1018 AD. Their bodies were found covered with "approximately fifty finely-carved animals, insects, birds and fish in jade, amber, agate and crystal" (Zhu Qixin 1991, p. 60).

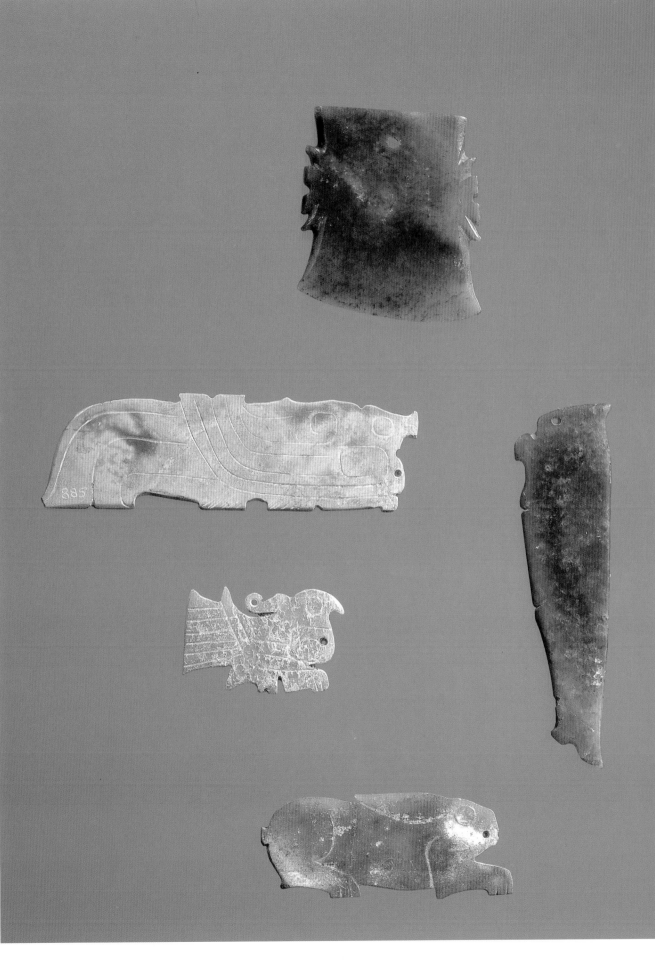

69 *Collared disc*

dark green jade with some alteration
late Shang period, c. 13th century BC
width 13 cm; height 3.4 cm; central opening 6.3 cm

This elegantly shaped disc represents a category of jade artifacts only occasionally documented in the late Shang (13th-11th century BC) and Western Zhou periods (c. 1050-770 BC). In fact, as pointed out by Jessica Rawson, this type of disc most likely originated in southern China, in areas on the periphery of Shang civilization cultural influences. This might explain why the form never entered the mainstream Chinese repertory but rather spread to southeast Asia.[1]

While often described as bracelets, collared discs usually have openings which seem too small for the hand and arm of an adult. Howard Hansford, in describing the skeletal remains found in a Neolithic burial at Gua Cha (Kelanton, Malaysia) with a collared disc still on one of its arms argued that "the ring was put on the wrist in early childhood, and when the hand had grown the amulet would become irremovable". He went on to affirm that he had witnessed this practice still in use in Guandong province.[2] It cannot be excluded that this practice was followed in Neolithic China, which would explain the very small openings of many ornaments identified as bracelets.

70 *Cong*

reddish-brown jade
late Shang, early Western Zhou, c. 1300-700 BC
height 4 cm; width 5.8 cm; central opening 4.4-4.6 cm
from the Landau Collection

The chronological and cultural attribution of this type of short, undecorated *cong* is still uncertain. While the form clearly derives from Liangzhu period prototypes, the few excavated examples range in time from the late Neolithic to the early Western Zhou periods. A small number of taller *cong* were found in early Western Zhou sites (see nos. 74 and 75), while a small *cong* of similar dimensions but different color has been unearthed in Shaanxi province.[3]

As is often the case with jades from old collections which have been much handled over time, the original color of this *cong* has turned a deep reddish-brown.

1 Rawson 1995, p. 130.
2 Hansford 1968, p. 73.
3 Gao and Xing 1995, pp. 70-71, pl. 21.

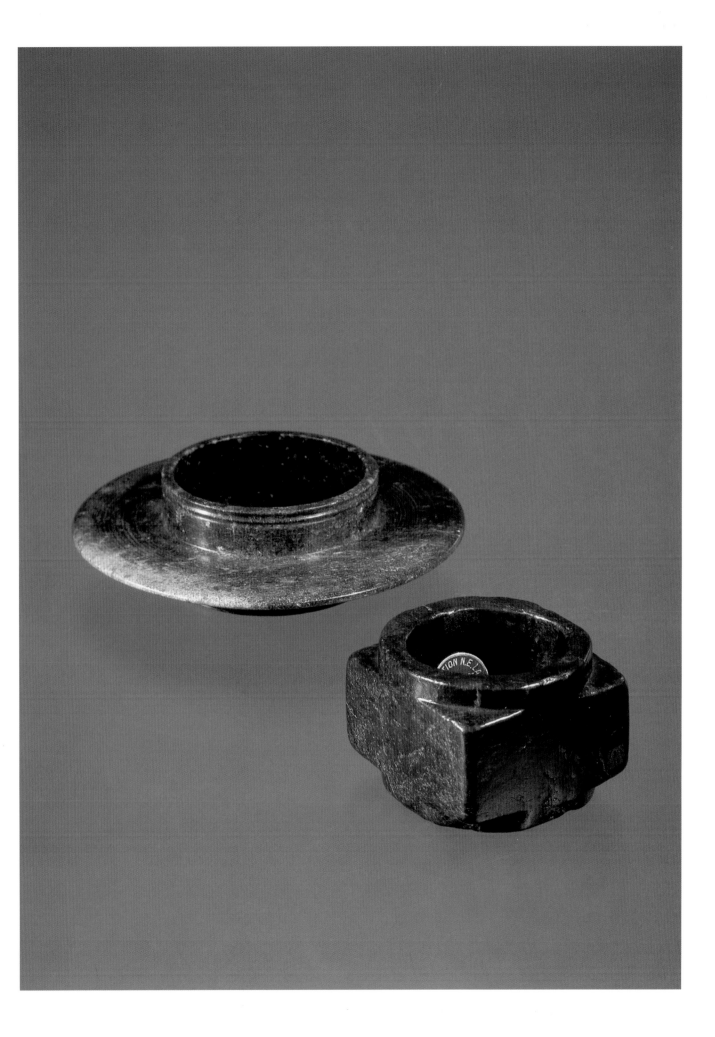

71 *Three arc-shaped pendants*
green jade with white areas
> Shang, Western Zhou period, c. 1500-1000 BC
> diameter 8.3 cm; central opening 3.2 cm
> from a French collection

72 *Three arc-shaped pendants composed as a disc*
light green jade with altered areas
> Shang, Western Zhou period, c. 1500-1000 BC
> diameter 10 cm; central opening 4 cm
> from a French collection

73 *Three arc-shaped pendants composed as a disc*
yellowish jade with brown and white areas
> Shang, Western Zhou period, c. 1500-1000 BC
> diameter 13.4 cm; central opening 6.3 cm
> from a French collection

These sets of arc-shaped pendants, which can be connected to form three segmented discs, belong to the same jade carving tradition as nos. 30-33. They are related to the discs crafted in western and central China by the use of variously colored, jade-related stones (though no. 72 is carved out of nephrite), by workmanship, as shown by the conical holes for suspension drilled from one side only and by the often glassy polished surfaces. These particular objects were made either by dividing an existing disc in three equal sections or by crafting each arc-shaped pendant from a single piece of jade, as is likely the case for no. 73. However, it is not clear if the pendants were meant to be joined together in a disc shape, or if they were used separately as ornamental hanging elements, following a disposition similar to no. 71. The second hypothesis seems more likely. If the finished object was meant to be made of separate units, cutting and rejoining a disc would not have made much sense, unless dictated by practical or ritual prescriptions.[1] The ultimate origin and function of these arc-shaped pendants, discovered in Shang and Western Zhou periods sites, remain unknown.

1 Yang Boda 1995, no. 67 argues that, jade being a precious material, "this method of making a disc by identical segments cut from the same block is the most effective means to maximize the use of the raw material".

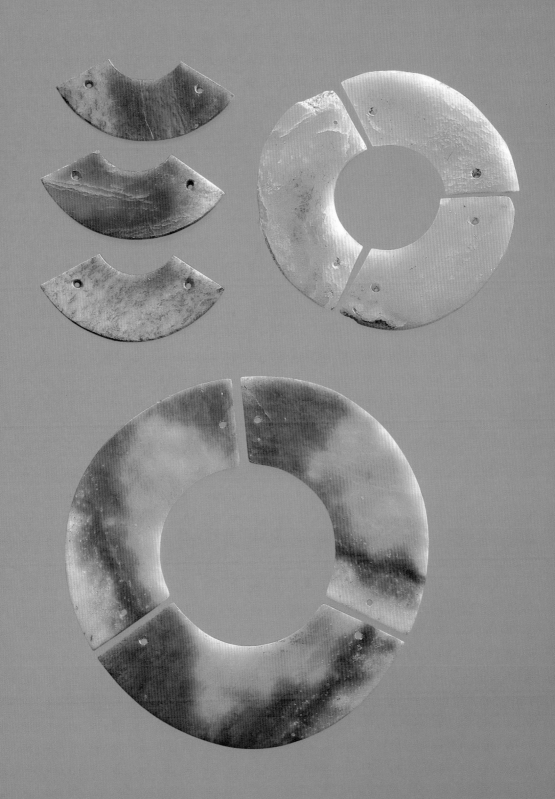

Western Zhou Period

74 *Cong*
yellow-green jade with red infusions
early Western Zhou period, c. 10th century BC
height 17.7 cm; width 8.2 cm
from a French collection

exhibited
Musée des Arts Asiatiques, Nice

On the basis of archaeological evidence, the creation of the *cong* can now be ascribed to the Liangzhu (c. 3300-2200 BC) late Neolithic culture (see entries nos. 10 to 12). *Cong* excavated in sites later in time and outside the Liangzhu geographical domain document transmission of this form to other cultures and areas. Over time, the form of these *cong* was subject to transformations from their Liangzhu prototypes. One of the major changes concerned the disappearance of the decorative motifs which characterized Liangzhu *cong* and the increasing emphasis on pure geometric form, as can be seen in the *cong* presented here and in no. 75. This process seems to have been accomplished in the early Western Zhou period, after which the *cong* disappeared, before being recreated in the Song dynasty (960-1279 AD) in longquan ceramic vessels in the form of ancient *cong*.

For a long time, it was believed that the *cong* and the *bi* were used in a ceremonial context during the Western Zhou period. This assumption, which implied a correlation between actual forms and names of objects mentioned in ancient Chinese texts, is based on a passage in the *Zhou Li* (The Zhou Book of Rites) stating that "...with a sky-blue *bi* worship is paid to Heaven; with a yellow *cong* to Earth".

Since, according to Chinese cosmology, the sky is round and the earth is square, the *bi* and the *cong* in jade have been regarded as types of ritual objects used by the Zhou to pay homage to Heaven and Earth. Unfortunately, the archaeological context does not provide any evidence to substantiate this theory, although one might assume that the texts contain a certain degree of truth and that specific jades were probably used in association with particular rituals.

This *cong* is very similar to one excavated in 1981 by Chinese archaeologists in the vicinity of the city of Xi'an, Shaanxi province, at the site where the Zhou established their first capital, Feng, soon after the conquest of the Shang around 1050 BC. The excavated *cong* is yellow jade, of regular form and one of the tallest among those discovered so far in a controlled excavation: it measures 20.5 cm in height and 9.8 in width. Since it was found in the Zhou capital, Chinese archaeologists speculate that it might have been an important and treasured object belonging to the Zhou royal family.[1] In any case, it seems to correspond, together with the one presented here, to the ideal type of yellow *cong* traditionally associated with the worship of Earth in the Zhou period.

1 Reproduced in Shaanxi 1992, p. 47.

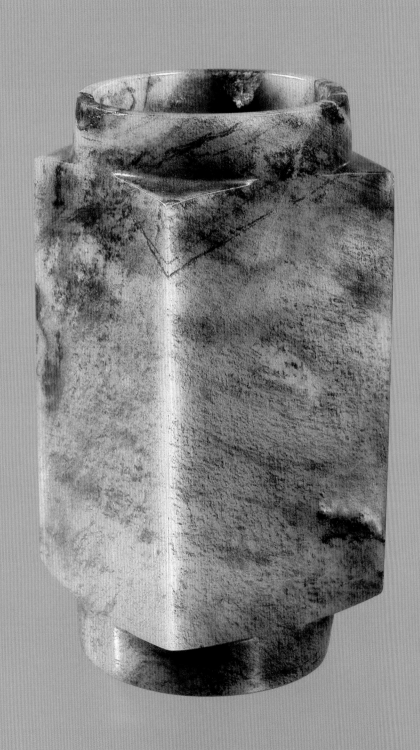

75 *Cong*
dark-green jade with extensive black and beige areas
early Western Zhou period, c. 10th century BC
height 14.4 cm; width 8.5 cm

No. 75 is another fine example of *cong* crafted in
the early Western Zhou period. As suggested by the
quality of the stone, it probably comes from central
China, the region which was one of the centers of
production of discs and other objects in jade and
jade-like stones (see nos. 30 to 33, 41, 71, 73, 74). Its
main appeal comes from its pure form and the way
the original block of jade has been worked to create
a harmonious balance between the differently color-
ed zones of the stone. There is a subtle gradation
from the deep green of the jade – visible in one of
the top corners and collar of the *cong*– to the beige
and black areas, enriched by dark veining. This *cong*
makes a strong modern visual impression, which
is probably due to the fact that aesthetic factors
were not of secondary importance to the craftsman
who created this object in a pure geometric form
with so much attention to harmony of proportions
and colors.

The earliest reference to the *cong* is contained in
the Chinese classic *Baihu Tong* of the 1st century AD,
written by Ban Gu. There we read that "the object
with a circular interior and a square exterior is called
a *cong*". The first scholar to identify actual objects
from this rather vague description was Wu Dacheng
(1835-1902) who, in his *Guyu Tukao* (Illustrated
Study of Ancient Jades, 1889) listed thirty-one
objects under the generic term *cong,* including
those with plain polished sides such as this example.
Wu Dacheng's identification was generally accepted
and all known *cong* were dated to the Shang (16th-
11th century BC) or Western Zhou (11th-8th century BC)
periods until recent archaeological discoveries dis-
closed the late Neolithic origins of the *cong.*

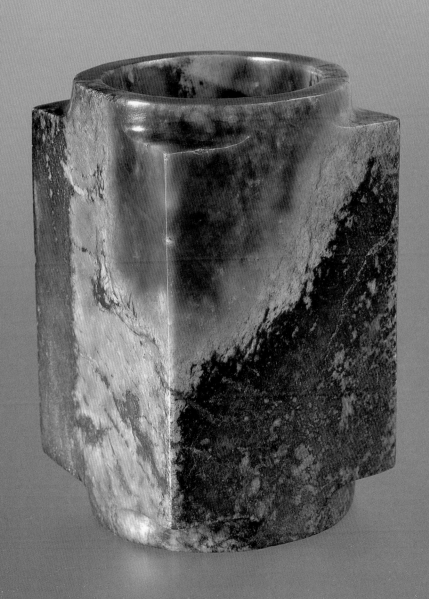

Eastern Zhou Period

76 *Slit ring* (top right)
translucent green jade
> Eastern Zhou period, first half of the 7th century BC
> diameter 4 cm
> from a French collection

77 *Pair of slit rings* (center)
completely altered jade
> Eastern Zhou period, first half of the 7th century BC
> diameter 4 cm
> from the Armand Trampitsch Collection

Slit rings –*jue* in Chinese– are among the earliest forms to have been made in jade, as documented by the finds of the pre-Hongshan culture of Chahai (Fuxin, Liaoning province) which yielded a group of small nephrite articles, including slit rings, dated to around 6000 BC.[1] Probably used as body ornaments, maybe as earrings, *jue* are also found in other Neolithic cultures of south China such as Majiabang (c. 5000-4000 BC) and Songze (c. 4000-3400 BC). After the Neolithic period they are only found sporadically until the 8th century BC, when the form seems to have gained new popularity. Slit rings were then made in pairs, with a rather thin body and only one side decorated with incised patterns of highly stylized dragon motifs. These same features are seen in the three 7th century BC *jue* presented here which can be compared to two similar pairs of slit rings in the Shanghai Museum.[2] The decoration on no. 76 is particularly interesting because the bodies of the two confronting dragon-like creatures incised on the translucent jade terminate in a bird's head. This combination of dragon and bird motifs, first seen on 10th century BC jades of the Western Zhou period, was fully developed in the elaborate pendants of the Warring States period (475-221 BC) such as nos. 102 and 104.

78 *Ring* (bottom)
completely altered jade
> Spring and Autumn period, probably 6th century BC
> diameter 3.9 cm
> from the Armand Trampitsch Collection

This small ring pendant is decorated with a motif often referred to as a "twisted rope pattern". As argued by Jessica Rawson, the ring and its decoration reproduce in jade gold ornaments made by twisting metal wires.[3] Initially borrowed from metalworking techniques, the motif remained in use throughout the Warring States period, as can be seen in nos. 100 and 113.

1 Guo Dashun 1995, pp. 47-48.
2 Reproduced on p. 21 of the guide to the "Ancient Chinese Jade Gallery" of the Shanghai Museum, published in conjunction with the reopening of the museum in 1996.
3 Rawson 1995, p. 263.

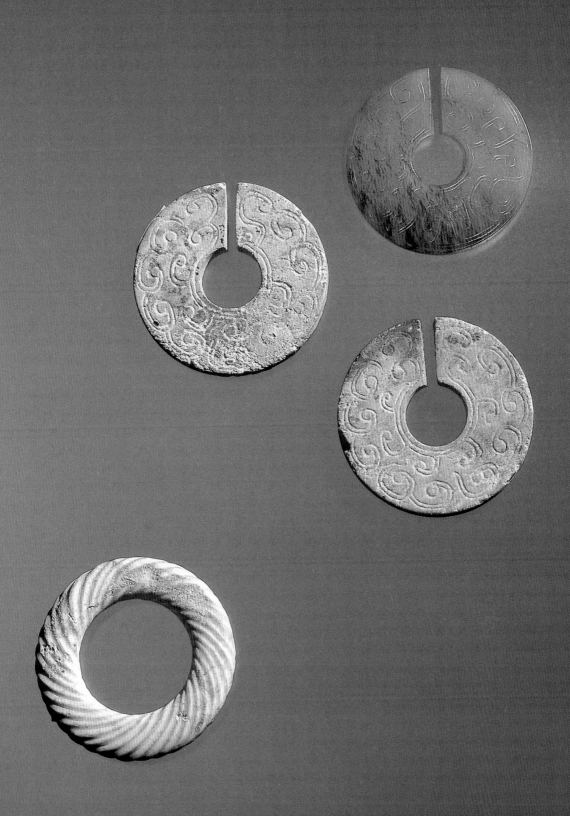

79 *Fitting* (top)

light brown jade with darker areas

Eastern Zhou period, late 6th-early 5th century BC
length 8 cm; width 2.6 cm; depth 1.8 cm; hole 2.7 x 0.9 cm

This object was probably used as a crossbow fitting, if not as the actual trigger-box inserted at the end of the wooden stock of the crossbow, the rounded side facing outward. The trigger would have been positioned vertically in the perforation and kept in place with a transversal pin passing through the small holes on the sides of the object; the arrow would have been lodged in the groove. Traces of metal incrustations near the hole support this interpretation.[1]

So far, the only comparable example is an almost identical object discovered in 1978 in a tomb at Xiquanxian (Xiasi, Henan province).[2] The practice of adding jade fittings to weapons to enhance their prestige is documented as early as the late Neolithic period through finds in Liangzhu culture sites (ca. 3300-2200 BC), although it developed real momentum during the Han dynasty (206 BC-220 AD), when fittings in jade were an almost essential feature of iron swords (see nos. 129 to 141).

80 *Ornament* (left)

pale gray-green jade with reddish-brown area

Eastern Zhou period, late 6th-early 5th century BC
length 15.2 cm; width 1 cm

This long pendant is perforated throughout its length. The surface is decorated with regularly spaced small bosses, a motif more often found carved on discs such as no. 88.

81 *Pendant* (right)

beige jade with altered areas

Eastern Zhou period, late 6th-early 5th century BC
length 11.2 cm; width 2 cm; thickness 0.8 cm

The profile of this rectangular pendant recalls the shape of a late Neolithic *cong,* with projections at the top and bottom and eight rectangular registers containing small circles comparable to the eyes carved on *cong.* The geometric motifs are actually dissolved images of stylized dragon-like creatures. The resemblance with the *cong* is probably intentional and the pendant may represent an Eastern Zhou case of archaism.

Two similar pendants were in fact discovered in a pit containing a cache of 6th-5th century BC jades and fragments of axes, *bi* and *cong* dating to the Liangzhu period. The pit is located in southern China, at Yangshan (Wuxian, Jiangsu province),[3] part of the territory controlled by the Wu state and roughly corresponding to the area where the Liangzhu culture had flourished.[4]

1 On the Chinese crossbow, see Temple 1986, pp. 218-224.
2 *Zhongguo Yuqi Quanji,* vol. 3, no. 83, p. 51.
3 Yao Qinde 1991, p. 50, figs. 8 and 9.
4 Alain Thote has shown how the face motif cast on sword guards of the 6th century BC discovered in Jiangsu, Zhejiang and Anhui provinces was derived from the mask motifs carved on Liangzhu jades (Thote 1996).

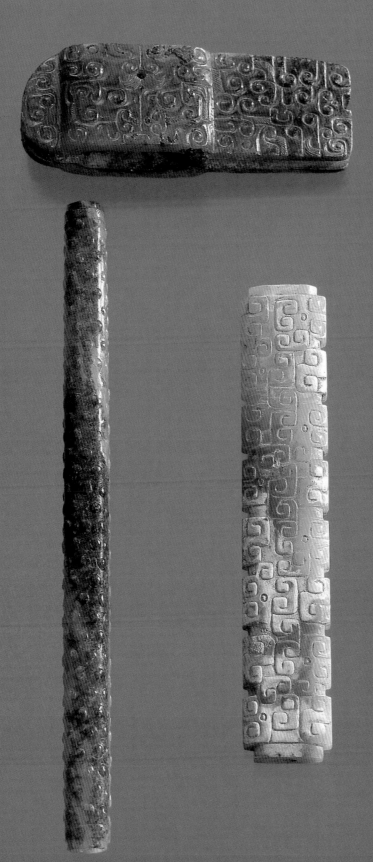

82 *Disc*
translucent pale green jade with altered areas
Eastern Zhou period, 5th century BC
diameter 11 cm; central opening 6 cm; thickness 0.4 cm

83 *Disc*
yellow-green jade with brown area
Eastern Zhou period, 5th century BC
diameter 10.8 cm; central opening 6.5 cm; thickness 0.4 cm

These finely carved discs were probably used in a funerary context. The decorative motifs used in these annular ornaments, contrary to the regular geometric patterns carved in low relief on nos. 84 to 90, are dissolved and highly stylized figures of dragon-like animals. The ring no. 82 is in fact decorated with two superimposed bands formed by the repeated pattern of heads in profile; the small circles represent the animals' eyes, while the rest of the body is transformed into small curls. This motif is derived from the interlaced dragons used in the decoration of Western Zhou jades, such as those excavated at Qucun Tianma, Shanxi province.[1] In no. 83 the animal heads are more discernible. There, they are done in two rows placed on top of each other, but are arranged in confronting pairs, forming sixteen single units within the overall design. The decoration on no. 82 can be compared to that carved on a ring in The Art Institute of Chicago.[2]

1 *Wenwu* 1995, 7, pp. 4-39.
2 Ayers and Rawson 1975, pl. 91.

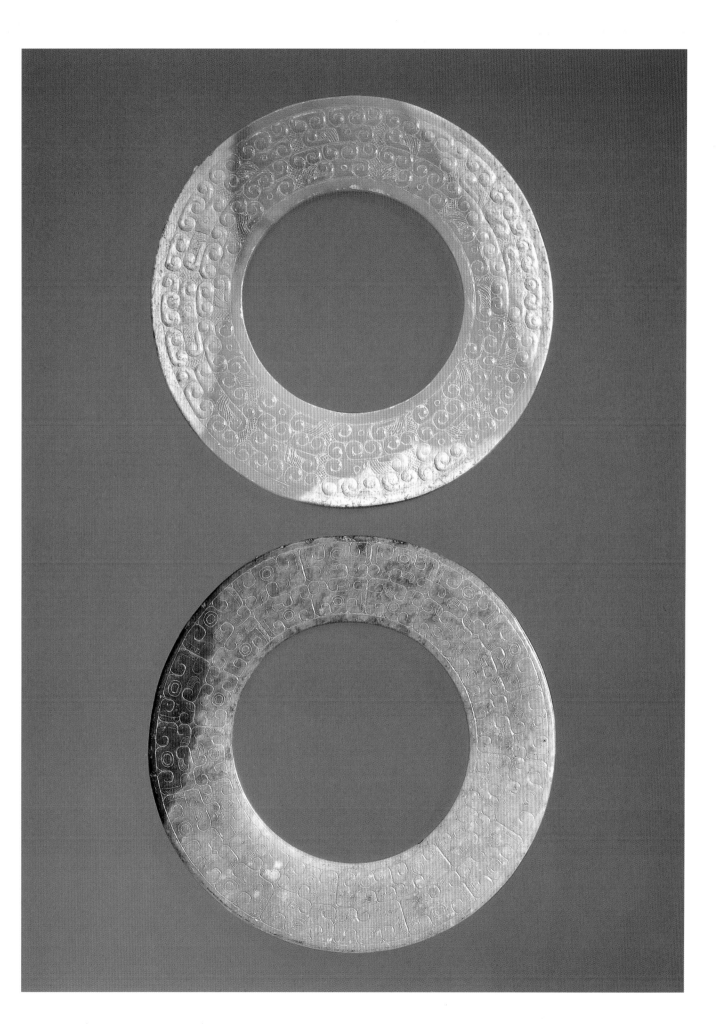

84 *Disc*
light brown jade with alteration
Eastern Zhou period, 4th century BC
diameter 14.8 cm; central opening 6 cm; thickness 0.4 cm

The jade of this disc is discolored, an alteration due to prolonged burial. The surface is simply decorated with tiny bosses, neatly spaced and aligned.

Two narrow, plain bands running along the outer perimeter and the circumference of the central opening delimit the decorated area, a scheme repeated on all discs of this type.

85 *Bi disc*
light reddish-brown marble
Eastern Zhou period, 4th century BC
diameter 14 cm; central opening 3.1 cm; thickness 0.5 cm
from the Armand Trampitsch Collection

While the other discs presented here are in jade, this one is carved using an opaque, reddish-brown marble. The surface is marked by regular intersecting lines creating a dense network of adjacent rhomboid patterns. It is possible that the disc is unfinished or that the use of stone rather than jade implied a less important burial. The way the decoration is carved illustrates one of the preliminary phases in making the regular pattern of small bosses, spirals or hexagons in relief decorating these discs. The incision of parallel, intersecting lines created the grid to mark the position of the elements which were to appear in relief after abrasion of the areas between them.

Discs in steatite and soapstone have been found in tombs of the Chu kingdom at Changsha, Hunan, in southern China,[1] although the patterns usually incised on them are more refined than in the present example.

The disc has been left inside the plastic envelope closed with sealing wax by the official French bureau which analyzed the material.

1 Fontein and Tung Wu 1973, pp. 84-85.

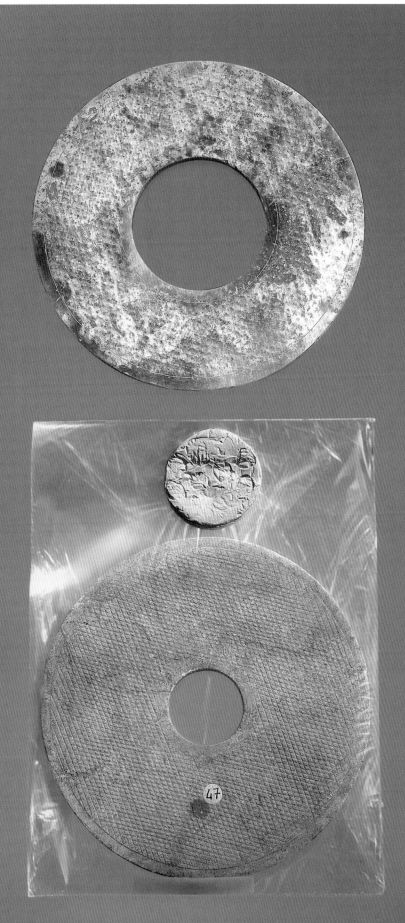

86 *Bi disc*
light green jade with alteration
 Eastern Zhou period, 4th century BC
 diameter 11.3 cm; central opening 5.9 cm; thickness 0.3 cm

87 *Bi disc*
yellow-green and brown jade
 Eastern Zhou period, 4th century BC
 diameter 19.8 cm; central opening 6.2 cm; thickness 0.4 cm

These two discs show similar patterns of small spirals
or bosses made by incising intersecting lines to create
minuscule protuberances on the surface which were
then worked to form the desired decor, often referred
to as the "grain pattern". The bosses and spirals
enhance the aesthetic effect of light on the surface
of the discs. The sense of movement and dynamism
is increased by the fact that the spirals turn in
different directions.

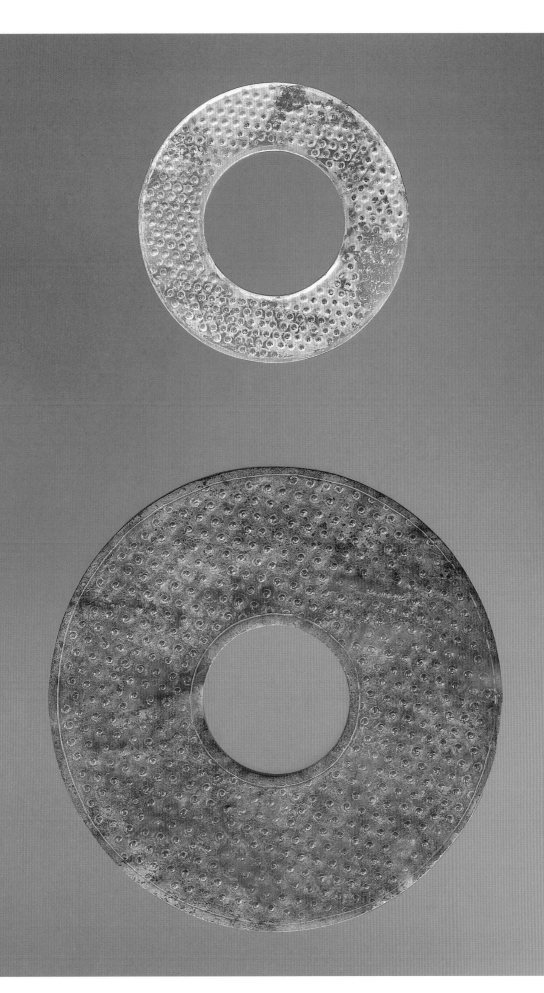

88 *Bi disc*
green jade, almost completely altered
Eastern Zhou period, 4th-3rd century BC
diameter 11.3 cm; central opening 4.2 cm; thickness 0.3 cm

89 *Disc*
green jade with alteration
Eastern Zhou period, 4th-3rd century BC
diameter 9.9 cm; central opening 6 cm; thickness 0.4 cm

90 *Bi disc*
green jade with altered areas
Eastern Zhou period, 4th-3rd century BC
diameter 16.3 cm; central opening 4.5 cm; thickness 0.4 cm

These three discs are made of a similar dark green jade, barely visible in no. 88 due to extensive deep alteration of the stone. They are carved with the same decorative pattern, small curls distributed over the whole surface. However, they differ in size and in the ratio between the width of the central perforation and the jade area, recalling similar differences seen in nos. 31 to 33.

Sets of discs of different sizes are not uncommon in tombs of the late Warring States period and the early Western Han dynasty (206 BC-9 AD), especially in southern China. Compare for example three similar discs discovered in tomb M172 at Yangzishan (Chengdu, Sichuan province).[1]

1 Lawton 1982, p. 129.

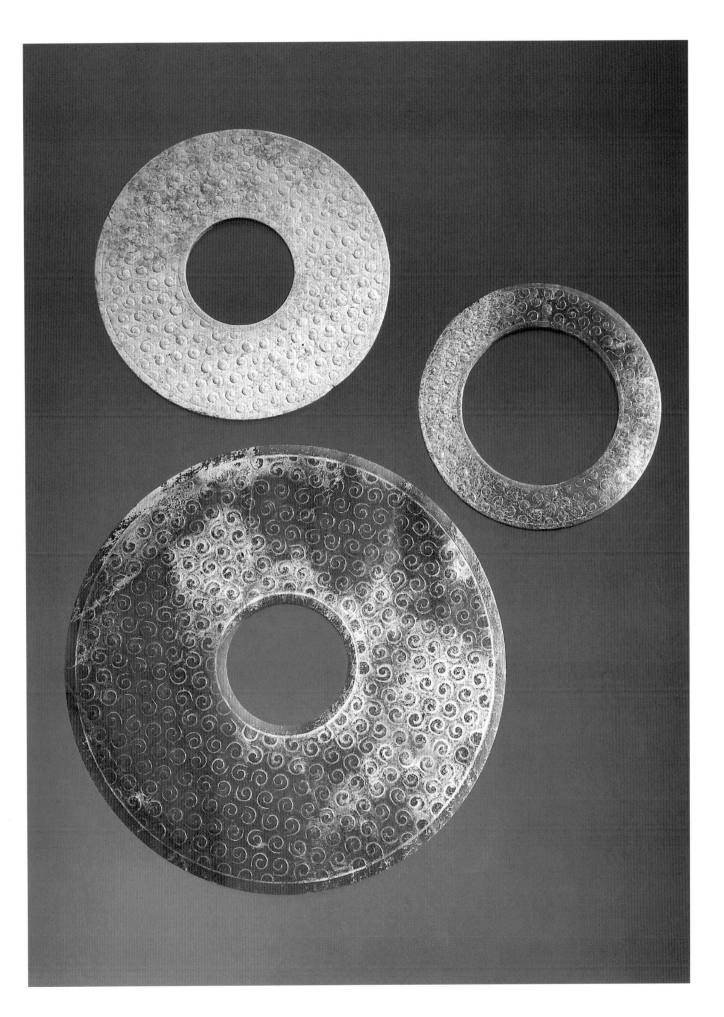

91 *Huang pendant*
dark green jade with alteration
Eastern Zhou period, 4th-3rd century BC
length 29 cm; width 4.5 cm

92 *Dragon-shaped pendant*
dark green jade with alteration
Eastern Zhou period, 4th-3rd century BC
length 13.3 cm; width 3.3 cm

93 *Dragon-shaped pendant*
dark green jade
Eastern Zhou period, 4th-3rd century BC
length 9 cm; width 6.3 cm

93A *Ring*
dark green jade
Eastern Zhou period, 4th-3rd century BC
diameter 3.2 cm; central opening 1.7 cm

The order in which these pendants are shown does not pretend to mirror the way they may have been arranged when worn during the Eastern Zhou period. However, arc-shaped pendants and small rings were quite often used together, as documented and represented on wooden funerary statuettes from Chu culture tombs in southern China and on jade figurines.[1] A set formed by two *huang*, two dragon-shaped pendants and a ring was discovered in a Chu tomb at Changtaiguan, Hunan province.[2]

The *huang* does not have the usual half-circular form typical of most pendants of this kind; instead, it has a modified V-shape with a wide angle reminiscent of a stone chime.

The two pendants in the shape of dragons belong to a well-defined group: the animals are highly stylized, represented in profile with volutes and small appendages extending from their bodies, their heads sometimes turned backward. The decoration of these pieces is in low relief or incised, as in these pendants. The somewhat coarse workmanship is another recurrent characteristic. Although it has been suggested that this particular type of dragon may have been created in southern China,[3] similarly shaped pendants have been excavated from sites in Shanxi, Shandong, Henan and Hebei provinces.

The two perforations at the right and left bottom corners of the pendant no. 92 indicate that other elements, probably small beads, might have been hung from it.

1 Sun Qingwei 1996, p. 90, figs. 5-6; Sun Ji 1998, p. 9, fig. 5: 1-3.
2 Reproduced in Hansford 1968, pl. 29c.
3 Fontein and Tung Wu 1973, p. 86.

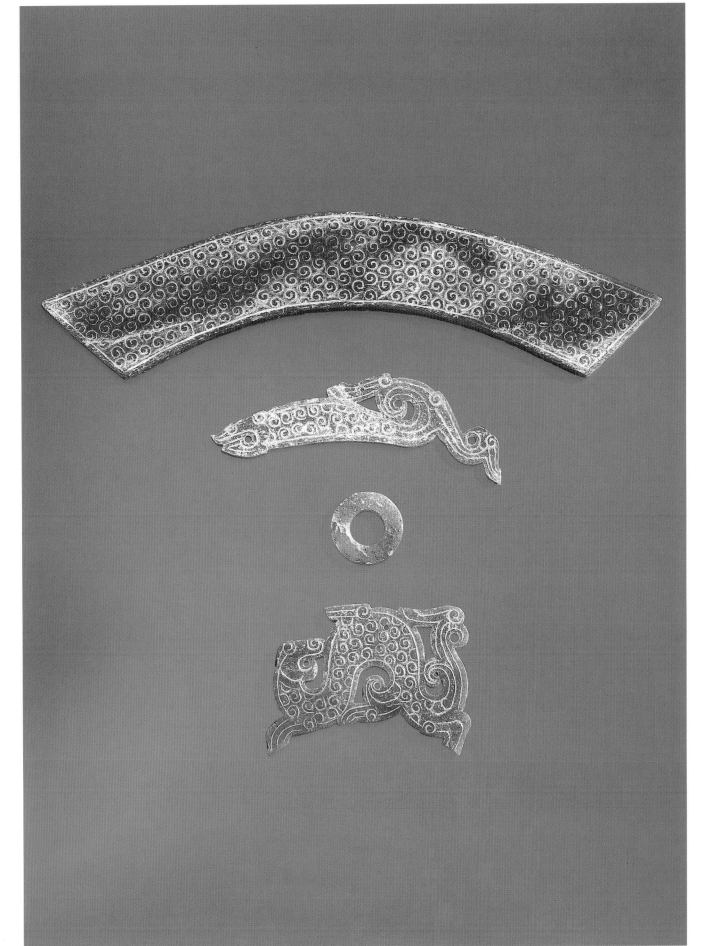

94 *Dragon-shaped pendant*
dark green jade with altered areas
Eastern Zhou period, 4th-3rd century BC
length 20.4 cm; width 2 cm

95 *Dragon-shaped pendant*
translucent green jade with traces of alteration
Eastern Zhou period, 4th-3rd century BC
length 12.7 cm; width 1.8 cm

96 *Dragon-shaped pendant*
green jade with rust incrustation
Eastern Zhou period, 4th-3rd century BC
length 9 cm; height 4.8 cm

These pendants show other ways of representing the body of dragons frequently seen in Eastern Zhou art (for another form, see the S-shape used in nos. 97 and 98). The dragons in nos. 94 and 95 have elongated bodies and undulating profiles terminating abruptly in flat, almost truncated, tails. When suspended, these ornaments would have oscillated gracefully, increasing the sense of movement inherent in the dynamic outline of the pendants. The shape is already documented in the Spring and Autumn period: compare, for example, pendants in rock-crystal, part of pectorals discovered at Lanjiazhuang, Linzi, Shandong province.[1]

No. 96 differs from the previous two examples, not only by virtue of its inward curved body and the head facing backward toward the bifurcated tail, but also because it has four small fin or wing-like appendages. It may well be that these iconographic differences had some meaning, that they served to distinguish different types of dragon-like creatures within a hierarchy of more or less important mythical animals.

The rusty areas on some parts of the jade, particularly on the snout of the dragon and on one of its fins, and the traces of iron incrustation near the tail, indicate that the object was probably mounted on metal. The combination of metal and jade is frequently seen on Eastern Zhou period belt-hooks, whose fine workmanship and precious materials reflected the status of the owner.[2]

1 Reproduced in Corradini 1993, p. 89, no. 38.
2 A similar dragon mounted on a metal belt-hook is reproduced in Ayers and Rawson 1975.

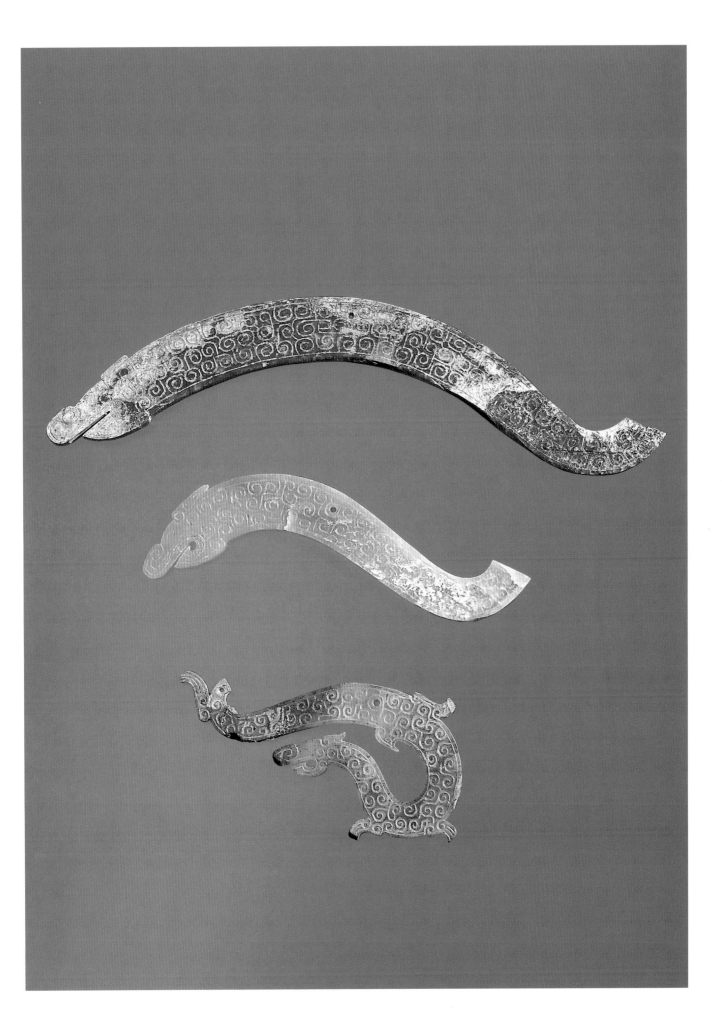

97 *Dragon-shaped pendant*
translucent yellow jade
Eastern Zhou period, 4th-3rd century BC
length 10.4 cm; width 4.8 cm

98 *Dragon-shaped pendant*
translucent white jade with brown areas
Eastern Zhou period, 4th-3rd century BC
length 7.3 cm; width 4.8 cm

The bodies of these dragon-like animals are presented in an S-shape, which can be considered as a compressed form of nos. 94 and 95. The fin or wing-like appendages are more pronounced and, in no. 97, have been transformed into hooked protuberances, similar to the tails of the animals. The bodies are adorned with small curls, incised in no. 98 and in low relief on no. 97. In these pendants, the decoration has become a comma-like spiral motif. The jade material is completely different in color and translucency from the green jade used to carve many such pendants (see nos. 92 to 96); it is closer to the material used to make the pendants nos. 102 and 103. The three perforations on no. 98 suggest that the object was affixed to something else. A group of similar pendants, though in green jade, excavated from Eastern Zhou tombs at Luoyang, Henan province, can be considered for comparison with the shape of the pieces presented here.[1]

1 *Wenwu* 1995, 8, p. 15.

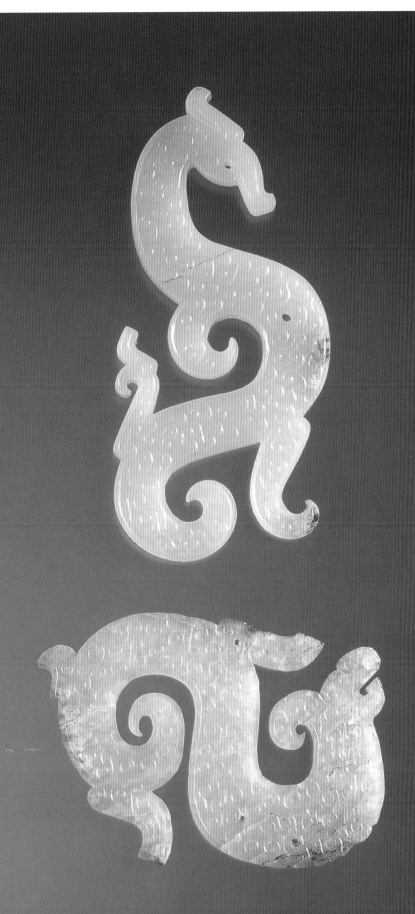

99 *Belt ornament*
grayish jade with dark areas
Eastern Zhou period, 5th century BC
length 9 cm; width 6.6 cm

During the Eastern Zhou period, personal ornaments in jade included belt accessories such as belt-hooks, girdles and pendants to be hung at the waist, similar to the one presented here. Adding ornamental elements to belts was a practice derived from the nomadic people of the regions north of China,[1] but the preference for jade is unmistakably Chinese.

Two intersecting bands divide the surface of this ornament into four sections, each decorated in openwork with dragon or snake-like creatures. A similar ornament, with the four sections filled with spiral motifs in low relief, was discovered in 1988 at Jinshengcun (Taiyuan, Shanxi province).[2] Similar oval-shaped elements are part of the girdle in jade excavated from the tomb of Marquis Yi of Zeng at Huixian (Leigudun, Hunan).[3] It is possible that this type of oval-shaped ornament, given its sporadic occurrence in the archaeological records, was one of the occasional replicas in jade of similar objects made in other materials. It is interesting to note that the same type of ornament, made in gold, is found in 5th-6th century Korean princely belts.[4]

100 *Ornament*
pale ivory-colored jade with alteration
Eastern Zhou period, 5th-4th century BC
length 6.1 cm; width 0.5 cm

The small perforation drilled in the central, rectangular section suggests that this curious object was a pendant or ornament. The pointed edge at one of the extremities brings it close to the category known by the Chinese name *xi*. The dragon's head with feline features carved at one extremity can be compared stylistically to a number of Eastern Zhou jades now in the Freer Gallery of Art, including *xi* pendants of similar length.[5]

1 See So 1997 for the origin and evolution of the ornamented belt in China.
2 *Zhongguo Yuqi Quanji*, vol. 3, no. 41.
3 Hubei 1988, figs. 23-24.
4 Goepper 1999, p. 180, no. 27.
5 Lawton 1982, p. 138, nos. 81 and 82.

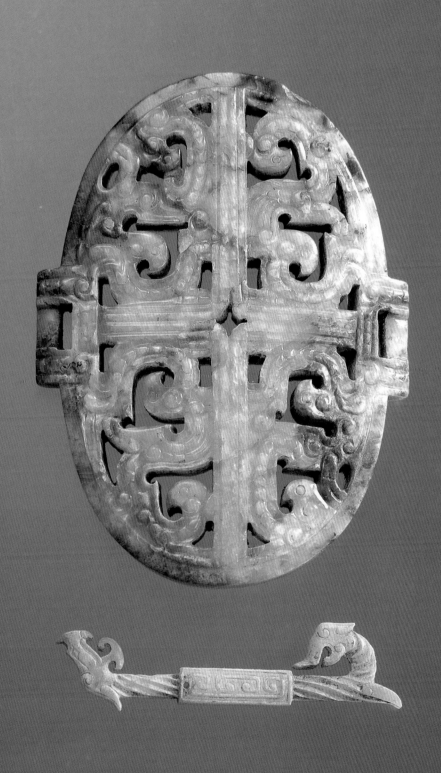

101 *Openwork disc*

translucent green jade with brown areas

Eastern Zhou period, 4th century BC
diameter 8.1 cm; central opening 3.1 cm

The decoration on this disc differs in the two areas into which the object is divided. The outer, solid ring is covered with a variation of the spiral motifs seen on many discs of the period, while the inner area is decorated in openwork with six highly stylized figures of animals. A careful reading reveals that the animals are two pairs of confronting dragons with their heads turned back toward a bird in a similar attitude placed between them. The disc can be compared to one in the Fogg Art Museum, although in the Fogg disc the animals are more clearly delineated and encircle in turn a smaller, inner ring.[1]

Discs with openwork decoration form a minor but interesting category among jades made in the latter part of the Eastern Zhou period. The cutout decoration gives a sense of lightness to the disc, which was probably combined with other jades to form a pectoral. It can be seen as an intermediate stage between discs having their surfaces decorated with stylized dragon heads (nos. 82 and 83) and discs in which dragons and phoenixes take on a much clearer shape and are more precisely carved (see no. 102).

1 Loehr and Huber 1975, p. 270, pl. 397.

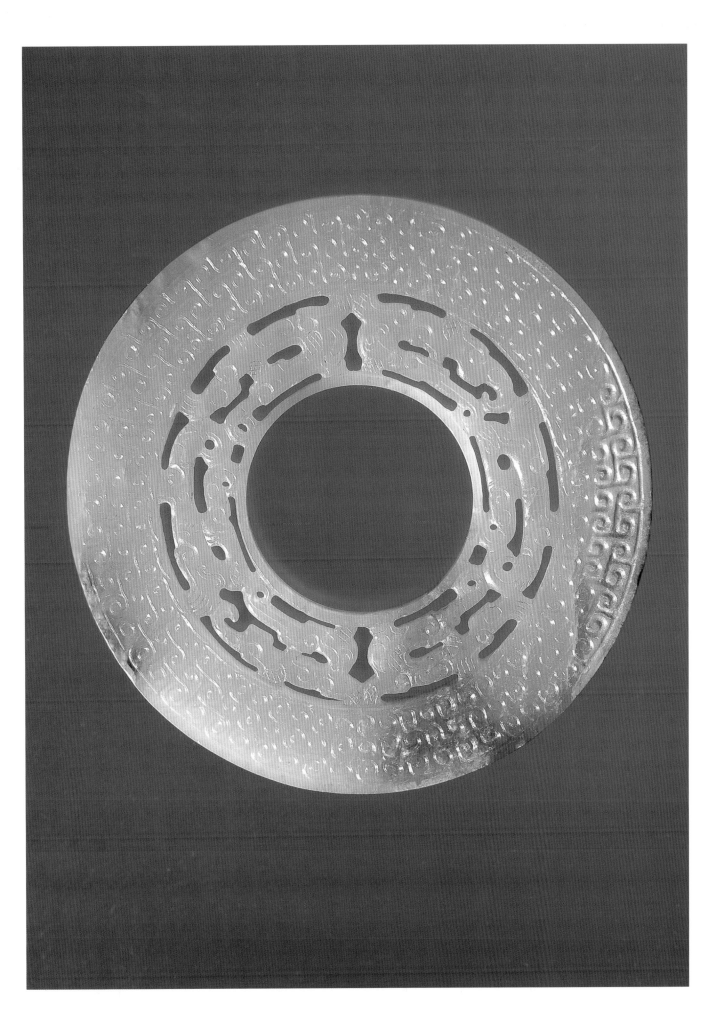

102 *Openwork disc*
translucent yellow jade with some alteration
Eastern Zhou period, 4th century BC
length 8 cm; width 5.3 cm

Organized in and around a disc, this pendant shows an encircled rampant beast with dragon-like features flanked on the outside by two phoenixes. The decorative motifs are basically the same as those in no. 101, but here they are arranged in a totally different manner, and the design is much more powerful and finely worked. The beast occupies the central position while the phoenixes are outside the disc, playing an ancillary role, suggesting a hierarchical disposition.

The almost heraldic arrangement of this pendant echoes similar excavated examples based on the same compositional principle. Ornaments in the form of discs supported by phoenixes with, in one case, an openwork dragon inside the ring, were elements in a jade pectoral discovered in the tomb of the King of Nanyue.[1]

103 *Arc-shaped openwork pendant*
translucent white jade with brown area
Eastern Zhou period, 4th century BC
length 9.3 cm; width 2.1 cm

This symmetrically designed pendant is formed by two intersecting dragons whose bodies and heads recall nos. 94 and 95. However, in this case a snake is incised over the dragons' bodies, in a manner similar to that on an ornament discovered in the 4th century BC tomb of King of Cuo of the Zhongshan state at Pingshan, Hebei province.[2]

104 *Pendant*
green jade with altered area
Eastern Zhou period, 4th century BC
length 8.8 cm; width 2.1 cm

When compared to the previous two pendants, this one has a less formal composition, but an equally strong and elegant design. As in no. 103, the pendant is formed by the body of the dragon which merges into that of a phoenix, whose long ornate tail partly covers the dragon's body. The pendant can be compared to a similar one from a tomb at Yanggong, Changfeng, in Anhui province.[3] Details such as the geometric motifs incised on the body of the dragon and the feline features of the head of the animal match elements seen on jades in the Freer Gallery of Art said to have been discovered at Jincun, Luoyang.[4]

1 Lam 1991, figs. 2 and 2a.
2 *Zhongguo Yuqi Quanji,* vol. 3, no. 217.
3 *Zhongguo Yuqi Quanji,* vol. 3, no. 289.
4 Compare the sort of flower carved on this dragon with a similar motif on a jade pendant illustrated in Lawton 1982, p. 137.

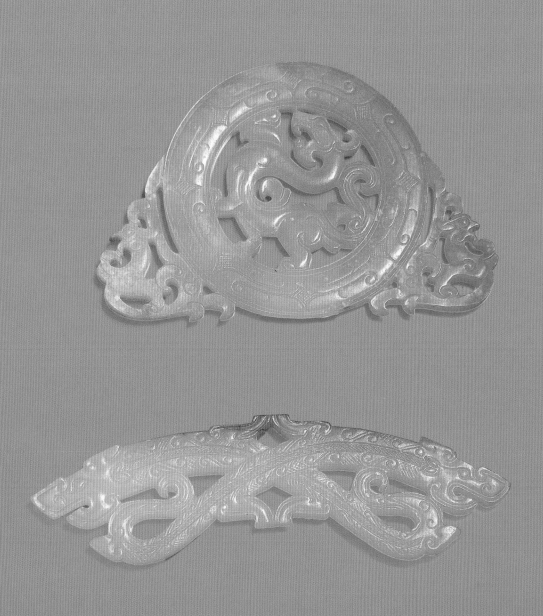
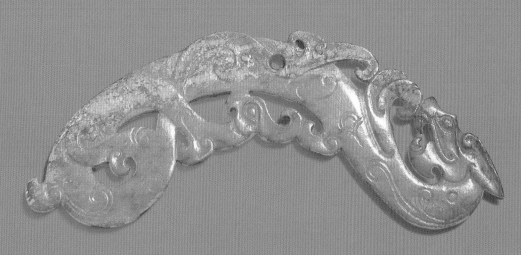

105 *Pendant*

yellow-brown jade with dark areas

Eastern Zhou period, 3rd century BC
length 10.7 cm; width 4 cm

This finely carved pendant has extensive traces of earth and the red cinnabar powder which was spread abundantly over the body and burial goods according to Chinese practices documented from at least the Shang period.

Although elaborate and flamboyant, the pendant has a clearly recognizable shape which is common to all jades of this kind (see nos. 103, 106 and 107). It is basically an arc-shaped pendant, *huang,* whose original, geometric aspect is visible in the central portion, decorated with small incised and interconnected T-patterns with curled ends. The extremities are carved in the form of crested and horned dragons' heads, while curvilinear openwork patterns run along the borders. The design is perfectly symmetrical, divided into mirror images with an imaginary line running vertically through the middle. The suspension hole is positioned in the center at the top of the pendant. It has a bell-shaped profile similar to that of a pendant in the Freer Gallery of Art said to come from Anhui province.[1]

Elaborate pendants of this kind are also called *heng,* a traditional term given to the jade positioned at the top of complex pectorals and hence one of the most important elements of the whole group, since its workmanship and iconography signalled the status of its owner.[2]

1 Lawton 1982, p. 144, no. 90.
2 See Sun Ji 1998 for a discussion of these pendants.

106 *Pendant*
translucent whitish jade with brown veins and rust-like areas
Eastern Zhou period, 3rd century BC
length 10.7 cm; width 3.4 cm

The quality of the carving and the elaborate decoration suggest that this pendant was a *heng,* the most important element in a pectoral. It exhibits many of the characteristics of no. **105.** In fact, the design is still based on the *huang* or arc-shaped pendant terminating in two dragon profiles, although in this case the animals have their heads turned backward. Above and below the arc, symmetrical abstract openwork patterns suggest confronting birds or animals.

Creating this ornament required a laborious process advancing through different stages. The design of the pendant was first outlined on the stone, and then accurately positioned holes were drilled in strategic points which defined the pattern of the motifs. These holes can be discerned here in the several curling motifs – at the top of the ornament, in the snouts of the dragons and in the openwork pattern at the bottom. Hollowed areas were then created by enlarging the spaces moving from the holes and then the contours were smoothed, "perhaps with drills and bow-drawn wires of bronze or iron. Hair-fine surface details were likely incised with the edges of thin, nail-like rotary tools." [1]

1 Pearlstein 1999, p. 110.

107 *Openwork pendant*

bluish-gray jade with white specks

Eastern Zhou period, 3rd century BC

length 12.5 cm; width 4 cm

The carved openwork of this pendant is basically the same as that in no. 106 – two confronting dragons' heads share the same arc-shaped body edged with flamboyant curling elements. However, this pendant has a totally plain undecorated surface: if not for the silhouette and the clearly outlined profiles of the dragons' heads, it would be almost impossible to recognize the motif. This makes the piece look unfinished, as if the artisan had left the work after having reached the stage, described in no. 106, of refining the cut-out spaces without adding decorative embellishments.

Several plain ornaments and pendants of this kind have been excavated in Eastern Zhou and early Western Han tombs,[1] but it is difficult to understand why these objects were left unfinished. Perhaps the persons for whom the ornaments were made died prematurely, although it is possible that, if these ornaments were specifically made as burial goods and not meant to be worn, it may have seemed unnecessary to add the surface decoration.

1 *Wenwu* 1995, 8, p. 16, fig. 17: 1; *Zhongguo Yuqi Quanji,* vol. 3, nos. 185 and 217 for examples belonging to the Eastern Zhou period; *Wenwu Ziliao Congkan,* 9, 1985, pl. II: 1, 3 and 5; *Zhongguo Yuqi Quanji,* vol. 4, pls. 199-201 and 215 for similar plain pendants and ornaments dating to the Western Han dynasty.

108 *Animal plaque*
translucent pale celadon green jade
late Eastern Zhou period, 4th-3rd century BC
length 22 cm; height 14.5 cm; thickness 0.5 cm
from the Charles Vignier Collection

This truly magnificent large plaque in the form of a mythical animal can be taken as representing one of the highest peaks reached in jade art in the late Eastern Zhou period. One of the most striking characteristics is the combination of different, apparently contrasting features which merge in a harmonious synthesis. The large size of the plaque and the attitude and anatomy of the animal – head down, almost in a compressed posture revealing the strength of its body – are counterbalanced by the lightness and transparency of the stone (not disturbed by the brown inclusions on the border, the skin of the block of jade) and by the gentle, undulating profile of the back or the almost baroque curls of the feet and mane. This sense of lightness is further enhanced by the fine parallel lines stressing details of the design, and by the motifs of birds and dragon-like creatures incised on both sides of the plaque, on the haunches and forelegs of the animal, possessing almost a painterly quality, recalling thin brushstrokes. The dense, though regular, arrangement of small bosses on the body of the animal provides a contrasting, geometric effect which harmonizes with the overall design.

This plaque stands at the end of a long line of development of tiger-shaped pendants[1] and although the animal depicted might recall a tiger, its mythical, non-realistic nature is stressed by the combination of all the elements mentioned above. Even the animals incised on the surface of the jade have disproportionate geometric elongated bodies, recalling similar otherworldly creatures woven on textiles of the period.[2]

Several plaques of this kind are known, but the closest is a pair in the Freer Gallery of Art reputed to come from the famed Jincun tombs, near Luoyang, Henan province.[3] The animal in this plaque is missing part of its tail. Apart from this, the quality of the design, the craftsmanship, the iconography, the animal motifs incised on the surfaces and even small details such as the sort of flower carved on the tail of the animal on this plaque are similar to those in the Freer Gallery, making it possible to theorize the same provenance, if not the same workshop, for all these outstanding jades.

1 Rawson 1995, pp. 259 and 262.
2 Such as those on the textiles from Mashan, Jiangling, Hubei province (Yang Xiaoneng 1999, pp. 323-324, no. 112).
3 Lawton 1982, pp. 149-150, no. 96.

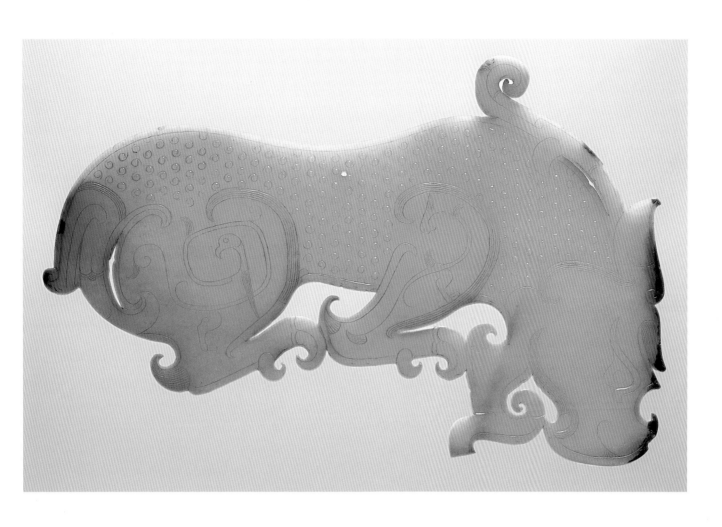

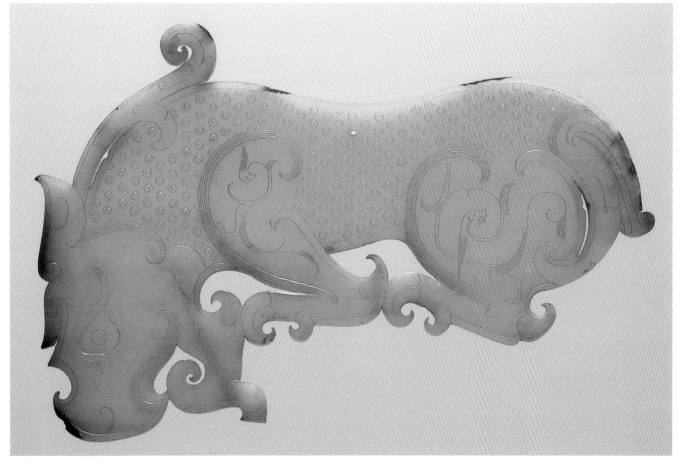

109 *Huang pendant* (top)
translucent pale celadon jade
Eastern Zhou period, 4th-3rd century BC
length 3.9 cm; width 1 cm
from a French collection

110 *Pendant*
celadon green jade with altered areas
Eastern Zhou period, 4th-3rd century BC
length 6.2 cm; width 3.7 cm

111 *Huang pendant*
russet jade with altered areas
Eastern Zhou period, 4th-3rd century BC
length 7.4 cm; width 1.2 cm

112 *Pendant* (left)
light green jade with alteration
Eastern Zhou period, 4th-3rd century BC
length 7.4 cm; width 2 cm

113 *Pendant* (right)
pale green jade with brown and altered areas
Eastern Zhou period, 4th-3rd century BC
length 8.3 cm; width 1.5 cm

Nos. 109 and 111 are miniature *huang* or arc-shaped ornaments carved in the shape of dragons. They follow, on a smaller scale, the same compositional principle as no. 105, with the two extremities of the pendants ending in dragons' heads. However, while in no. 109 the body is decorated with regular, interconnected scroll patterns,[1] the curved striations incised on no. 111 suggest the skin of a tiger and feline traits are discernible in the face of the animal.

The dragon in no. 113 has the body and tail worked with parallel, twisted grooves: these are derived from the rope pattern seen on the ring pendant no. 78 and in turn anticipate the treatment of the tail of the Western Han dragons in nos. 139 to 143. A similar pendant is in the British Museum,[2] although that dragon has a more elongated head and lacks the slightly upturned tail of the example presented here. The design in the openwork pendant no. 112 shows again the combination of the dragon and the phoenix motifs seen on other jades (as in nos. 102 and 104). In this object, the awkward tail of the dragon indicates that the piece was carved from half a section of a jade ring. Finally, the ornate crest, the outline of the jaws and the tuft of hair near the mouth in no. 110 are features shared by the dragon-like creatures on nos. 105 and 108. This piece can be compared to a similar one in the British Museum.[3]

1 Compare a similar but slightly bigger pendant discovered in an Eastern Zhou period tomb at Xinzhou (Lixian, Hunan province) reproduced in *Kaogu* 1988, 5, p. 430, fig. 4: 4.
2 Ayers and Rawson 1975, no. 127.
3 Ayers and Rawson 1975, no. 138.

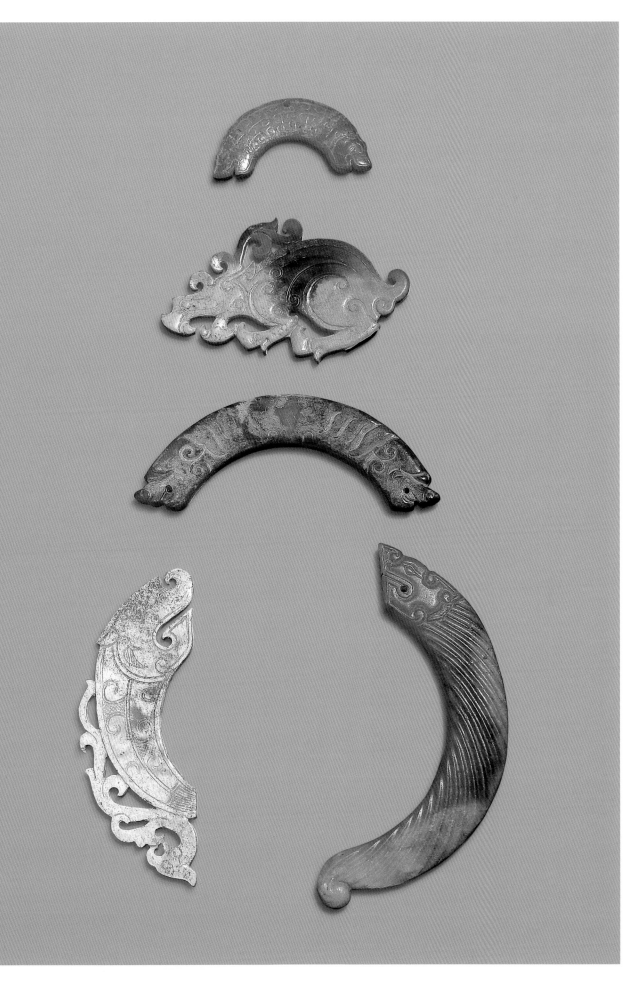

114 *Zoomorphic pendant* (top left)
green jade with brown inclusions
 Eastern Zhou period, 5th-3rd century BC
 height 4.7 cm; width 4.6 cm
 from an English collection

115 *Zoomorphic plaque* (bottom left)
light green jade with inclusions
 Eastern Zhou period, 5th-3rd century BC
 width 5.4 cm; thickness 0.3 cm

116 *Zoomorphic pendant* (right)
light brown jade
 Eastern Zhou period, 5th-3rd century BC
 lengh 3.9 cm; height 2.3 cm

The three jades in this plate all share stylistic and ico-nographic features which bring them close to the art of the nomadic peoples who inhabited the territories north of China. More exactly, they can be regarded as jade versions of artifacts made in metal,[1] adaptations of foreign forms to the Chinese cultural context, as noted for the belt accessories (see no. 99). In the absence of any information, it is hard however to determine if these objects in jade retained the original function of their metal prototypes or if they were used differently: the small holes in nos. 114 and 116 suggest, for example, that these jades were probably used as ornamental pendants.

No. 115, which is shaped like an animal whose body forms a circle, reproduces a form of openwork plaque in metal used as a decorative element of horse harnesses.[2] The animal carved on this jade can be regarded as a variation of the Chinese dragon: its head displays features seen on other artifacts influenced by the art of the steppe.[3] The representation of the animal in no. 114 follows basically the same scheme, although the head does not touch the tail, as in the previous example.

No. 116 was probably used, with a number of similar small plaques, to decorate clothing or a leather belt. The crouching feline has the annular, clawed feet typical of steppe animal art; the bevelled decoration also suggests the influence of carving techniques prevalent in working wood.[4]

Both nos. 114 and 116 are similar to jades in the Royal Ontario Museum, Toronto, said to have been discovered at Jincun, Luoyang, Henan province.[5]

1 Rawson 1995, pp. 308-311.
2 As for example the 6th-4th century BC plaque from Besoba, Aktjube, western Kazakhstan (Popescu, Silvi Antonini and Baipakov 1998, p. 149, no. 186). See also the same scheme in contemporary Scythian gold plaques representing coiled felines, probably snow leopards native of Siberia: Watson 1971, pl. 74.
3 Hájek and Kesner 1990, p. 228, fig. 121.
4 Such as the objects excavated from the Pazyryk tombs. See Hermitage and British Museum 1978, nos. 59, 60, 76, 78, 97.
5 Hansford 1968, pls. 37a and 37b.

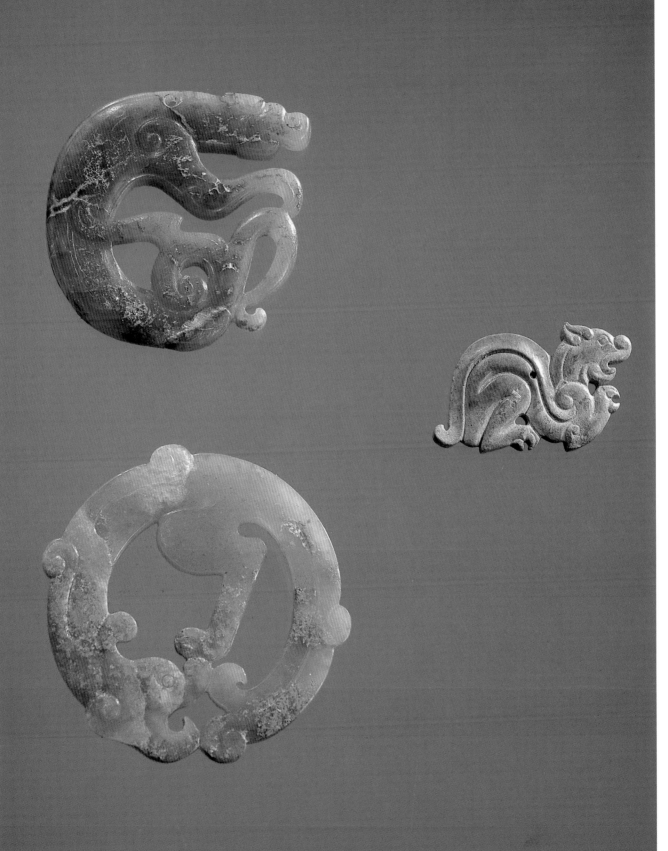

Eastern Zhou and Western Han Period

117 *Ornaments*
ivory-colored jade

late Eastern Zhou, early Western Han period, 3rd-1st century BC
from top to bottom: height 3.6, 4.5, 4.7, 5 cm; width 0.8, 1.1, 1, 1.1 cm

This group of ornaments comprises four similar thin, slit rings of decreasing size characterized by a large, eccentric hole and two small perforations at the extremities. The shape recalls that of the *jue* slit rings (see nos. 76 and 77), but here the central opening is much larger and off-center, giving the bodies of the objects varying width. This type of ornament is occasionally documented in finds of the Neolithic period, such as a ring discovered at Nanjing, Jiangsu province,[1] but it is only from the Warring States period (475-221 BC) that it appears more regularly in archaeological records. Its diffusion is limited to south-east China and to Yunnan province in particular, attesting to a local preference for a shape which did not enter the main repertory of Chinese forms.

The small holes suggest that these ornaments were strung together in a vertical row, arranged according to their diminishing size, in a manner similar to the disposition shown in the photograph. Two such sets, each formed by fourteen rings, have been discovered in tomb M13:15 of the Shizhaishan cemetery of the Dian culture (Jinning, Yunnan province, c. 150 - 50 BC): they are believed to have been worn as long pendants hung from the ears.[2] That these ornaments were used as earrings by the Dian people is documented in some bronze figurines belonging to this southern culture, showing also that the slit in the ring was used to secure the ornament to the earlobes.[3] Such earrings would have lacked the small perforations, exactly like the rings of this type discovered in tomb M10:7 of the Gejiu Shiliuba site, Yunnan, dated to the Warring States period.[4]

1 Watson 1973, pp. 55-56, no. 50.
2 Ciarla and Lanciotti 1987, pp. 92-93, no. 52. Compare also a pair of similar ornaments in the Kwan collection reproduced in Yang Boda 1994, no. 238.
3 Ciarla and Lanciotti 1987, p. 43, no. 3.
4 *Kaogu* 1992, 2, p. 134, fig. 6:3.

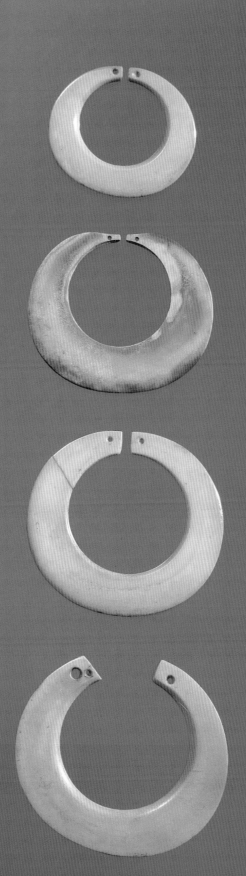

118 *Discs and beads*
shades of turquoise with inclusions
late Eastern Zhou, early Western Han period, 3rd-2nd century BC
diameter 1.6 cm to 4.2 cm

Jade has indisputably played the major role in the lapidary tradition of China, but the Chinese have manifested interest, in all periods, in other hard-stones such as turquoise, carnelian, agate, malachite, soapstone, chalcedony and many others.[1] The majority of these stones were exploited only during the later dynasties, while their use in ancient China, in the long period spanning the Neolithic to the Tang dynasty (618-907 AD), is erratic and subject to cultural factors as well as to the availability of raw materials. This emerges from analysis of archaeological data which offer, as far as the ancient periods are concerned, evidence to reconstruct the use and diffusion in China of each type of stone. However, the detailed story of the majority of these stones has still to be written.[2] An exception is turquoise; its relatively extensive use in ancient China, mostly as an inlaid material, is fairly well known and documented thanks to recent studies.[3]

This group of discs and beads illustrates the use of turquoise in ancient China to fashion elements for necklaces or other ornaments. The small discs of varying sizes and purity (only the top one on the left and some of the beads of the necklace do not contain inclusions) have a slightly cushion-like form and look something like miniature *bi* discs. The discs and the necklace composed of round beads of equal size may have come from southern China, where the use of turquoise and malachite reflect a strong local preference documented by archeological discoveries.[4]

1 For a brief overview of hardstones in China, see Soame Jenyns 1982, pp. 185 and 192.
2 It is interesting to note that Berthold Laufer, the scholar to whom we owe the first thorough study of Chinese jades in a Western language (Laufer 1912), was also the author of two seminal studies devoted to the use of turquoise and agate in China (Laufer 1913; Laufer and Farrington 1927).
3 On the presence of turquoise in finds from the Neolithic to the early Bronze Age in China, see Salviati (forthcoming).
4 In Yunnan province, for example, the Dian culture manufactured many bronze artifacts decorated with tiny fragments of malachite obtained by slicing tubular beads. See Ciarla and Lanciotti 1987, nos. 20, 47 and 50.

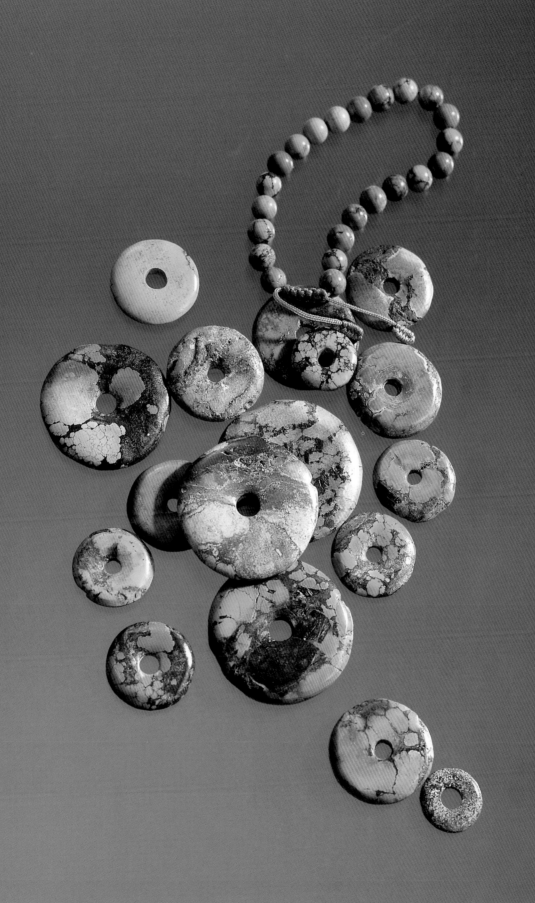

119 *Figure of a female dancer*
translucent light green jade

late Eastern Zhou, early Western Han period, 3rd-2nd century BC
height 9.3 cm; width 3.2 cm

Music has always played an important role in the court rituals of ancient China. This is especially true in the Eastern Zhou period, when entire sets of instruments were placed in tombs of aristocrats as part of the burial goods.[1] Thus it is not surprising if representations of dancers occur with a certain frequency in the jades of the Warring States period (475-221 BC), anticipating what will become a popular subject in the funerary art of the Han (206 BC-220 AD) and Tang (618-907 AD) periods, when figures of dancers, musicians and performers were customarily molded in terracotta and placed in tombs.[2]

This delicate pendant representing a female dancer performing a "long sleeve dance"[3] is carved out of a thin section of translucent light green jade. The expression on her face reveals the performer's absorption in the dance. She is elegantly dressed in the typical Chinese robe with long, full sleeves. Her body is slightly turned in an attitude suggesting the movement of the dance. The position of the arms, one held over the head and the other bent and passing in front of the waist, and the long hair tied in the back of the figurine, are features found in other examples of dancing figures, such as those of the 5th-4th century BC in the Freer Gallery of Art, said to have been unearthed at Jincun (Luoyang, Henan province).[4] Other recurrent features include the fine treatment of details, from the face to the folds of the robe, and the small tab below the robe, indicating that the jade was originally attached to another ornament, since these exquisite pendants were probably part of elaborate jade pectorals. See a similar plaque from the Arthur M. Sackler Collection sold at Christie's New York on December 1, 1994.[5]

1 See So 2000 for an analysis of the musical instruments discovered in the 5th century BC tomb of the Marquis Yi of Zeng at Suizhou, Hubei province.
2 It is worth remembering the extraordinary discovery of two well preserved reliefs in painted marble portraying two ensembles of musicians placed in the 10th century AD tomb of Wang Chuzhi at Xiyanchuan, Quyang, Hebei province (Yang Xiaoneng 1999, pp. 506-513, nos. 174-175).
3 On this dance and on the representation of dancers in Han art, see Fu Xueyou 1994.
4 Lawton 1982, pp. 132-136, nos. 77-79.
5 Christie's, December 1, 1994 catalogue, no. 116.

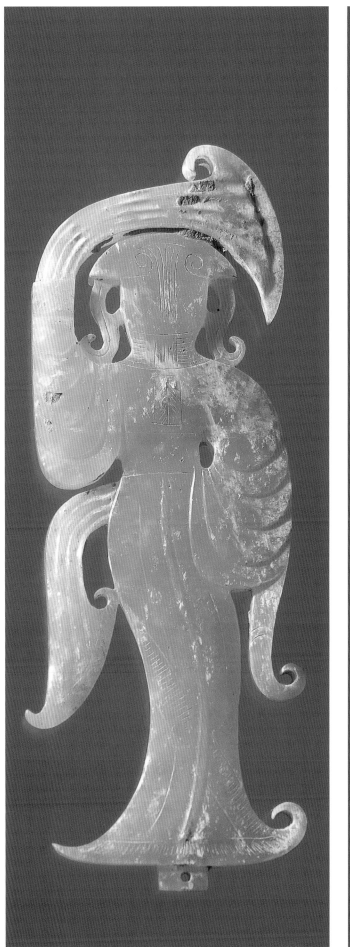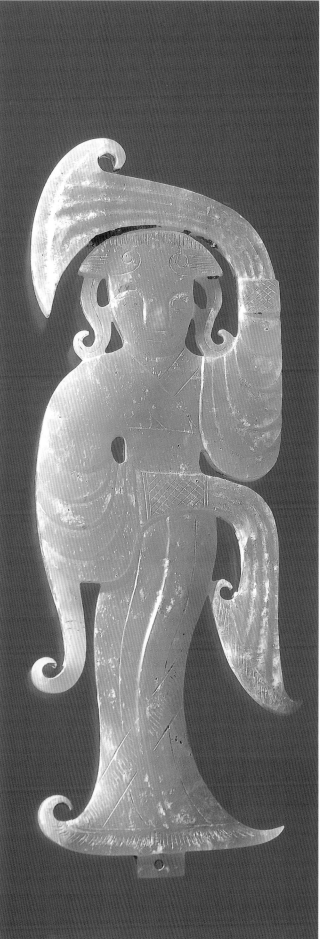

120 *Bi disc*

dark green jade with rust incrustations

late Eastern Zhou, Western Han period, 3rd century BC-1st century AD

diameter 18.9 cm; central opening 3.2-3.4 cm

This disc exemplifies the last of a series of transformations which, over the centuries, affected the form of the *bi* disc from the time this type of object originated in the Neolithic period. In this version, the disc unites two different Eastern Zhou traditions of decorating the surfaces of *bi:* the abstract patterns made of small bosses and animal motifs.

In this example, the bosses have become tiny faceted bumps on a hexagonal base, produced by cutting regularly spaced and intersecting lines in a manner similar that of no. 85. The geometric decoration is limited to the inner area of the disc, which is in turn encircled by a wide band incised with a motif of bovine heads with long, sinuous horns. Repeated three times, this decor derives from the tradition of carving discs with images of animals, often highly stylized as in nos. 82 and 83. An example close to this one, in which the two patterns are combined, is represented by the openwork disc no. 101.[1]

1 On this type of disc and on its decoration, see Rawson 1995, pp. 253-256, no. 15: 4.

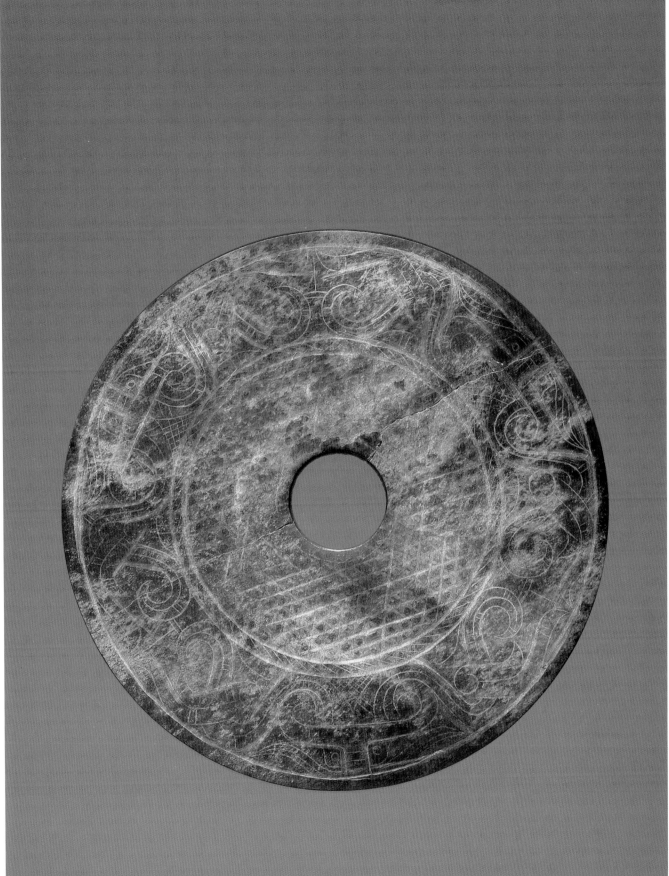

Western Han Period

121 *Funerary vest*

jade tesserae in various shades of green and brown

Western Han period, 3rd-1st century BC
length 75 cm; width 59 cm

The influence of Daoist ideas about immortality and the preservation of the body after death undoubtedly inspired the practice, under the Han dynasty, of encasing the body of high-ranking persons in funerary suits made of jade. Once known only through textual references, the existence of jade garments was confirmed after the discovery in 1968 of the undisturbed tomb of Prince Liu Sheng and his consort, Dou Wan, at Mancheng, Hubei province.[1] Since then, more than forty complete or partial jade suits have been discovered by Chinese archaeologists, mostly in sites located in Eastern China. One of the latest published examples is a partial suit discovered in a princely tomb at Shizishan, Xuzhou, northern Jiangsu province.[2] Its form and composition are evidence that these jade garments, although conforming to basic models and to a widely diffused funerary practice, show frequent differences, probably reflecting personal choice and taste.

This funerary vest is made in two sections, a front and a back, each formed by small rectangular plaques cut from various kinds of jade, shaped on the top to follow the curve of the neck and shoulders. The plaques – showing clear signs of stains, corrosion and alteration – have sharp edges and small perforations drilled at each corner through which a metal thread, as in the present reconstruction, would originally have passed to hold the plaques together.

The most peculiar feature of this funerary vest is the image of a bird in flight, possibly a phoenix, incised on the plaques at the center of the front section. The image does not have any counterpart in the complete or partial jade funerary suits discovered in controlled archaeological excavations in China, which are all undecorated. However, the Museum of Fine Arts, Boston, houses a group of glass plaques with relief decoration which were probably originally used as components for a funerary suit destined for a person of minor rank, hence the use of glass as a substitute for jade.[3] These plaques are the only comparable example of decorated plaques for a funerary garment, though in a different medium. However, as pointed out by Robert L. Thorp, "both literary and archaeological sources suggest that jade suits more elaborately decorated than those found at Lingshan [Mancheng] were also produced. *Han shu* records a 'pearl robe jade suit' in its description of the funeral accorded the notorious eunuch Dong Xian. The Tang commentator Yan Shigu (581-645) explains the phrase: 'A pearl robe has pearls for the tunic like a suit of armor sewn together using gold thread. From the waist down the suit is jade [plaques], and down to the feet it too is sewn together with gold thread.' If no archaeological corollary to this kind of shroud has yet been reported, there are at least two known examples of suits made from plaques that were engraved and then decorated with gold thread or foil on their surfaces. The dragon, floral, and cloud patterns rendered in gold found on these plaques may indicate that over time jade suits became even more elaborate".[4]

It seems unlikely, although it cannot be ruled out, that the motif of the phoenix is a later addition. However, the rendering of the bird does not fully conform to the usual representation of the phoenix in Han art. Further research is needed to clarify the nature of the decoration on this jade vest.

1 See Yang Xiaoneng 1999, pp. 388-393, 415-416, nos. 129 and 139.
2 *Wenwu* 1998, 8, pp. 4-33 and fig. 30 at p. 22.
3 Fontein & Tung Wu 1973, pp. 100-102.
4 Thorp 1991, p. 36.

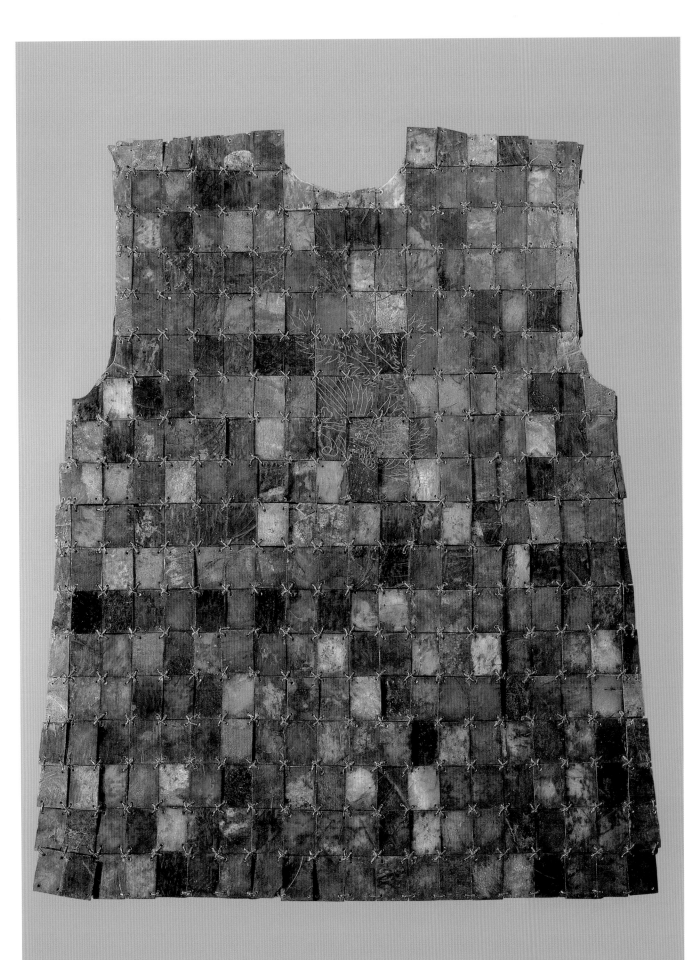

122 *Cicada*
pale green jade with veining
Western Han period, 2nd-1st century BC
length 3.8 cm; width 2.1 cm
from Fiorillo, Philadelphia

123 *Cicada*
light gray jade
Western Han period, 2nd-1st century BC
length 4.5 cm; width 2.5 cm

124 *Cicada*
pale green jade with veining
Western Han period, 2nd-1st century BC
length 5.8 cm; width 2.9 cm

125 *Pair of pigs*
mottled beige jade with altered areas
Western Han period, 2nd-1st century BC
length 11.2 cm; width 2.4 cm; height 2.9 cm

If funerary suits in jade were an extravagance which only nobles could afford to have in the afterlife,[1] much more common and widespread during the Han period was the use of smaller, less costly burial jades to accompany and protect the deceased.

The jades presented here belong to this second category and may be regarded, in general terms, as auspicious jades, because of the meaning attached to them. The cicada is an ancient symbol which, in Chinese art, is first documented in decoration of Shang period (16th-11th century BC) bronzes. In that context, it may have been a symbol of transformation in reference to the metamorphosis of the cicada during its life cycle.[2] In the Han period, cicadas in jade were usually placed in the mouth of the deceased, probably to help the process of passage and transformation after death. For this purpose, it was not necessary for jade cicadas to be elaborately carved: a few incisions suggesting essential features

would have sufficed and in most cases, as in no. 122, the object would have fit perfectly on the tongue. However, in some cases jade cicadas were pierced with small holes for suspension, as in no. 124, allowing them to be worn as amulets by the living, without ever being placed in burials.[3] This would explain the large number of cicadas in collections all over the world without any trace of the alteration visible in buried jades.

The pigs, which usually come in pairs, were probably simply considered symbols of wealth or abundance, reflecting their importance in everyday life in China since Neolithic times. They are described as having been occasionally found clasped in the hands of the deceased,[4] but we really lack any systematic study which would clarify their exact role and function. It is not clear, for example, why their tails are very often pierced with a hole, as if they were meant to be suspended.

1 Thorp 1991, pp. 27 and 35-36.
2 Allan 1991, p. 166.
3 This was noted by Salmony 1933, p. 175.
4 Rawson 1995, pp. 319-320, no.24: 10.

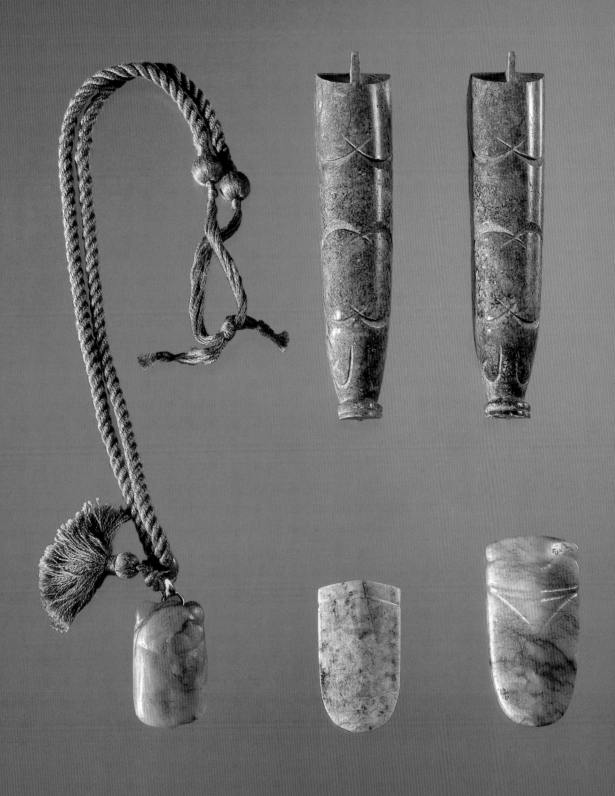

126 *Figure*
light green jade
Western Han period, 2nd-1st century BC
height 3.7 cm

127 *Figure*
altered jade
Western Han period, 2nd-1st century BC
height 5 cm

128 *Figure*
russet jade
Western Han period, 2nd-1st century BC
height 7.5 cm

These three figures, all similarly carved in the form of a bearded standing man, represent one of the most curious and, as yet, little understood categories of Chinese jades. Despite the large number of them in public and private collections, their function, origin and even dating remain highly conjectural. They are usually dated to the Han period but, so far, archaeological evidence to corroborate such an assumption is very limited.[1]

It is possible that these figures were pendants and, like the cicadas nos. 122 to 124, served as amulets or charms which were worn by their owners and not placed in burials. Why the figure portrayed in such pendants was always standing in a hieratic and dignified manner, his hands concealed in the long sleeves of his robe, remains unclear. Wu Hung describes a small jade figure of the 2nd century BC from the tomb of Prince Liu Sheng, at Mancheng, inscribed with the words *gu yu ren,* "Jade gentleman of antiquity". He then relates it to the "Divine

Gentleman" mentioned in a passage of the *Zhuangzi,* suggesting that the two personages represented, in different contexts, the same notion of immortality.[2] It is possible that these pendants had similar meanings or associations with ideas of longevity, as the beard, a sign of venerable age, would suggest.

The three pendants exhibit interesting features, apart from the obvious differences in size. No. 126 is the simplest, carved in a jade still retaining its original color and contrasting with no. 127, made in totally altered stone. The latter has in fact been crafted by carving a Neolithic period tubular bead, probably belonging to the Liangzhu culture (c. 3300-2200 BC). The third one, no. 128, is discolored through repeated handling, showing how these little charms were, at least in some cases, handled by their owners over the years. The highly simplified form, similar to that of the cicadas and pigs, would have permitted the artisans to carve easily and quickly many of these little pendants to satisfy a large clientele.

1 Forsyth and McElney 1994, p. 247, no. 144, who cite a similar
 pendant discovered in the tomb of the King of Nanyue a Guangzhou.
2 Wu Hung 1997, pp. 165-166.

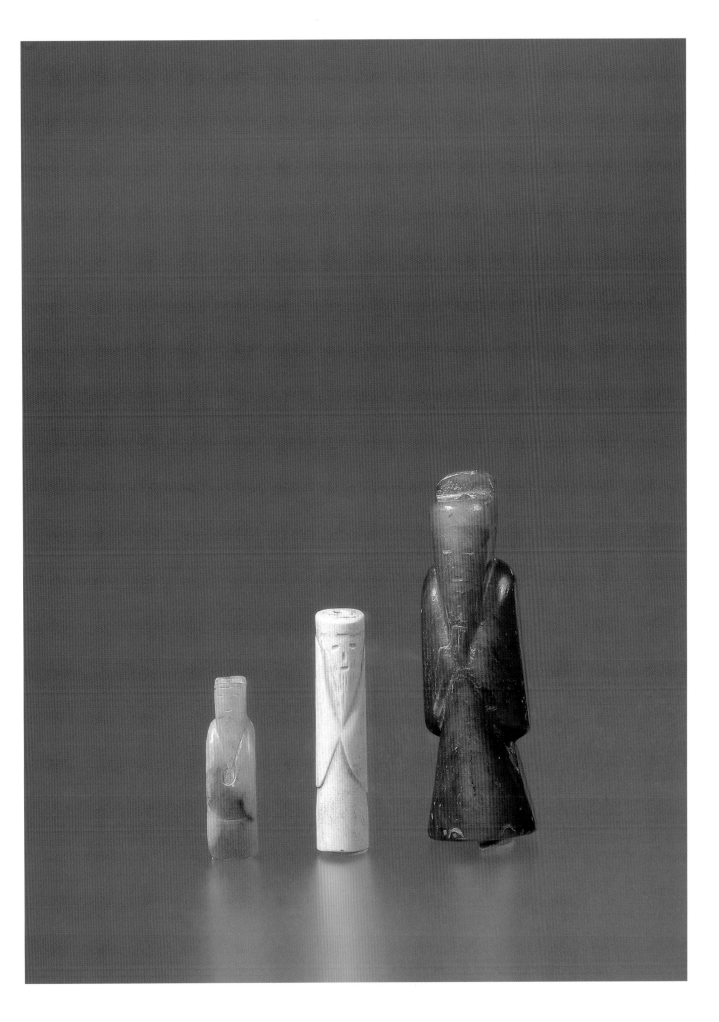

129 *Sword with guard*
rusted iron and creamy white altered jade
Western Han period
length 34 cm

130 *Sword pommel*
green jade with alteration
late Eastern Zhou period, 3rd century BC
diameter 5.3 cm; height 1.5 cm

131 *Sword guard*
translucent green jade with russet areas
and traces of iron incrustation
Western Han period, 3rd-2nd century BC
width 5 cm; height 1.9 cm; thickness 1.8 cm

132 *Scabbard slide*
translucent green jade with russet areas
and iron incrustation
Western Han period, 3rd-2nd century BC
length 9.5 cm; width 2.5 cm; thickness 1.5 cm

133 *Scabbard chape*
translucent green jade with russet areas
Western Han period, 3rd-2nd century BC
height 4.2 cm; top width 5.2 cm; bottom width 4.3 cm

This group of jades illustrates the fittings associated with iron swords (no. 129) in the late Eastern Zhou and Han periods:[1] a pommel of round shape (no. 130); a roughly triangular decorative fitting for the guard (no. 131); a slide fixed to the scabbard to suspend the sword from the belt (no. 132); and a trapezoidal chape to protect the point of the sword and prevent perforation of the scabbard (no. 133). The pommel and guard were substitutes in jade for parts which, in the 5th to 3rd centuries BC, were customarily forged in iron as integral components of swords. The use of jade fittings is a Chinese innovation in the decoration of weapons borrowed from the nomadic peoples of the North.

Decorative motifs used in the ornamentation of these fittings were generally limited to those seen on these jades: geometric patterns, animal faces and dragons which could be adapted to all the pieces. The pommel is decorated with curling motifs derived from the ornamentation of discs; the whorl pattern in the center occurs on bronzes and lacquers of the period.[2] The sword guard affixed to no. 129 is decorated with a stylized animal mask used on chapes (nos. 134 and 135), while the guard no. 131 bears a lively, striding dragon. The same motif embellishes the scabbard slide no. 132 and the chape no. 133. The latter can be compared to a similar object in openwork excavated in 1986 from a Western Han tomb at Yongchengxian (Mangshan, Henan province).[3]

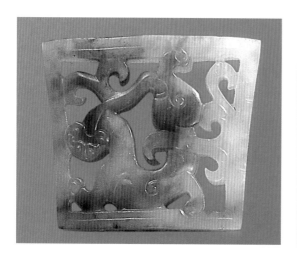
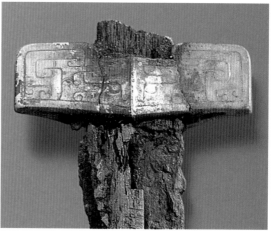

1 The fittings did not necessarily occur together: see, for example, a Chu period sword with only a jade pommel (Wong and Yeow 1993, p. 28, first on the left); a sword complete with its wooden case and a jade chape (Fontein and Tung Wu 1973, pp. 94-95, no. 39) or a more complete set formed by a pommel, a guard and a scabbard slide associated with remains of an iron sword (De Bisscop 1995, p. 69, no. 34).

2 Thote 1991, pp. 28-29, figs. 7 and 8. Compare a similar pommel in the Rietberg Museum, Zurich (Burkart-Bauer 1986, p. 78, no. 96, illustrated at p. 77).

3 *Zhongguo Yuqi Quanji*, vol. 4, no. 195.

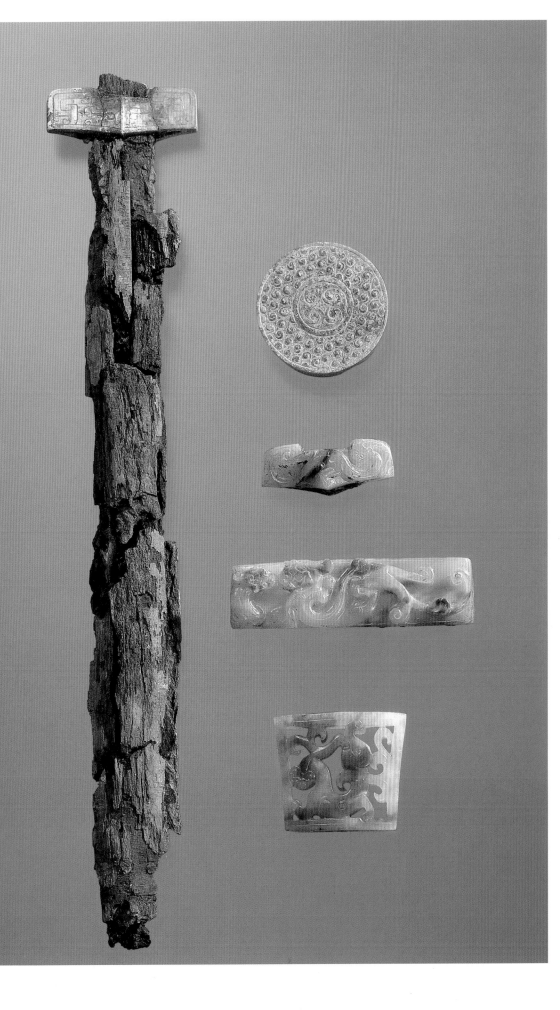

134 *Scabbard chape*
green jade with brown areas and metal incrustation
Western Han period, 3rd-2nd century BC
height 3.7 cm; top width 8.8 cm; bottom width 7.8 cm
from the Armand Trampitsch Collection

135 *Scabbard chape*
altered jade
Western Han period, 3rd-2nd century BC
height 4.1 cm; top width 5.2 cm; bottom width 4.5 cm

136 *Scabbard chape*
yellowish jade with alteration
late Eastern Zhou, early Western Han period, 4th-3rd century BC
height 3.8 cm; top width 5.1 cm; bottom width 3.5 cm

In the late Eastern Zhou period, the stylized animal mask carved on the guard in no. **129** was frequently used to decorate sword chapes, as here in nos. **134** and **135**, which are the most usual type of this class of jade object. At first glance, the pattern carved on these chapes, and on no. **134** in particular, looks like no more than a series of regular geometric motifs. The animal face from which this abstract ornamentation derived is visible, turned upside down, on the top part of no. **136**: it is a bovine head with long horns, the same motif used in the ornamentation of large *bi* discs, such as the one in no. **120**.

The motifs carved on no. **136** are, on the contrary, much less common and make this object quite unusual in the category of scabbard chapes. The form is distinctive, with flaring sides terminating in acute angles and a central, pronounced ridge. The patterns, though symmetrically arranged and roughly divided in four sections, have a more naturalistic feeling than those in nos. **134** and **135**. Particularly noteworthy are the two crouching feline creatures with heads turned backward placed at the top corners of the object, showing stylistic influences from steppe art. The bodies of the animals are marked by S-shaped patterns recalling the stripes on a tiger skin, while their tails are striated, similar to the dragons with feline features in nos. **139** to **143**. The two crouching animals are counterbalanced at the bottom of the chape by two birds' heads, while two of the long horn-like protrusions extending from the bovine's head are engraved with scale-like patterns recalling the skin of snakes.

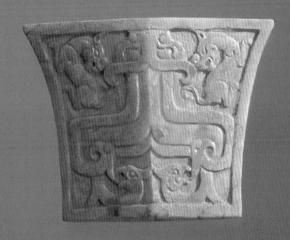

137 *Fitting*

translucent creamy white jade with alteration and iron incrustation
Western Han period, 3rd-2nd century BC
length 6.2 cm; height 4 cm; width 1.7 cm

The iron incrustations and the yellowish patination caused by corrosion of the iron (compare the same effect on the sword guard in no. 129), indicate that this curiously shaped jade decorated with a three-dimensional ram's head was used as a fitting, although its exact function is obscure. The few parts of the object showing the original, translucent white color of the jade suggest the fitting was probably carved from Khotanese jade, one of the most prized varieties, obtained from Central Asia. The geometric motifs carved on the sides and in openwork on the top and bottom of the fitting have an outline similar to those carved on the chape no. 138.

138 *Scabbard chape*

translucent green jade with altered areas
Western Han period, 3rd-2nd century BC
height, 3.8 cm; top width 5.5 cm; bottom width 4.5 cm

By the late Eastern Zhou period, a significant stylistic transformation occurred in the decoration of sword fittings. The motifs were often three-dimensional –as seen on this chape and on nos. 131, 132 and 139 to 141– in contrast with the essentially low relief decor carved, for example, on nos. 134 and 135. The themes are almost invariably dragons with strongly marked feline features, their sinuous bodies moving over the surface of the object, sometimes emerging from it, as if it were a liquid instead of solid jade (see nos. 140 and 142). This style breaks the rigidity and geometric formality which had limited the decor to the space defined by the outline of the fitting. Animals now move freely on and around the objects, often, as in this case, surpassing the physical boundaries of the fitting with parts of their bodies. The practical function of the object becomes secondary to the virtuosity of the jade carver and the inventiveness of the design.

A number of chapes and scabbard slides decorated in this style are known in public and private collections, matched by excavated examples.[1] On the basis of current archaeological evidence, jades illustrative of this style are principally found in sites in Shandong, Jiangsu, Jiangxi, Zhejiang, Hunan and Guangdong provinces, indicating a southern and eastern origin of this style and possible location of workshops in that area.

1 Musées Royaux d'Art et d'Histoire, Brussels (d'Arschot 1976, pls. 25-28); The Metropolitan Museum of Art, New York (O'Neill 1987, p. 72, no. 104); The Art Institute of Chicago (Pearlstein 1999, p. 110, fig. 40); British Museum, London (Ayers and Rawson 1975, no. 161); Hotung Collection (Rawson 1995, p. 299, no. 21: 9); The Peony Collection (Forsyth and McElney 1994, p. 232, no. 127). See also Keverne 1991, p. 109, fig. 38.

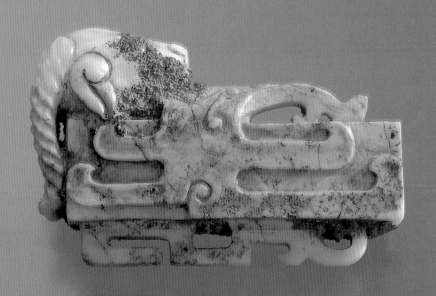
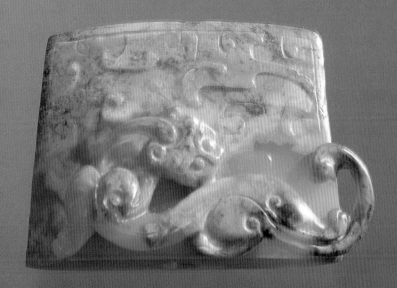

139 *Scabbard slide*

altered jade

early Western Han period, c. mid 2nd century BC
length 14.5 cm; width 4.5 cm; thickness 2.7 cm

The three-dimensional style characteristic of the decoration of late Eastern Zhou and Western Han sword fittings in jade reaches one of its peaks in this scabbard slide. The decoration is organized in multiple layers: the surface, engraved with delicate curls and undulating motifs,[1] acts as the physical support on which the dragons rest, their bodies twisted in strongly emphasized S-shapes. The feline-like dragons, frequently carved on scabbard slides of the period (see no.132) differ, one is hornless and the other has a long single horn. The trifurcate tails of the animals terminate near geometric abstract motifs in relief decorated with incised linear patterns. These motifs recall those incised on the chape no.138 and derive from the geometric patterns used to

decorate earlier, more sober sword chapes such as no.134. In this piece, the motifs are much more elaborate; they have a pronounced baroque aspect, seen on other contemporary richly decorated sword fittings.[2] The geometric pattern carved in openwork on the top of the scabbard slide forms the profile of a dragon's head turned toward the left, with a clearly delineated snout, mouth, fang and eye.

The large size of this scabbard slide, the exhuberant ornamentation and the baroque design relate it to the jades recovered from the tomb of the King of Nanyue (Guangzhou, Guangdong province).[3] The fine workmanship and the size indicate that it was crafted for a high-ranking person.

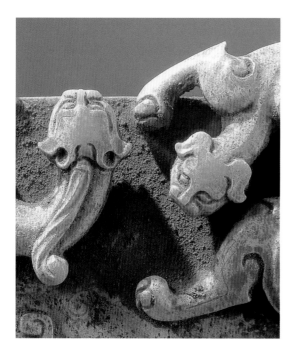

1 The dense layer of red powder covering the jade hides part of these motifs which become visible once the powder has been removed, as tested in the bottom central section of the object.

2 See for example the group of jade fittings excavated in 1977 in a Western Han tomb at Hongtushan, Juye, Shandong province (*Zhongguo Yuqi Quanji,* vol. 4, nos 119-123).

3 Lam 1991, figs. 6-7, 9; Prüch 1999, pp. 222-225.

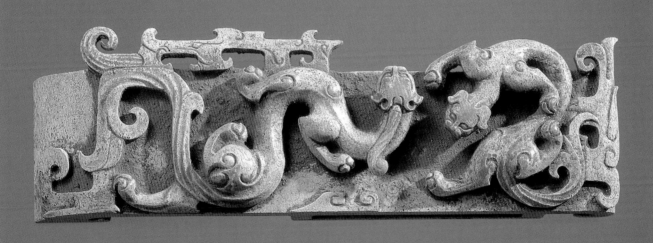

140 *Sword pommel*
altered beige jade

early Western Han period, c. 2nd century BC
diameter of base 5.7 cm; height 3 cm

Although the diameter of this sword pommel is
nearly the same as no. 130, the two differ completely
since the one presented here possesses a sculptural
quality only rarely seen on this type of fitting,
which brings it close to the group of jades discussed
in entries nos. 137 to 143. The decoration is quite
unusual, combining the motif of a coiled dragon
with feline features and a snake whose body passes
into the surface of the jade. Although the meaning
of the motif is obscure, snakes associated with
dragons or feline creatures are quite common
in Eastern Zhou art.[1]

The decorative motifs and the form of the pommel
recall another category of objects: bronze weights,
often cast with images of animals in relief, sometimes
engaged in combat.[2] It is possible that this pommel
was intentionally made in imitation of such bronze
weights, which in turn probably derived – in terms of
form, size and iconography – from harness ornaments
in metal used by the nomadic peoples of the North,
which were decorated with curled animals.

This pommel can be compared, in size and style,
to a similar one from the King of Nanyue tomb
(Guangzhou, Guangdong province) decorated with
two dragons.[3] The same animals occur on a jade
pommel in the Hotung Collection measuring
5.9 cm in diameter.[4]

141 *Scabbard slide*
altered green jade

early Western Han period, c. 2nd century BC
length 7.2 cm; width 3.3 cm

The motif of a dragon associated with a phoenix,
which occurs so frequently in the ornamentation
of jades of the Eastern Zhou period, forms the main
decorative theme on this scabbard slide. Though
much smaller, this slide can be related to no. 139
by the abstract patterns protruding from the border
recalling the stylized profile of a dragon.

The attitude of the feline with its S-shaped body
and upturned, striated tail terminating in a curl
match a similar animal engraved on one side of
a sword chape from the King of Nanyue tomb.[5]

1 Thote 1992.
2 See a set of four inlaid bronze weights in Eskenazi 2000, no. 9.
3 Lam 1991, p. 86, fig. 6
4 Rawson 1995, p. 297, no. 21: 6
5 *Zhongguo Yuqi Quanji*, vol. 4, no. 71 and 72 (showing the two
 sides of the object).

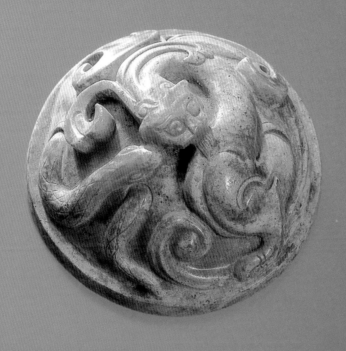
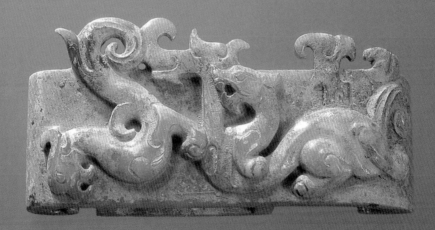

142 *Belt hook*

mottled green jade with alteration
early Western Han period, c. 2nd century BC
length 12.6 cm; width 4.5 cm; thickness 2.3 cm

In terms of style, workmanship and material, this belt hook shares a number of features with the jades in nos. **139** to **141**. The extensive alteration has produced a mottled effect on the green stone similar to no. **141**. Two elements in openwork, an abstract motif and a dragon clearly represented in profile, as in nos. **139** and **141**, adorn one side of the belt hook.[1] The main decoration is carved in relief on the central portion of the object: a bear is represented standing and holding a geometric extension emanating from the dragon's back. The body of the dragon, in the typical undulating S-shaped position, passes through the jade, emerging from the stone itself.

This same theme occurs on a scabbard slide from the tomb of the King of Nanyue (Guangzhou, Guangdong province), while a sword chape from the same tomb is decorated with a bear biting the tail of a dragon.[2] Compare also a belt hook in the Musées Royaux d'Art et d'Histoire for a geometric form similar to the one protruding from the dragon.[3]

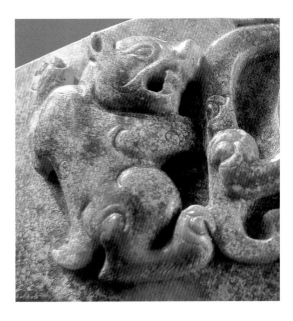

1 Animals in profile, mostly dragons or felines, carved on the borders or sides of various types of objects are not infrequent in Eastern Zhou period jades. For a few examples, including belt-hooks, see Hansford 1968, pls. 30, 35, 36b, 42a, 49 and 52.
2 See *Zhongguo Yuqi Quanji*, vol. 4, no. 76 and Lam 1991, p. 87, fig. 9a respectively.
3 D'Arschot 1976, pl. 28.

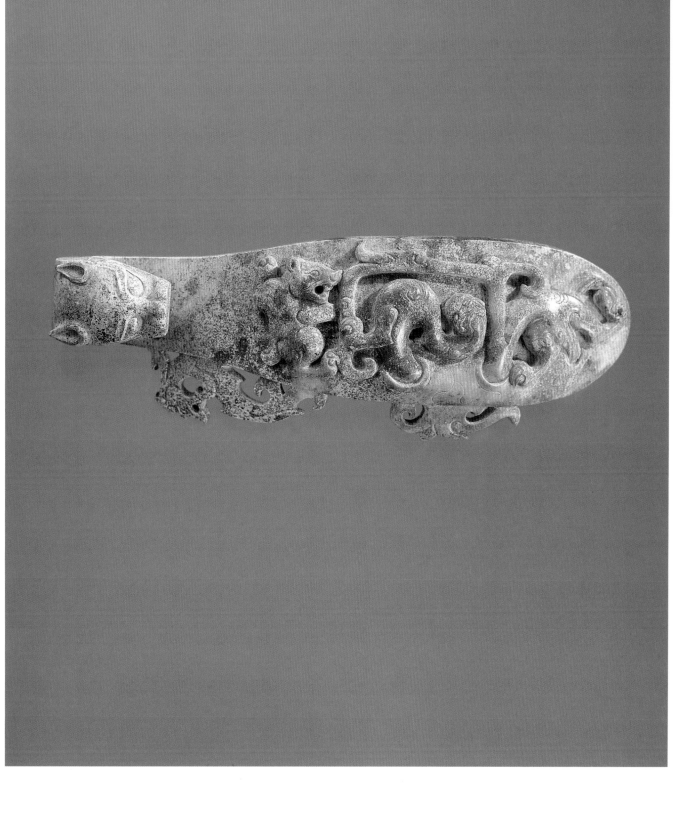

143 *Belt hook*
completely altered jade
early Western Han Period, c. 2nd century BC
length 11.5 cm; width 3.3 cm; thickness 3.2 cm

The Eastern Zhou and the Western Han periods represent a moment of intense cultural interaction between the Chinese and the nomads of the North. This interaction can be seen in the arts from the adoption by the Chinese of certain types of objects, decorative motifs and stylistic solutions typical of the artifacts of nomadic peoples. Some of these artistic borrowings are reflected in a number of the jades presented in this catalogue (nos. 99 and 114 to 116). The belt hooks illustrated here and in no. 142 are examples of such borrowings, ornaments customarily used by the mounted tribesmen transformed into luxury items during the Eastern Zhou period in China.

Similar to other jades made by Chinese craftsmen following foreign prototypes (nos. 114 to 116), this belt-hook is a copy in jade of an ornament commonly made in metal, often inlaid with precious and semi-precious stones. The feline-looking dragon with its body twisted like a figure eight is often seen in metal belt-hooks.[1] What makes this belt hook unique is not just the fine execution and rendering of the details, but also the additional engraved pattern of sinuous lines on the underside of the hook which adds refinement to an already elegant object.

1 For examples of garment hooks in metal with similar form and decoration, see Lutz 1994, nos. 8 and 54.

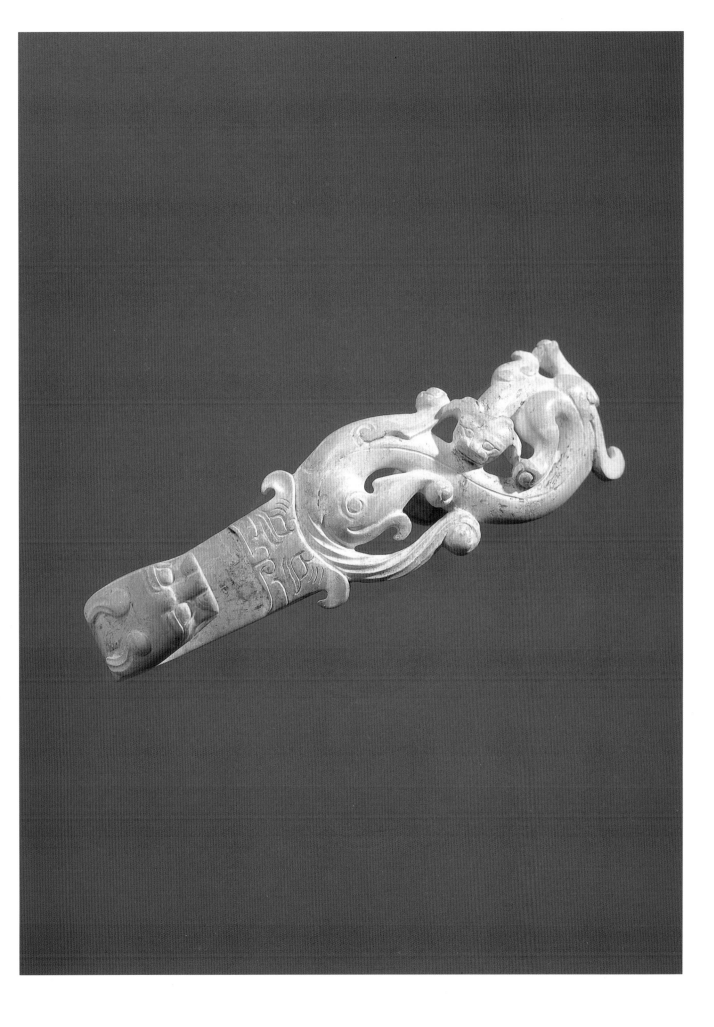

144 *Shield-shaped pendant*
translucent pale green jade with russet areas

Western Han period, c. 2nd-1st century BC
length 5 cm; width 2.6 cm

The aesthetic quality of this pendant arises in part from its subtle coloration. It is again an excellent example of exploiting the color variations of the stone. In this case, there is a delicate interplay of the translucent pale green areas and those of a rich russet color. This elegance is reinforced by the refined design of the pendant.

The oval shape of this pendant is derived from an archer's ring worn to protect the thumb of the archer when drawing the string of a bow.[1] Such rings were documented in the late Shang period (13th-11th century BC), but it was during the Han dynasty that the typical oblong ring was transformed, as if flattened, becoming the shield-shaped central element of small elaborate pendants richly decorated with dragons. The two parts of this pendant, the central section and the two dragons encircling it, are enhanced by the changing colors of the stone. On the reverse side – where the outline of the form reminiscent of the archer's ring is engraved with fine lines and curls – the two tones of the jade tend to blend and diffuse over the surface.

1 Rawson 1995, pp. 286-287.

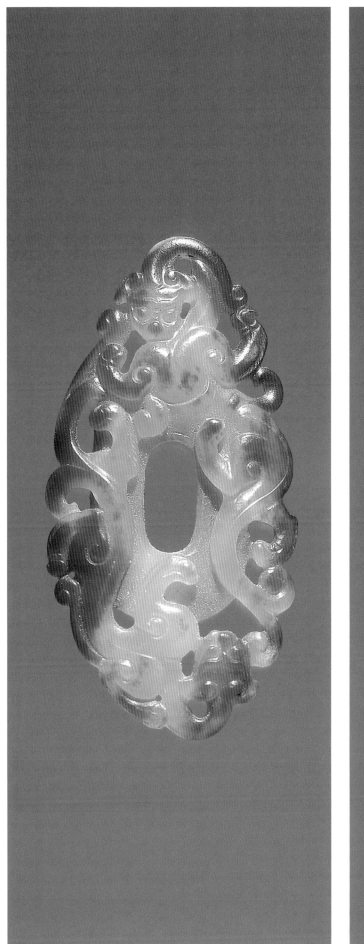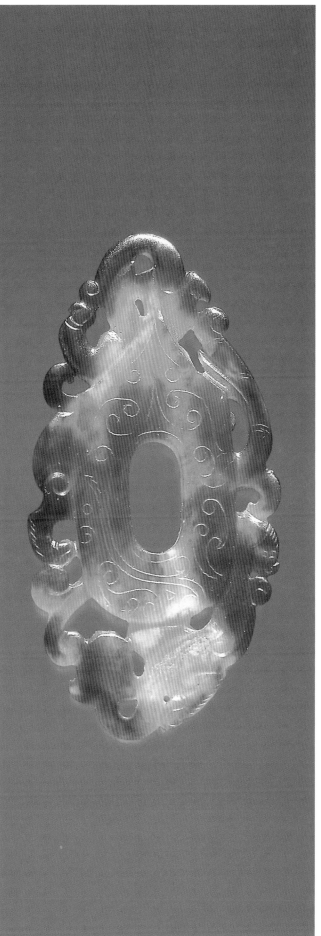

145 *Cylindrical pendant*
opaque white jade with altered areas
Western Han period, c. 2nd-1st century BC
length 6 cm; width 2 cm

The simple tubular form of this pendant is almost concealed by relief carving of writhing dragons on its surface. The simple bodies of the dragons, their limbs and their tails, create a sinuous allover pattern. In the manner already mentioned, dragons seem to emerge from the material itself. The pendant no. 144 shows the delicacy of openwork jade carving, while this pendant despite its small scale has a quality of monumentality, yet both ornaments are almost exclusively decorated with dragons. These two completely different treatments demonstrate mastery of jade carving techniques achieved by Chinese craftsmen in this period.

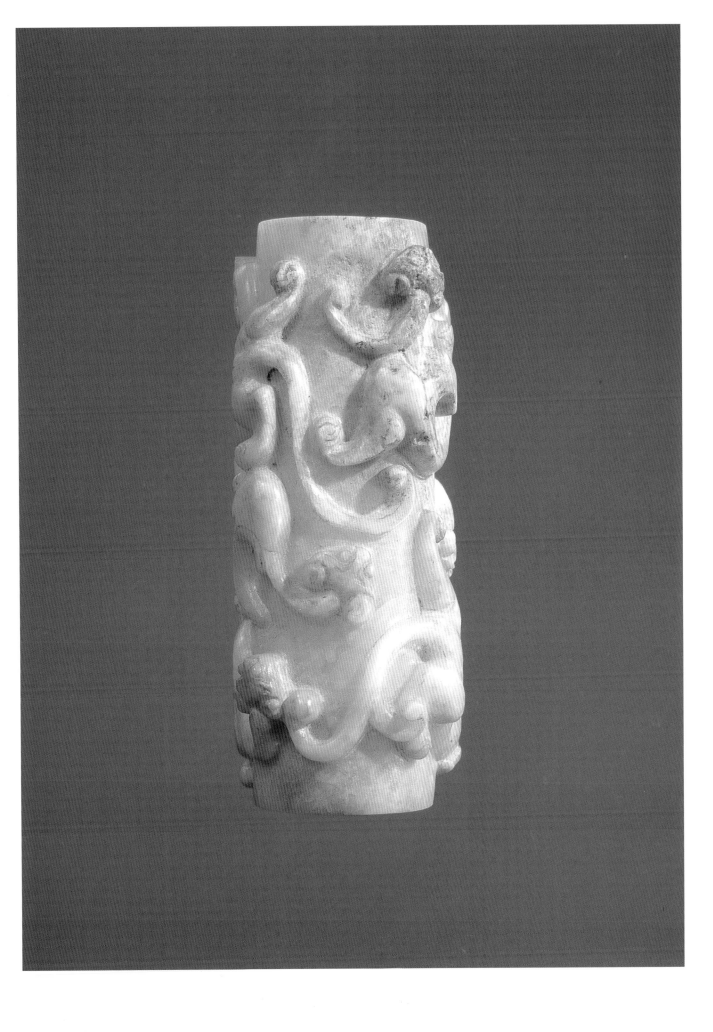

Western Jin Period

146 *Ornament*

white jade with alterations
Western Jin period, 265-317 AD
length 14.5 cm; width 2.5 cm

Although it is pierced for suspension, the ultimate function of this ornament of white jade of possibly Khotanese origin is a mystery: it might be viewed as a columnar pendant, but it also resembles a miniature stele supporting a mythical animal. This three-dimensional carving of a winged feline, known as a *bixie* or Chinese chimera, is stylistically similar to the monumental stone animals which lined the spirit roads leading to important tombs from the Han period.[1]

The low relief carving on the slightly convex sides of the main rectangular portion of the ornament is best read when held horizontally. Each side then presents a different decor contained like a frieze within thin frame-like borders. On one side, in a scene moving from left to right, a kneeling figure, winged or wearing a cape, holds before him scrolling vegetation. This may be interpreted as an immortal or *Xian* with a plant perhaps used for the preparation of an elixir of immortality. Just ahead a bear-like animal emerges from clouds and both figures advance toward an enthroned figure, Xi Wang Mu, the Queen Mother of the West. These images would all be drawn from Daoist mythology popular in the Han dynasty, reflecting contemporary preoccupations

with immortality.[2] The decor on the reverse side shows intertwined mythological creatures, part dragon, feline and bird, in a fluid swirling movement.

This ornament has features which link it to a fascinating white jade vessel from the Western Jin (265-317) tomb of Liu Hong in Anxiang country, excavated in 1991,[3] and recently exhibited at the Guggenheim Museum in New York. On that vessel as well, the decor is organized in friezes, one above the other, within frame-like bands. Similar figures – the immortal, the bear and Xi Wang Mu – appear amid swirling clouds and dragons, treated with the same rounded contours as are discernible in the ornament presented here and having similar striated and twisted rope-like details. Another marked similarity is the presence in the decor – both relief and sculptural – of small round holes which may have been drilled to guide the laying out of the decor, a jade working technique previously mentioned in entry no. 106.

On the basis of these iconographic, stylistic and technical comparisons, an attribution to the Western Jin dynasty can be proposed for the present ornament whose decor holds the promise of immortality.

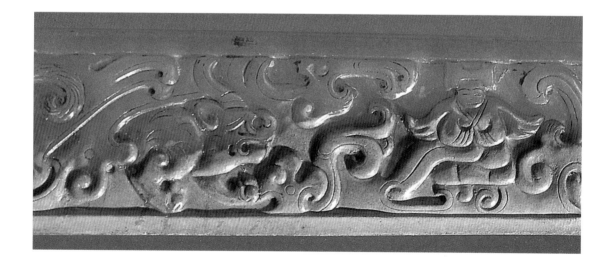

1 Paludan 1988.
2 For a detailed discussion of the Queen Mother of the West, see Loewe 1979, pp. 86-126.
3 *Wenwu* 1993, 11, pp. 1-18, color pl. 2: 1. The object is also reproduced and discussed in the Guggenheim exhibition catalogue, Lee 1998, p. 66 and no. 19.

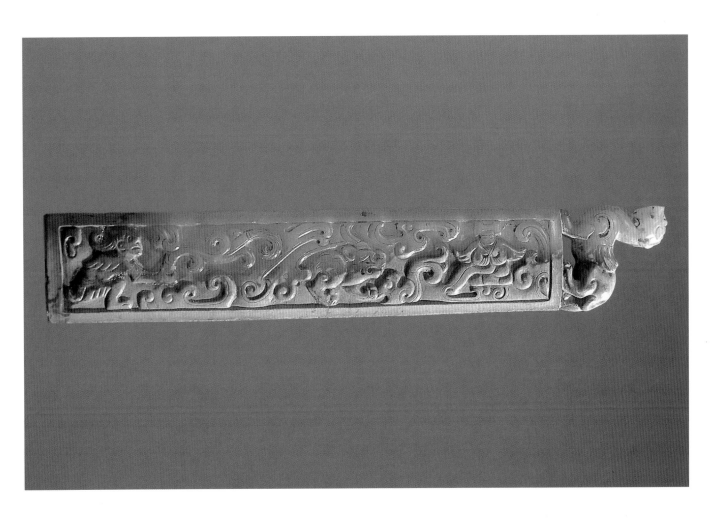

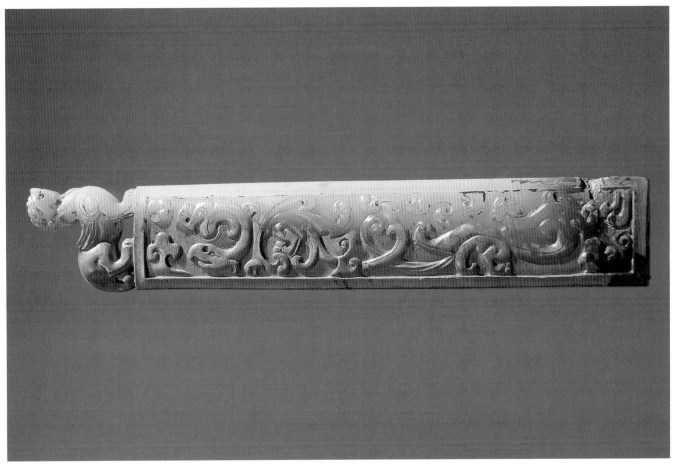

Funerary vest, Western Han

Bibliography

ALLAN 1991
Allan, Sarah, *The Shape of the Turtle. Myth, Art and Cosmos in Early China,* New York 1991

AYERS AND RAWSON 1975
Ayers, John and Rawson, Jessica, *Chinese Jades Throughout the Ages,* London 1975

BECK AND NEICH 1992
Beck, Russell and Neich, Roger, "Jades of the New Zealand Maori", in Stephen Markel (ed.) *The World of Jade,* Bombay 1992, pp. 89-108

BURKART-BAUER 1986
Burkart-Bauer, Marie-Fleur, *Chinesische Jaden aus drei Jahrtausenden,* Zurich 1986

CHILDS-JOHNSON 1995
Childs-Johnson, Elizabeth, "Symbolic Jades of the Erlitou Period: A Xia Royal Tradition", *Archives of Asian Art,* vol. 48, 1995, pp. 64-90

CIARLA AND LANCIOTTI 1987
Ciarla, Roberto and Lanciotti, Lionello, *Dian. I bronzi del regno di Dian, Yunnan Cina (secoli VI/I a. C.),* Rome 1987

CORRADINI 1993
Corradini, Piero (ed.), *Confucius, la via dell'uomo,* Milan 1993

D'ARSCHOT 1976
D'Arschot, Philippe, *Jades archaïques de Chine aux Musées Royaux d'Art et d'Histoire,* Bruxelles 1976 (typescript)

DE BISSCOP 1995
De Bisscop, Nicole, *Chinese Jade and Scroll Paintings from the Dongxi Collection,* Brussels 1995

DESROCHES 1998
Desroches, Jean-Paul, "Ancient Jade: Its Modification and Forgery Under the Qianlong Emperor", *Orientations,* vol. 29, November 1998, pp. 70-74

DU JINPENG 1998
Du Jinpeng, "Hongshan wenhua 'gou yun xing' lei yuqi tantao", *Kaogu* 1998, 5, pp. 50-64

ESKENAZI 2000
Eskenazi Ltd., *Masterpieces from Ancient China,* London 2000

FONTEIN AND TUNG WU 1973
Fontein, Jan and Tung Wu, *Unearthing China's Past,* Boston, 1973

FORSYTH 1990
Forsyth, Angus, "Five Chinese Jade Figures. A Study of the Development of Sculptural Form in Hongshan Neolithic Jade Working", *Orientations,* vol. 21, May 1990, pp. 54-63

FORSYTH AND MCELNEY 1994
Forsyth, Angus and McElney, Brian, *Jades from China,* Bath 1994

FU XUEYOU 1994
Fu Xueyou, "Luan Fei Tian Han, Xiu Wu Chang Hong. Handai chang xiu wu yong he shu jia", *Gugong Wenwu Yuekan ,* no. 130, January 1994, pp. 116-133 and no. 131, February 1994, pp. 86-91

GAO AND XING 1995
Gao, Dalun and Xing, Jinyuan, "Sichuan Daxue bowuguan shou zang de Han yiqian bufen yu, shiqi", *Wenwu* 1995, 4, pp. 68-75

GIGLIOLI 1898
Giglioli, Enrico Hillyer, "L'Età della Pietra nella Cina, colla descrizione di alcuni esemplari nella mia collezione", in *Rivista di Archeologia, Antropologia, Etnografia,* vol. 28, 1898

GOEPPER 1999
Goepper, Roger (ed.), *Korea, Die Alten Königreiche,* Munich 1999

GREEN 1993
Green, Jean M., "Unraveling the Enigma of the *Bi:* The Spindle Whorl as the Model of the Ritual Disk", *Asian Perspectives,* vol. 23, no. 1, 1993, pp. 105-124

GUO DASHUN 1995
Guo Dashun, "Hongshan and Related Cultures", in Sarah M. Nelson (ed.), *The Archaeology of North-East China. Beyond the Great Wall,* London 1995, pp. 21-64

GUO DASHUN 1996
Guo Dashun, "A Study on the Cloud-Scroll Jade Plaque of the Hongshan Culture" in Sam Bernstein (ed.), *The Journal of Chinese Jade,* San Francisco 1996, pp. 8-35

HANSFORD 1968
Hansford, S. Howard, *Chinese Carved Jades,* London 1968

HÁJEK AND KESNER 1990
Hájek, Lubor and Kesner, Ladislav, *Nejstarší Čínské Umění ve sbírkách Národní galerie v Praze,* Prague 1990

HERMITAGE AND BRITISH MUSEUM 1978
Hermitage State Museum and British Museum, *Frozen Tombs. The Culture and Art of the Ancient Tribes of Siberia,* London 1978

HUANG TSUI-MEI 1992
Huang Tsui-mei, *The Role of Jade in the Late Neolithic Culture of Ancient China: The Case of Liangzhu,* doctoral dissertation submitted to the University of Pittsburgh, Ann Arbor, Michigan 1992

HUBEI 1988
Hubei Sheng Bowuguan, *Tomb of Marquis Yi of Zeng in Suixian County,* Hong Kong 1988

JAMES 1991
James, Jean M., "Images of Power: Masks of the Liangzhu Culture", *Orientations,* vol. 22, June 1991, pp. 46-55

JENYNS 1982
Jenyns, Soame, *Chinese Art III,* New York 1982

JIAN RONG 1993
Jian Rong, "Shilun sanjiao yuan tongqi ge", *Wenwu* 1993, 3, pp. 78-84

KEVERNE 1991
Keverne, Roger (ed.), *Jade,* London 1991

LAM 1991
Lam, Peter Y.K., "Selected Jades from an Imperial Nanyue Tomb", *Orientations,* vol. 22, no. 11, November 1991, pp. 84-87

LAUFER 1912
Laufer, Berthold, *Jade. A Study in Chinese Archaeology and Religion,* Chicago 1912. Reprinted New York 1972 and 1989

LAUFER 1913
Laufer, Berthold, *Notes on Turquoise in the East,* "Anthropological Series", no. 169, Chicago 1913

LAUFER AND FARRINGTON 1927
Laufer, Berthold and Farrington, O.C., *Agate, Physical Properties and Origin ; Archaeology and Folklore,* "Geological Leaflet Series", no. 8. Chicago 1927

LAWTON 1982
Lawton, Thomas, *Chinese Art of the Warring States Period. Change and Continuity 480-221 BC,* Washington, DC 1982

LI XUEQIN 1992
Li Xueqin, "Liangzhu Culture and the Shang Dynasty *Taotie* Motif", in Roderick Whitfield (ed.), *The Problem of Meaning in Early Chinese Ritual Bronzes,* London 1992, pp. 56-66

LIU GUOXIANG 1998
Liu Guoxiang, "Hongshan wenhua gou yun xing yuqi yanjiu", *Kaogu* 1998, 5, pp. 65-79

LOEHR AND HUBER 1975
Loehr, Max and Huber, Louisa G. Fitzgerald, *Ancient Chinese Jades from the Grenville L. Winthrop Collection in the Fogg Art Museum, Harvard University,* Cambridge, Mass. 1979

LOEWE 1979
Loewe, Michael, *Ways to Paradise. The Chinese Quest for Immortality,* London 1979

LUTZ 1994
Lutz, Albert (ed.), *Chinesisches Gold und Silber. Die Sammlung Pierre Uldry,* Zürich 1994

MIDDLETON AND FREESTONE 1995
Middleton, Andrew and Freestone, Ian, "The Mineralogy and Occurrence of Jade", in Rawson 1995, pp. 413-423

NEEDHAM 1959
Needham, Joseph, *Science and Civilization in China,* vol. 3, Cambridge 1959

O'NEILL 1987
O'Neill, John P. (ed.), *Ancient Chinese Art. The Ernst Erickson Collection,* New York 1987

PEARLSTEIN 1999
Pearlstein, Elinor, "Ancient Chinese Jades, the Sonnenschein Legacy", *Arts of Asia,* vol. 29, no. 3, May-June 1999, pp. 98-110

POPESCU, SILVI ANTONINI AND BAIPAKOV 1998
Popescu, Grigore Arbore; Silvi Antonini, Chiara and Baipakov, Karl, *L'uomo d'oro. La cultura delle steppe del Kazakhstan dall'età del bronzo alle grandi migrazioni,* Rome 1998

PRÜCH 1999
Prüch, Margarete (ed.), *Schätze für König Zhao Mo. Das Grab von Nan Yue,* Frankfurt 1999

RAWSON 1975
Rawson, Jessica, "The Surface Decoration on Jades of the Chou and Han Dynasties", *Oriental Art,* no. 21, 1, Spring 1975, pp. 36-55

RAWSON 1995
Rawson, Jessica, *Chinese Jade from the Neolithic to the Qing,* London 1995

RAWSON 1996
Rawson, Jessica (ed.), *Mysteries of Ancient China. New Discoveries from the Early Dynasties,* London 1996

ROGERS 1998
Rogers, Howard (ed.), *China 5000 Years*

SALMONY 1933
Salmony, Alfred, "The Cicada in Ancient Chinese Art", *Connoisseur,* March 1933, pp. 174-179

SALMONY 1952
Salmony, Alfred, *Archaic Chinese Jades from the Edward and Louise B. Sonnenschein Collection,* Chicago 1952

SALVIATI 1995
Salviati, Filippo, "Bird and bird-related images in the iconography of the Liangzhu culture", *Rivista degli Studi Orientali,* vol. LXVIII, nos. 1-2, 1995, pp. 133-160

SALVIATI 1998
Salviati, Filippo, "Alla ricerca della pietra verde. La giada nel mondo antico", *Archeo,* no. 6, June 1998, pp. 57-83

SALVIATI 2000
Salviati, Filippo, "Decorated Pottery and Jade Carving of the Liangzhu Culture" in Roderick Whitfield and Wang Tao (eds.), *Exploring China's Past: New Discoveries and Studies in Archaeology and Art,* London 2000 pp. 212-226

SALVIATI (forthcoming)
Salviati, Filippo, "Archaeological Finds of Turquoise in Early China, Neolithic to Early Bronze Age (5000-1500 BC)", *Journal of East Asian Archaeology,* forthcoming.

SHAANXI 1992
Shaanxi Provincial Museum (ed.), *The Gems of the Cultural Relics,* Hong Kong 1992

SHANGHAI MUSEUM 1992
Shanghai Museum and Hong Kong Urban Council, *Gems of Liangzhu Culture from the Shanghai Museum,* Hong Kong 1992

SO 1993
So, Jenny F., "A Hongshan Jade Pendant in the Freer Gallery of Art", *Orientations,* vol. 24, May 1993, pp. 87-92

SO 1997
So, Jenny F., "The Ornamented Belt in China", *Orientations,* vol. 28, no. 3, March 1997, pp. 70-78

SO 2000
So, Jenny F., "Different Tunes, Different Strings: Court and Chamber Music in Ancient China", *Orientations,* vol. 31, no. 5, May 2000, pp. 26-34

SOTHEBY'S 1998
Sotheby's, *Fine Chinese Works of Art,* auction catalogue, March 23 and 24, New York 1998

SUN JI 1998
Sun Ji, "Zhou tai de zu yupei", *Wenwu* 1998, 4, pp. 4-14

SUN QINQWEI 1996
Sun Qinqwei, "Liang Zhou 'pei yu' kao", *Wenwu* 1996, 9, pp. 87-92

SUN ZHIXIN 1997
Sun Zhixin, "A Chronology of the Decoration of Liangzhu Jades", in Rosemary E. Scott (ed.) *Chinese Jades,* London 1997, pp. 49-62

TANG CHUNG 1991
Tang Chung, *A Journey into Hong Kong's Archaeological Past*,
Hong Kong 1991

THORP 1991
Thorp, Robert L., "Mountain Tombs and Jade Burial Suits:
Preparations for Eternity in the Western Han", in G. Kuwayama (ed.),
Ancient Mortuary Traditions of China, Los Angeles County Museum
of Art 1991, pp. 26-39

THOTE 1991
Thote, Alain, "The Double Coffin of Leigudun Tomb No. 1:
Iconographic Sources and Related Problems", in Thomas Lawton (ed.),
New Perspectives on Chu Culture during the Eastern Zhou Period,
Washington 1991, pp. 23-46

THOTE 1992
Thote, Alain, "Aspects of the Serpent on Eastern Zhou Bronzes and
Lacquerware", in Roderick Whitfield (ed.), *The Problem of Meaning
in Early Chinese Ritual Bronzes*, London 1992, pp. 150-160

THOTE 1996
Thote, Alain, "Note sur la postérité du masque de Liangzhu à l'époque
des Zhou orientaux", *Arts Asiatiques*, vol. 51, 1996, pp. 60-72

WANG MINGDA 1997
Wang Mingda, "A Study of Jades of the Liangzhu Culture", Rosemary
E. Scott (ed.), *Chinese Jade*, London 1997, pp. 37-47

WANG MINGDA AND LU WENBAO 1998
Wang Mingda and Lu Wenbao, *Jades of the Liangzhu Culture*, Hong
Kong 1998

WATSON 1971
Watson, William, *Cultural Frontiers in Ancient East Asia*,
Edinburgh 1971

WATSON 1973
Watson, William, *The Genius of China*, London 1973

WATT 1990
Watt, James C.Y., "Neolithic Jade Carving in China", *Transactions
of the Oriental Ceramic Society 1988-1989*, London 1990, pp. 11-26

WEN FONG 1980
Wen Fong (ed.), *The Great Bronze Age of China*, New York 1980

WONG AND YEOW 1993
Wong, Grace and Yeow, Lesley (eds.), *War and Ritual. Treasures
from the Warring States*, Singapore 1993

WU HUNG 1985
Wu Hung, "Bird Motifs in Eastern Yi Art", *Orientations*, vol. 16,
October 1985, pp. 30-41

WU HUNG 1990
Wu Hung, "A Great Beginning. Ancient Chinese Jades and the
Origin of Ritual Art", introduction to the catalogue *Chinese Jades
from the Mu-Fei Collection*, Bluett & Sons Ltd, London 1990

WU HUNG 1990
Wu Hung, "The Prince of Jade Revisited: The Material Symbolism
of Jade as Observed in Mancheng Tombs", in Rosemary Scott (ed.),
Chinese Jades, London 1997, pp. 147-169

WU HUNG 1995
Wu Hung, *Monumentality in Early Chinese Art and Architecture*,
Stanford 1995

YANG BODA 1994
Yang Boda, *Chinese Archaic Jades from the Kwan Collection*,
Hong Kong 1994

YANG BODA 1995
Yang Boda, "Jade *Zhang* in the Collection of the Palace Museum,
Beijing", *Orientations*, vol. 26, no. 2, February 1995, pp. 53-60

YANG MEILI 1993
Yang Meili, "Pu an cheng daojue, yabi qi xuanji", *Gugong wenwu yuekan*,
no. 129, November 1993, pp. 68-76.

YANG MEILI 1994a
Yang Meili, "Gudai Xibei diqu de huan yu, shiqi xilie zhi yi. Qijia
wenhua fengge de huanxing qi", *Gugong Wenwu Yuekan*, no. 131,
February 1994, pp. 66-79

YANG MEILI 1994b
Yang Meili, "Gudai Xibei diqu de huan yu, shiqi xilie zhi er. Taosi,
Shimao leixing wenhua de huanxing qi", *Gugong Wenwu Yuekan*, no. 132,
March 1994, pp. 16-25

YANG MEILI 1994c
Yang Meili, "Gudai Xibei diqu de huan yu, shiqi xilie zhi san. Xi Zhou
de huanxing yuqi", *Gugong Wenwu Yuekan*, no. 134, May 1994, pp. 34-49

YANG XIAONENG 1999
Yang Xiaoneng (ed.), *The Golden Age of Chinese Archaeology. Celebrated
Discoveries from the People's Republic of China*, London and New Haven
1999

YAO QINDE 1991
Yao Qinde, "Spring and Autumn Period Jades from the State of Wu",
Orientations, vol. 22, no. 10, October 1991, pp. 47-52

ZHANG CHANGSHOU 1993
Zhang Changshou, "Xi Zhou de zang yu", *Wenwu* 1993, 9, pp. 55-59.

ZHEJIANG 1990
Zhejiang, Sheng Wenwu Kaogu Yanjiusuo (ed.), *Liangzhu Wenhua Yuqi*,
Beijing 1990

ZHONGGUO YUQI QUANJI
Zhongguo Yuqi Quanji, vol. 1, (Neolithic period), 1992; vol. 2 (Shang and
Western Zhou), 1993; vol. 3 (Spring and Autumn, Warring States), 1993;
vol. 4 (Qin, Han and Six Dynasties), 1993, Shijiazhuang 1992-1993

ZHU QIXIN 1991
Zhu Qixin, "The Liao Dynasty Tomb of a Prince and Princess of
the Chen Kingdom", *Orientations*, vol. 22, October 1991, pp. 53-61.

photographs by
Thierry Prat

graphic design by
sarl Tauros
assisted by
Nathalie Mallat

printed by
Orientations
in August 2000

published by
Myrna Myers